Paradise Found

BETONY VERNON

PARADISE FOUND

AN EROTIC TREASURY
FOR SYBARITES

RIZZOLI
NEW YORK

New York Paris London Milan

CONTENTS

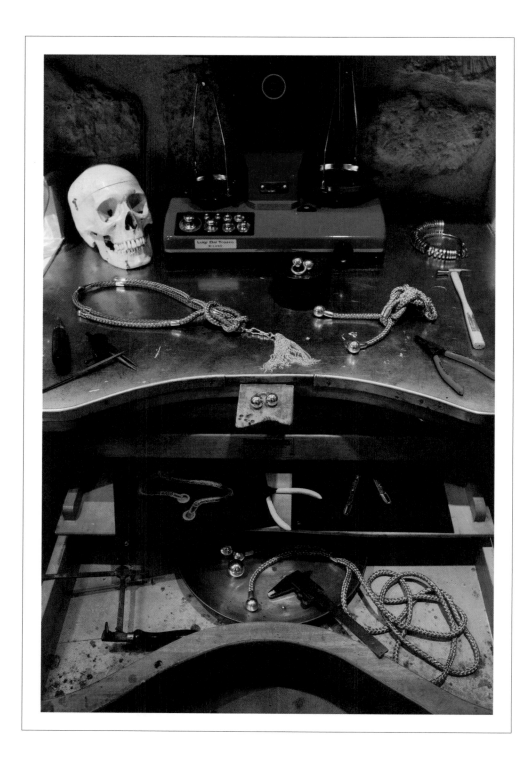

INTRODUCTION

A vision changed the course of my life—and sparked my quest to design for and encourage enhanced sexual wellness and satisfaction. It was March 1998, during a Parisian promenade; I was then a young designer, only six years into refining my collection of erotic jewelry, Sado-Chic. It was Fashion Week and before we started our meetings with collectors and buyers, I invited my assistant to see the erotic highlights of the city on her first trip to Paris. As I was describing to her the details of the private salons in Lapérouse, my mind's eye shifted from scenes of senators and their mistresses, from those "cocottes" who used the mirrors in the private salons of the illustrious restaurant to verify the authenticity of the diamonds they were gifted... to the turn of the twenty-first century. I began telling her what was unfolding in my mind. She hung on my words while I was caught in a trance, suspended between the Belle Époque and a spellbinding future. In this vision, I saw Sado-Chic transform into ever more fearless and functional body art, designed to provide sensual pleasures as well as to adorn. I was imparted an intimate glimpse into a private, experiential space in Paris where my work would be showcased... I saw myself traveling with a pleasure "necessaire," a transportable gallery for my erotic jewelry collection... I watched private clients embrace the spirit of Sado-Chic and the promise of enhanced pleasure in their lives. In my vision, without knowing it, I was encountering the people who would work with me for the next nearly three decades to make my vision become reality, from collectors, photographers, illustrators, and influencers to my brave team. Inspired, I returned to my atelier in Italy, and I set to work fabricating the deluxe leather travel case that I called "the Boudoir Box." By the end of 2000, this portable tabernacle for sophisticated lovers who yearn to expand their sensual repertoires was ready for its first voyage. In my Paradise Found salons since then, the Boudoir Box and its curated array of tools for anal and vaginal play, G-spot stimulators, clamps, and more have helped many explore for the first time their yearning for deep connection and sexual satisfaction without shame or inhibition. My research in the language of love also led to the creation of Paradise Found Fine Erotic Jewelry. This collection consists today of more than four hundred jewels and what I call "jewel-tools"—jewels that transform from Sado-Chic chains, cuffs, and rings into instruments of pleasure, erotic massage rings, leather whip attachments, feather ticklers, sophisticated bondage belts, and sterling silver vessels that

become dilettos—all designed with the sexual aesthete in mind. They allow sybarites and novices alike the ability to offer (and feel) sensations that cannot be experienced with the hands and body alone. Transcendental sensations! I always felt that the value of jewelry could be more than purely aesthetic or empirical. In my Florence atelier in 1992, I experimented with fabricating the bonds of love and desire into jewelry, making the prototypes myself and launching my first line, which included the family of pieces I playfully called "Sado-Chic." Censorship on social media later forced me to change the line's name to the "O-Ring" collection; it wouldn't be the only time I had to make alterations. The series called Yoni (Sanskrit for "vulva") would eventually need to be changed to "Venus" while the "Pierced Penis" collection became "Boys." I didn't dare show Sado-Chic to the accessory buyers who visited my atelier, because I knew I was ahead of my time—in the 1990s, sexy was in vogue but the topics of real sex, sensual aesthetics, and pleasure enhancement were not, even in the fashion world. However, I had many devoted collectors, because those who prioritize their pleasure and seek deep sexual satisfaction are the same people who crave the best life has to offer. The Boudoir Box, fabricated following the vision I had in 1999, enabled me to transport my erotic collections for private viewings around the world. Then the terrorist attacks on September 11, 2001, gave me the courage to devote all of my creative intentions to my vision and the art of loving. I became a sexologist and educator, as well as continuing my work as a designer and artist. My desire was to dismantle taboos

and shallow clichés, to celebrate sensual experiences with a refined aesthetic and a playful sensibility, to bring instruments of sensual pleasures out of shame-filled, dark metaphorical dungeons and into the light. It was nothing less than a sexual wellness concept that I was creating, a Paradise Found. But when I introduced my erotic collection to the world of fashion, even the more cutting-edge retailers declined to represent me. This led me to understand that sexual pleasure is still one of the most diehard taboos that society has yet to overcome, and I would have to crack open an entirely new niche. Like my collectors, I am inspired by the human body and by the primordial instinct that makes us want to have great sex—that keeps us yearning for maximum pleasure and believing that our sex lives should and can only get better! The human body is a universe to discover, a temple of pleasure to worship, and everyone is curious about discovering and pushing their erotic limits, even though they often don't know where to start. I designed the Paradise Found Fine Erotic collection as an interface for this ecstatic adventure. The objects themselves are a voyage through erotic expression from ancient tradition to modern-day society and are interpreted in gold and silver with precious and semiprecious stones and other natural—and thus noble—materials. They are designed for and intend to glorify the human instinct to attract by emphasizing the innate beauty, harmony, and sensuality of the body. Many objects are interactive but their elegant forms conceal the duality of their sensual functions. Some may be used for self-care, like the Finger Ring, while other jewel-tools can be used in

good company, like the Whip Collier, Double Sphere Massage Ring, Shibari Belt, and the Petting Ring. The latter jewel best expresses the philosophy of what I describe as the sexual ceremony, when lovers transcend the doldrums of everyday sex—by taking the time to explore the entire body, mind and soul, not just the genitals, as a sexual whole. The Paradise Found collection debuted as a precious, durable alternative to the contemporary market of erotic accessories. In order to bring my vision to the forefront, I had to put my fears (and shyness) aside and communicate openly about my work, and, inevitably, certain aspects of my own intimacy with the world. However controversial and potentially "dangerous" my jewelry concept was considered to be by most people at the turn of the twenty-first century, some editors and journalists of creative lifestyle, design, and fashion magazines grasped the idea. Thanks to them, my jewels and my mission in sexual wellness were given a window to the world. Many cutting-edge photographers shot my work over the years; they dared not only to celebrate sexual aesthetics (as fashion often does) but the pro-pleasure practices I was propagating through my art as well. All of these people in the creative industry took part in my mission, and I am eternally grateful to them. Bare skin is the best backdrop for my work but it is not easy to find models that agree to be photographed in the nude, so it was not uncommon for me to do the job. I was photographed often, and my jewelry was central to the building of the characters I embodied for the camera. In most cultures, nakedness is seen as shameful, but I learned that it can actually be

freeing to reveal yourself fully. Yet, in 2004, representation of my erotic works in public venues was still nearly impossible. It was at this time that I reached another milestone in my vision, Eden, an experiential space in Paris, where the Paradise Found collection and the Boudoir Box could be viewed by appointment only. As the collection grew, the miniature manual that I provided with each purchase became too small to proffer all of the information that I wanted to share. There was much need for initiation, so I decided to compose my take on a modern-day Kamasutra. Published in 2013, The Boudoir Bible: The Uninhibited Sex Guide for Today, aims to educate and inspire anyone who desires to expand their sexual horizons. As of 2021, it has been translated into French, Greek, Portuguese, Czech, Taiwanese, Polish, Russian, and Italian, and it stands as a testament to the universality of love and to our quest for sexual satisfaction. Since its inception, the Boudoir Box was meant to be viewed privately so, when I was invited to exhibit it at the Musée d'Art Moderne in Paris in 2017, I initially declined. Yet I recognized the challenging times we all were—and still are—living in. After deep consideration, I accepted the invitation to share my best-kept secret. I knew it was an important step toward inspiring many others to embark on the essential journey of sexual wellness—the heartbeat of our overall wellness. With this book, my decision to inspire as many people as possible to expand their sexual horizons continues, as I share some of the most iconic images and designs from the Paradise Found collection. May you herein unleash your own Paradise Found!

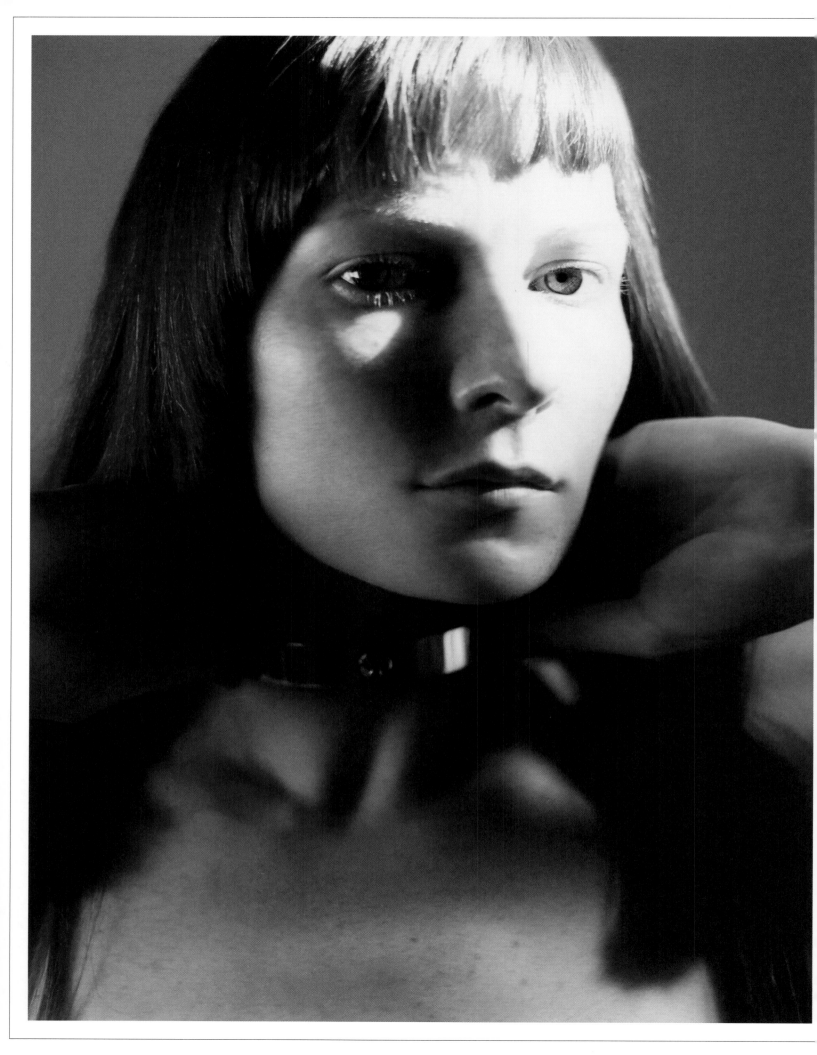

I.
SADO-CHIC

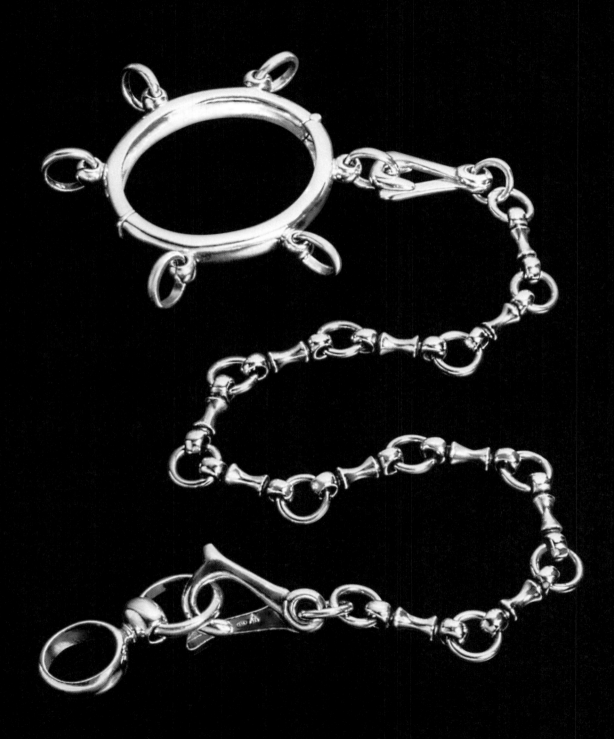

In 1992, I went on a dinner date wearing my latest creation—a ring and wrist cuff connected together by a chain. This Sado-Chic kit was inspired by the symbols of submission in Pauline Réage's erotic masterpiece "The Story of O." On a whim, I passed my ring to my companion. He slipped it onto his finger and I immediately felt something like an electrical current run through the jewel. He felt the pulse too, and we smiled at each other in surprise, and laced our fingers together. It was a sexy sensation. He was chained to me, and I was chained to him, yet he didn't have more power over me than I had over him. We felt a sense of belonging to each other and we both realized that we were part of something bigger. I designed the Sado-Chic collection to celebrate intimate bonds. Each piece empowers through connection, beauty, and play. The designs are not only ornamental; they are also transformational. The true potential of each object is revealed when it is used to provide sensations. Since my first prototype of the Sado-Chic kit (p. 12), made using the "lost wax" casting technique, I have refined the designs of the cuffs. Silver and gold are buttery soft metals, so my challenge was to figure out how to give thin slivers of metal "memory." The molecular structure of these heavily laminated sheets of precious metal holds the secret of the jewels' characteristic springy grip around wrists, neck, waist, and ankles. Rivets, not solder, hold the mechanisms in place, as the torch's flame would cause them to lose this memory. Once they are perfectly polished, they are ready to adorn and to transform. Each Sado-Chic design is crowned with a ball-and-ring mechanism that symbolizes a special bond with oneself or another—the o-ring is the discreet key to the jewel's transformational potential. Some jewels in the collection can be hooked onto this mechanism, which can be exquisitely refined with diamond or ruby pavé encrustations (pp. 40, 41), or multiplied for greater transformational possibilities on the Three Mechanisms bracelet and necklace (pp. 25, 26-27). The same mechanism becomes the cufflinks in the Tuxedo Bondage kit (p. 30), which includes two silk cuffs and a bond link to turn any formal engagement into a potentially erotic affair. The Sado-Chic chains not only embellish. Hook the meter-long signature chain onto the o-rings of the Love-Lock necklace (p. 22) to transform the piece into a shiny harness of desire, or clasp it around the waist and add the Scepter (p. 29) or Tassel pendant to concoct an eye-catching belt. Attached to cuffs, it provides an exquisite restraint to bind a lover's feet and hands together. Soft bondage implies that the bound may escape with very little effort. To practice hard bondage, in which it is virtually impossible to escape, find inspiration in the chapter "Intimate Bonds." The chain's allure stems from its inception as well as its potent symbolism, as I coupled the original inspiration of an ancient Celtic chain used to fasten garments with equestrian allusions—bondage aficionados are known to appreciate the functional aesthetics and fine craftsmanship of riding gear. I assembled the Sado-Chic links to form intricate pieces like the Body Chain (pp. 35, 36) and the bacciamano (p. 24) that recall the clinging protection of chainmail, or the cascading jewels worn by Charles Beaudelaire's naked beloved, as described in his infamous poem "Les Bijoux."

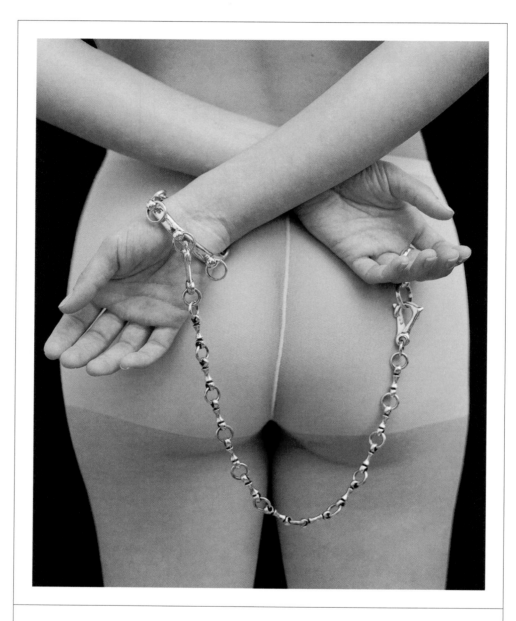

Cuffed hands and feet restrict movement... yet set fantasy free. Link the o-ring to your lover's cuff, and they are yours for the night. The psychological impact of belonging to someone is as empowering as the secret that these jewels encompass.

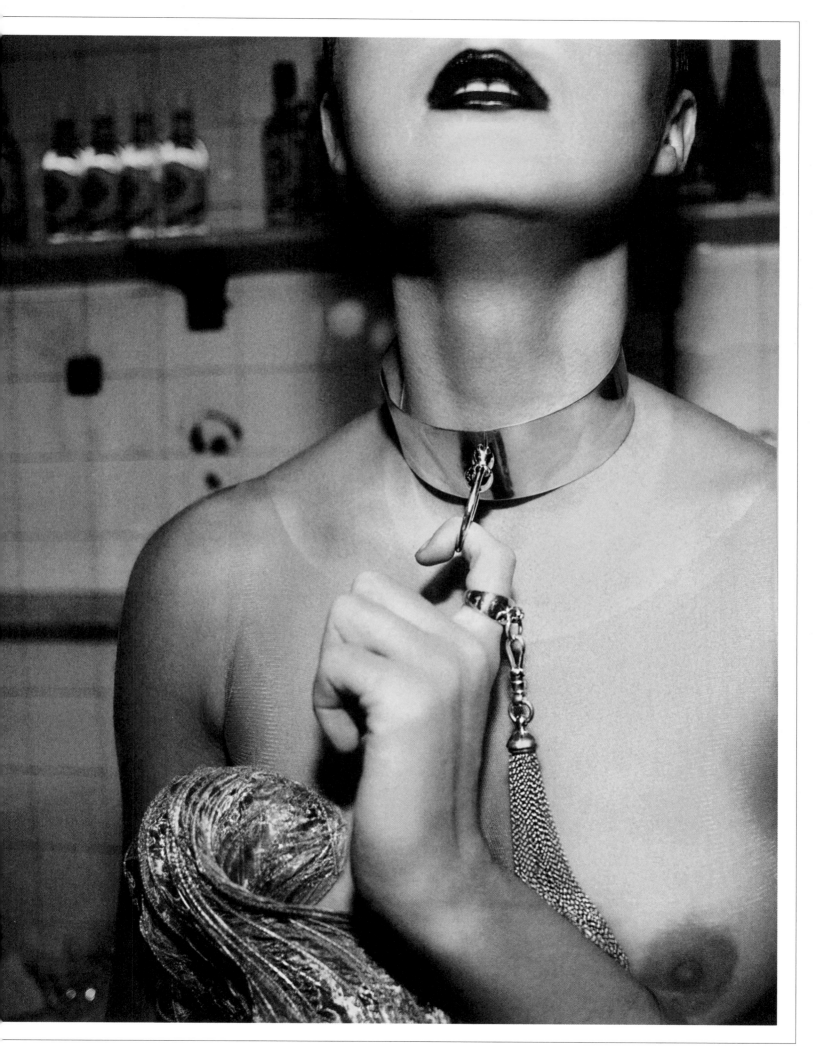

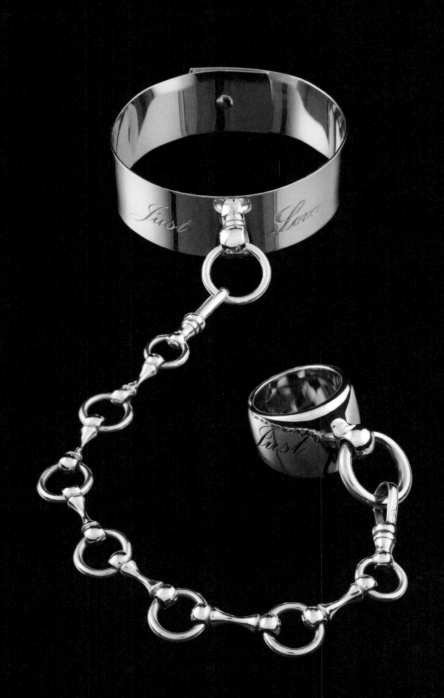

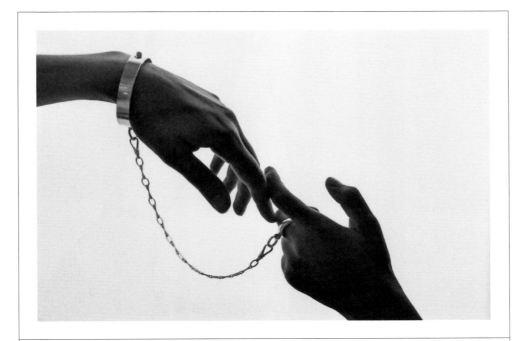

Precious, durable materials honor our relationships. Have you ever
experienced sensations through jewels? While chained to
the cuff, slip the ring onto your lover's finger, and feel the charge.

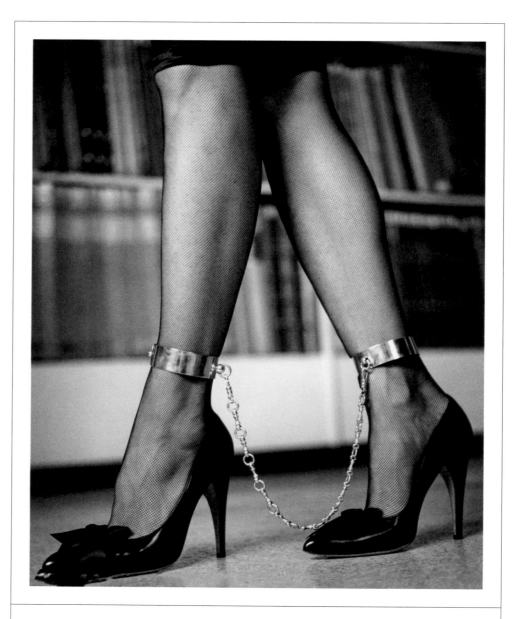

Saying "Now, walk for me" after restraining a lover with ankle cuffs
is undeniably exciting. Walking becomes awareness, each step is
conscious, controlled. The length of the chain is calculated—small,
restricted steps make for a slightly wobbly but very entertaining bottom.

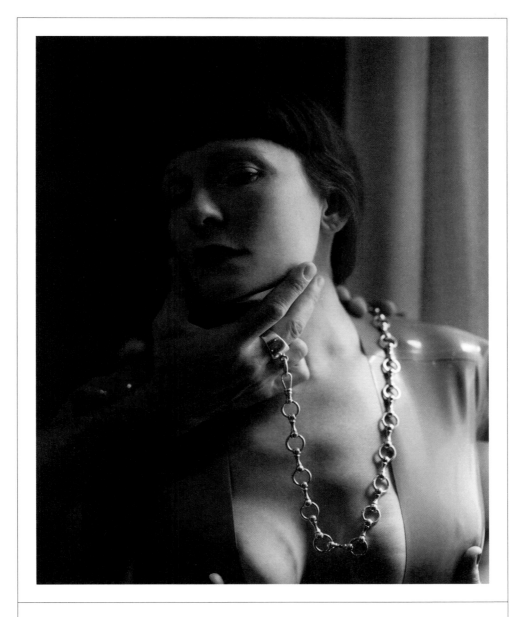

When a devoted top takes the lead, the glide of silver chains over
your skin will send chills up your spine and transport you into even deeper
states of delectable submission. If you are the master of these silver
chains, handle them with the intent to guide your bottom to Paradise.

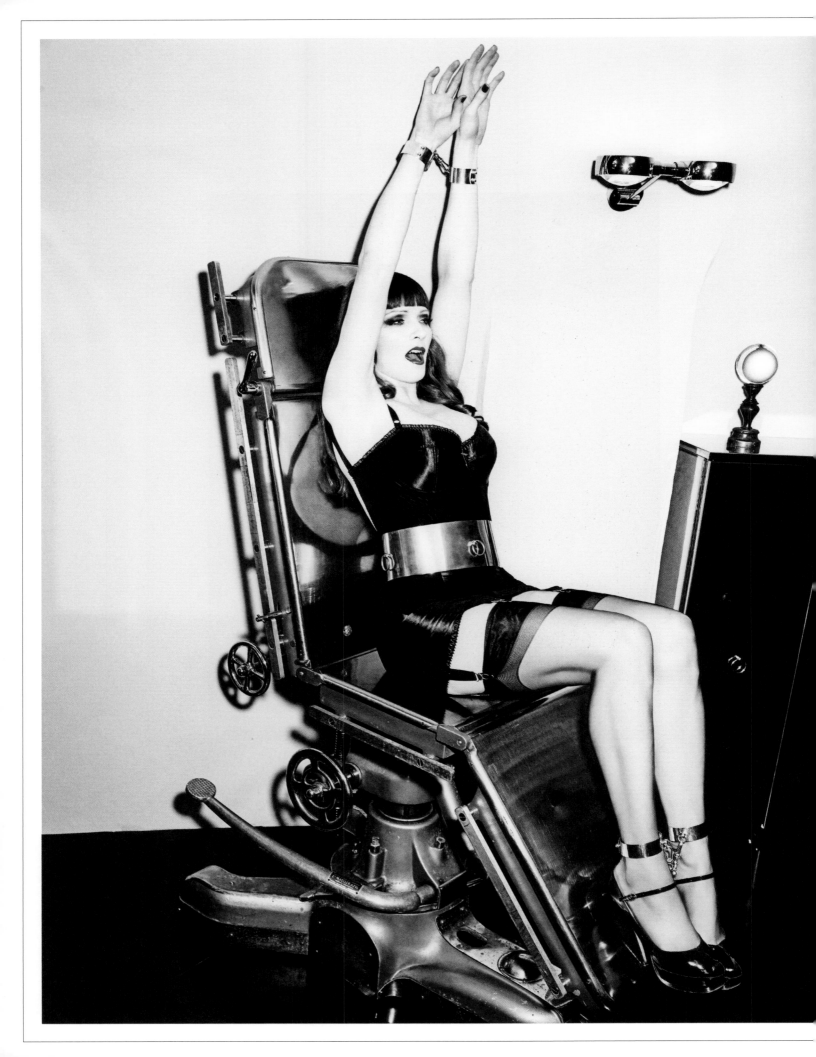

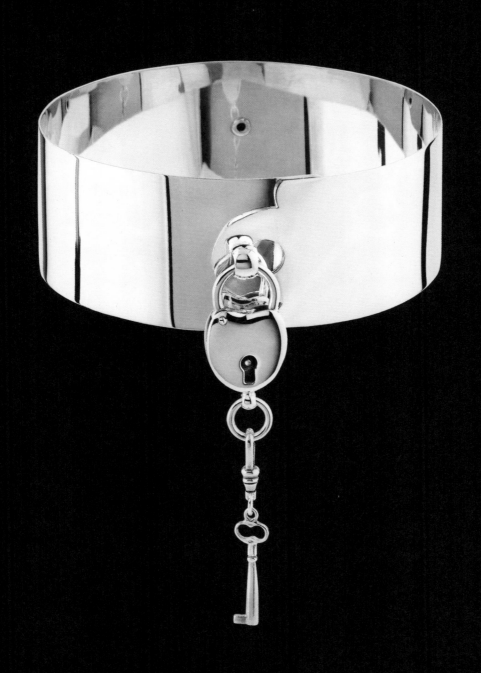

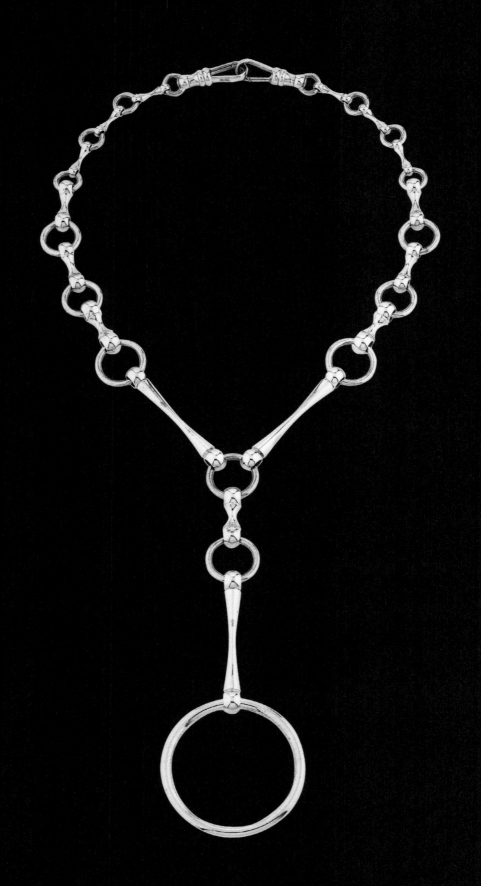

Worn under clothing, the body-clinging weight of this harness fills you with
secret anticipation. Once revealed, the jewel empowers you to share unparalleled
pleasures as the beguiling o-ring may serve as an intimate shaft ring for him.

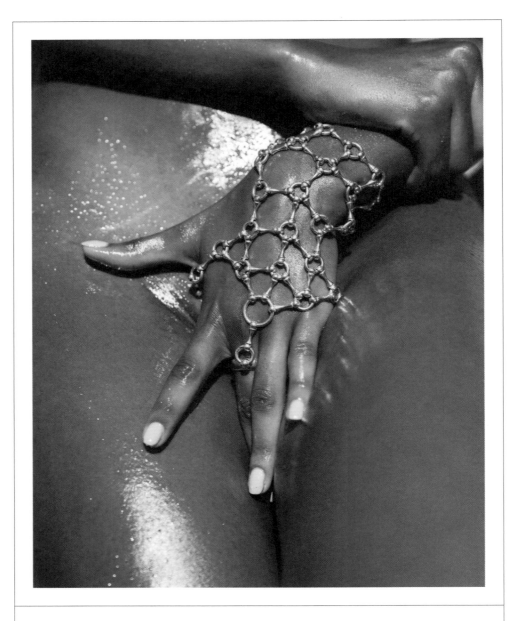

This baccia-mano, literally "the hand kisser," is constructed with Sado-Chic signature links to form a chainmail-inspired jewel. The silver glove indicates a position of power. To kiss the ring is to confirm one's submission to the wearer's authority.

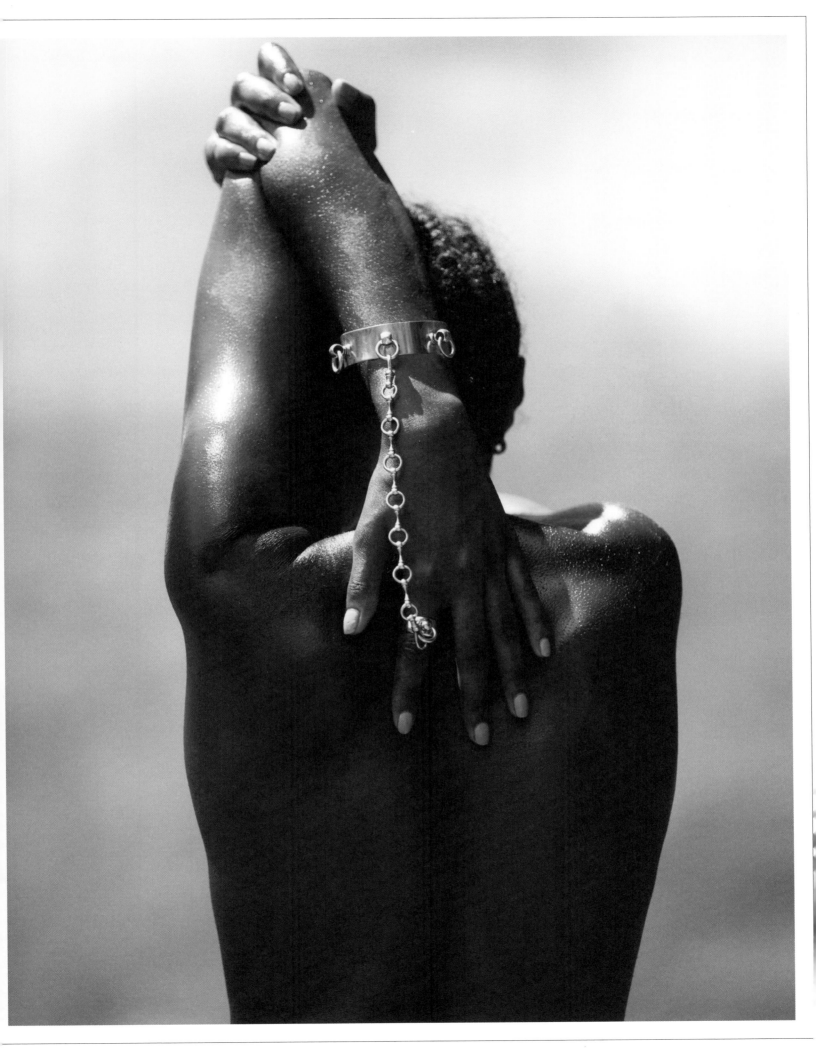

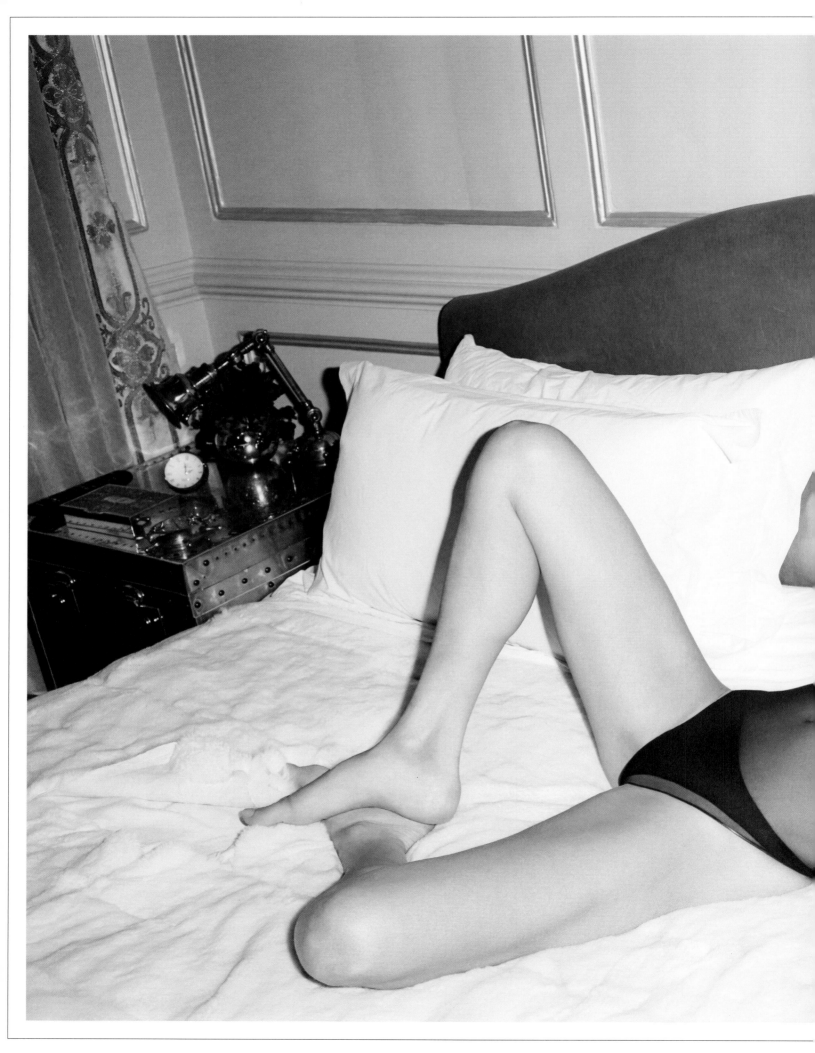

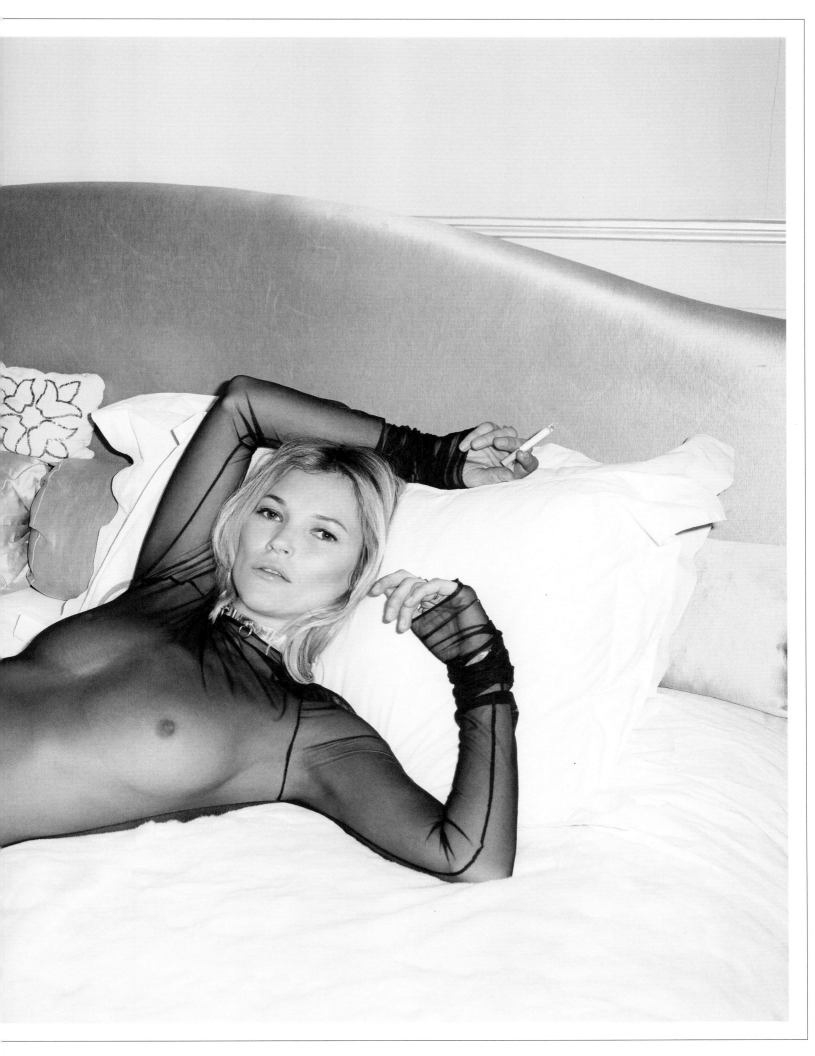

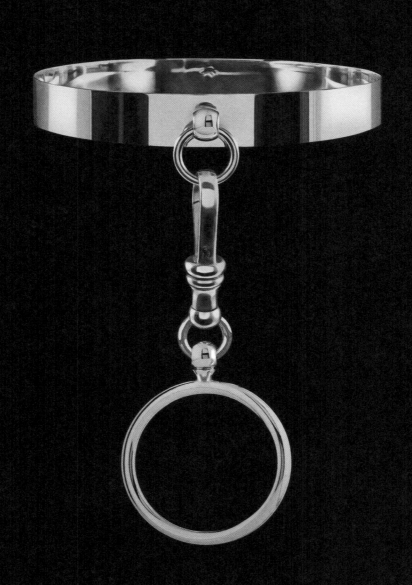

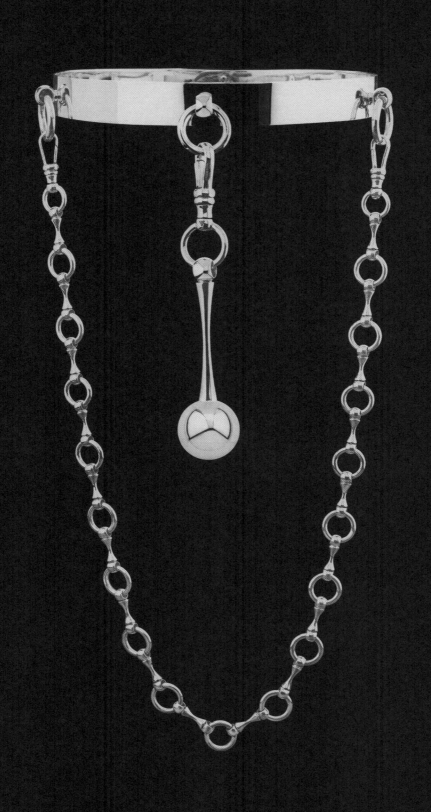

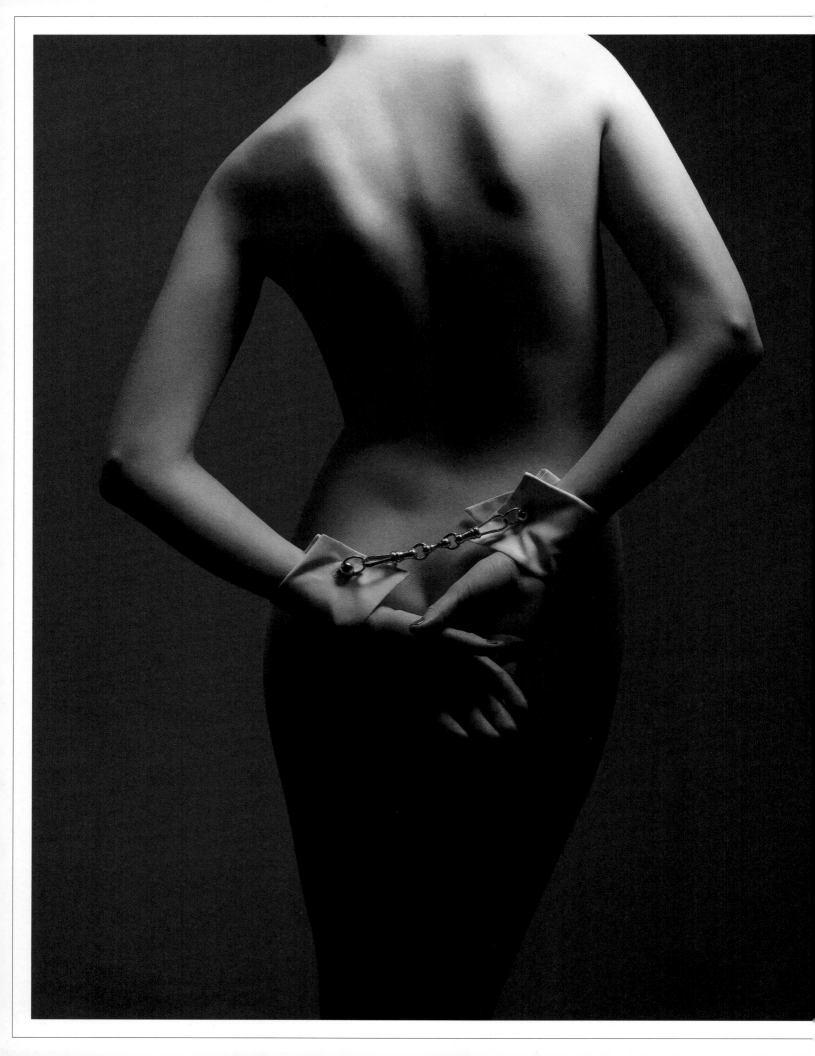

The psychological impact of being locked or linked (to yourself or another) is powerful and can reinforce the dynamic of domination and submission inherent to every mutually gratifying sexual encounter. To avoid clichés, I call the receiver the "bottom" and the provider the "top." The sexually empowering equestrian-inspired Love-Lock collier (p. 22) is one of my favorite jewels, as it gracefully transforms from outer to intimate wear. The necklace terminates with a shaft ring that may be used for intimate purposes. In this case, while the jewel is still in place, the ring should be held in the stroking hand then slid carefully down the erect penis of the receiver. Once the shaft ring is in place, partners will feel their intimate connection intensify, as they are literally "locked" together in a state of closeness and restriction. This combined manual and oral stimulation takes on unexpected nuances of pleasure for both partners. The sliding to and fro of the ring sends waves of enhanced sensation throughout the receiver's entire body. The Cock Ring attachment is a pendant that serves the same purpose. It can be attached to the Love-Lock to double its sensational effects (pp. 23, 32), or to a collar to open up suggestive realms of possibility. These necklaces are timeless style statements, but for those who are in the know, they take on many meanings. Collars can be symbols of submission and of the willingness to please when worn consensually with erotic purpose. Aligning with the wearer's intent, the collar's o-ring serves to attach many different jewels, including chains, which transform into elegant leashes for those who revel in such exciting forms of adult play. There is nothing more appealing for a willing submissive than to be kept on a very short leash. I created collars for every occasion. The Mini choker is discreet enough for everyday wear, while the bold Slave to Love collar takes evenings of ritualized intimacy to luxurious new levels. This jewel, like the You-Are-Mine necklace, is closed with a miniature locket (pp. 33, 38, 39) that doubles as an erotic piercing and comes with a set of two keys. The key holder can attach them to their own jewelry, so that they are visible to their beloved as reassuring signals of physical and psychological safety. To accept being chained or collared opens a portal to rarefied mind/body experiences that reach exquisitely refined heights when Sado-Chic bonds are locked. To don such an important symbol of ownership—and to consensually impose it on another—is a privilege. Whether you prefer to conceal or flaunt this unique relationship, trust is fundamental. The sensations incited by erotic ownership, no matter how fleeting or enduring the moment may be, are exhilarating and comforting. Being that the o-ring symbolizes the ultimate intimate bond, my O-Ring bands are often commissioned as a contemporary alternative to traditional wedding bands. Engraving the pieces with fantasies, promises, and names imbues them with even deeper meaning. Deciding together what to inscribe on these intimate jewels lends a greater understanding of each other's expectations. The act of writing one's wishes and desires is proven to reinforce the likelihood that they come true, and wearing these written thoughts fortifies that eventuality. To that end, the Mantra jewels (pp. 42, 43) are designed to make even the wildest dreams become reality.

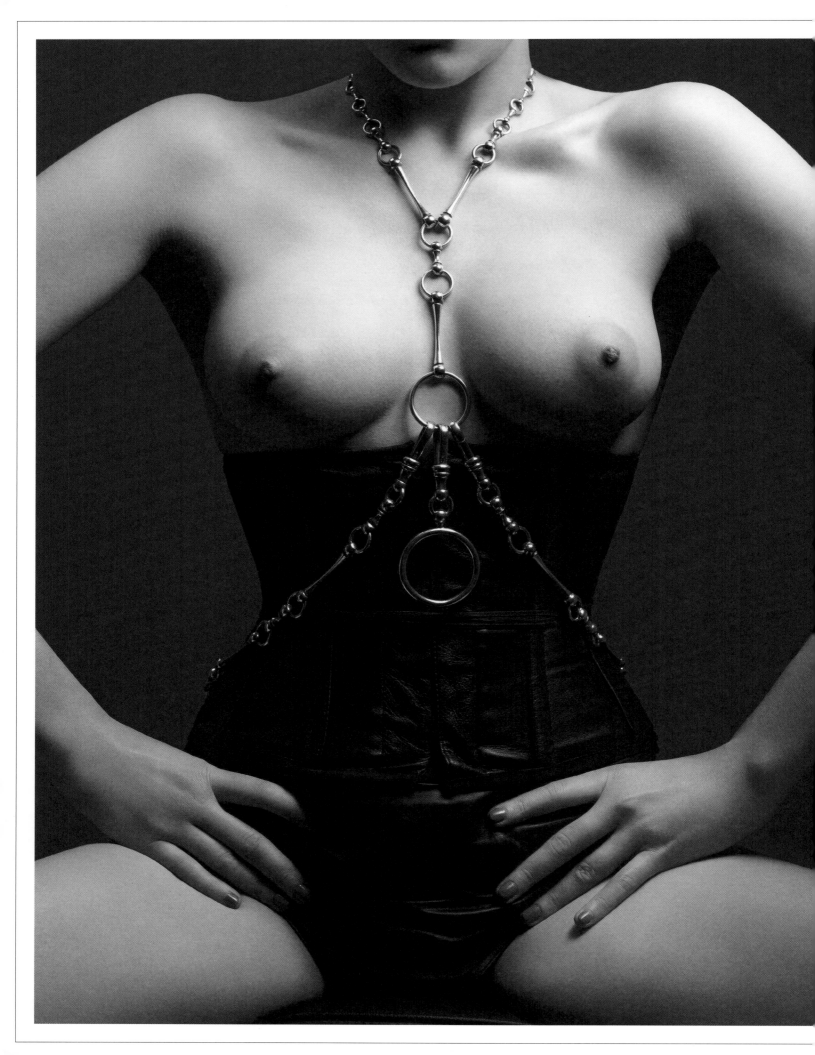

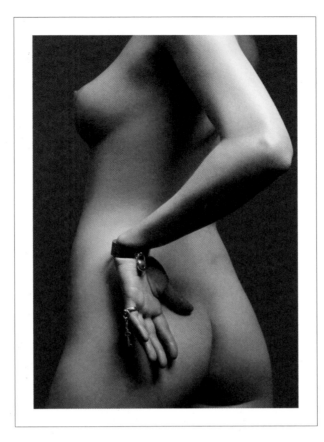

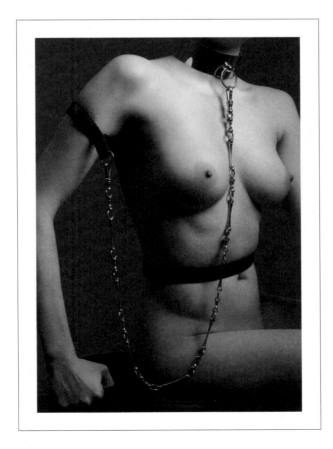

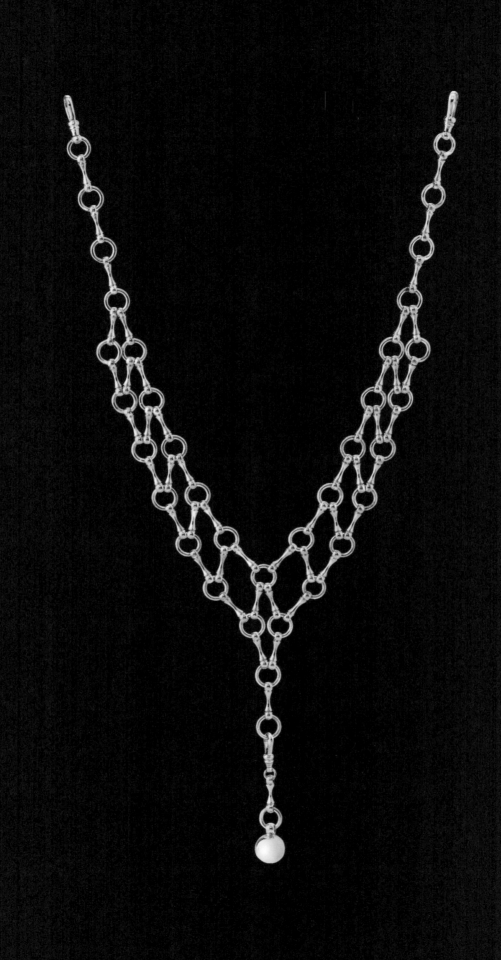

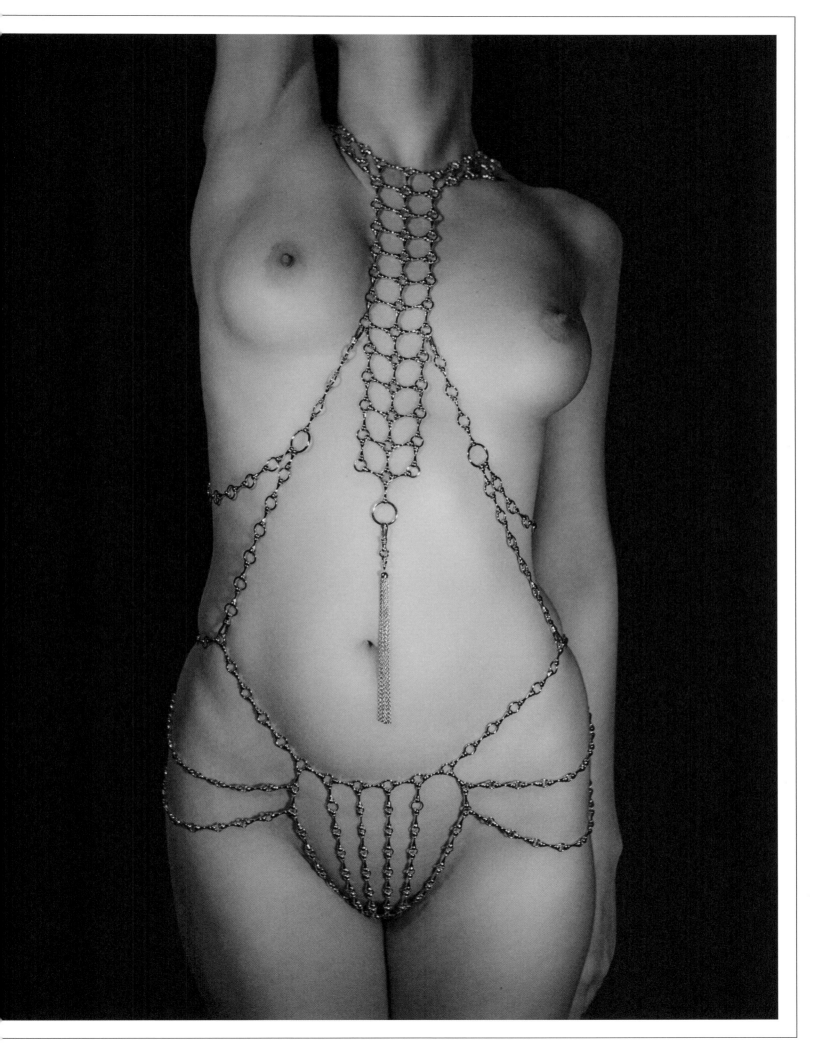

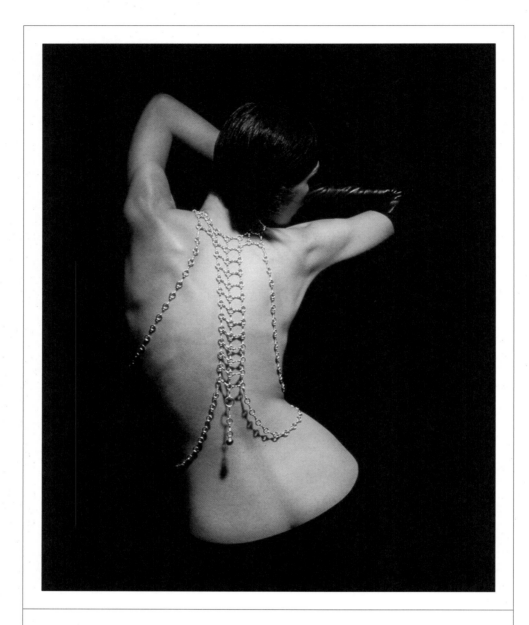

La très chère était nue, et, connaissant mon coeur,
Elle n'avait gardé que ses bijoux sonores,...
My darling was naked, and knowing my heart well,
She was wearing only her sonorous jewels,...
"LES BIJOUX" ("THE JEWELS")—CHARLES BAUDELAIRE, 1857

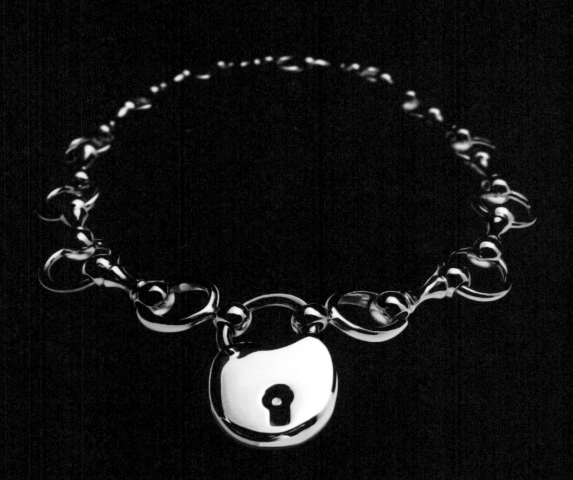

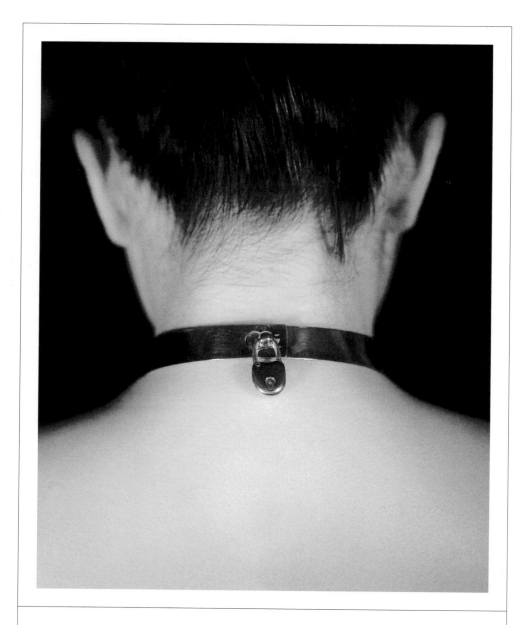

The psychological effects of being collared will have you feeling exquisitely
trapped, under an erotic spell, deliciously at the mercy of the key holder.
The collar ensures that you belong... for as long as the locket is in place.
Use it to adorn or to communicate your desire to be possessed.

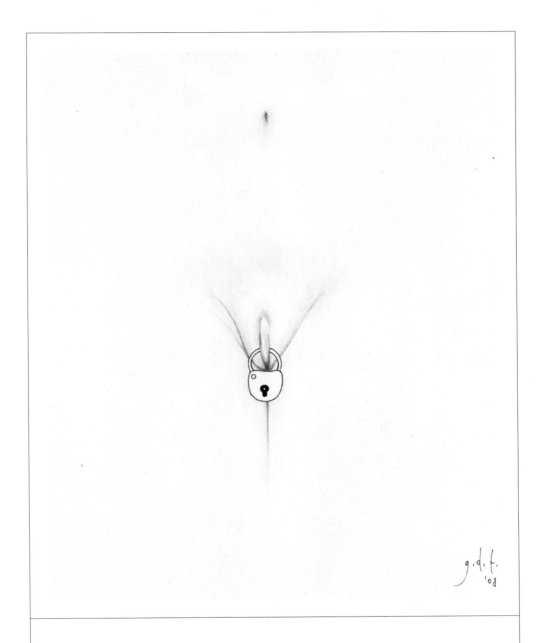

When worn as a piercing, the locket takes on a whole new meaning.
On nipples or other erogenous zones like the clitoral hood or the scrotum,
its discreet, weighty presence is a constant reminder of the intimate significance
that it holds. This jewel may express chastity, propriety, or even self-ownership.

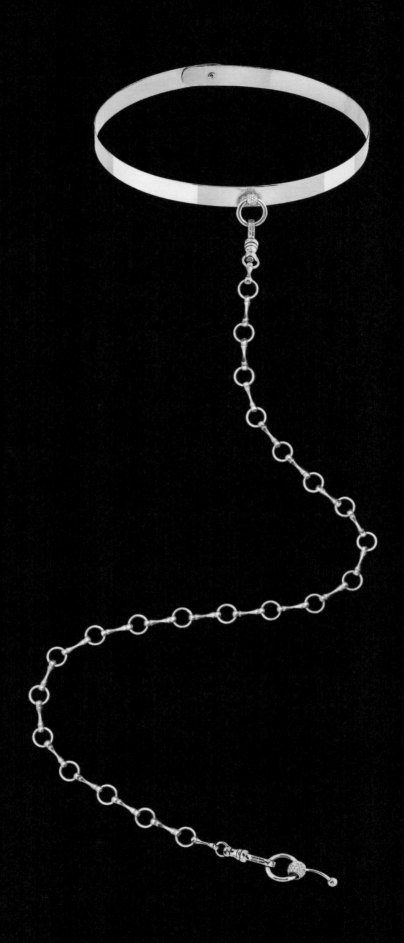

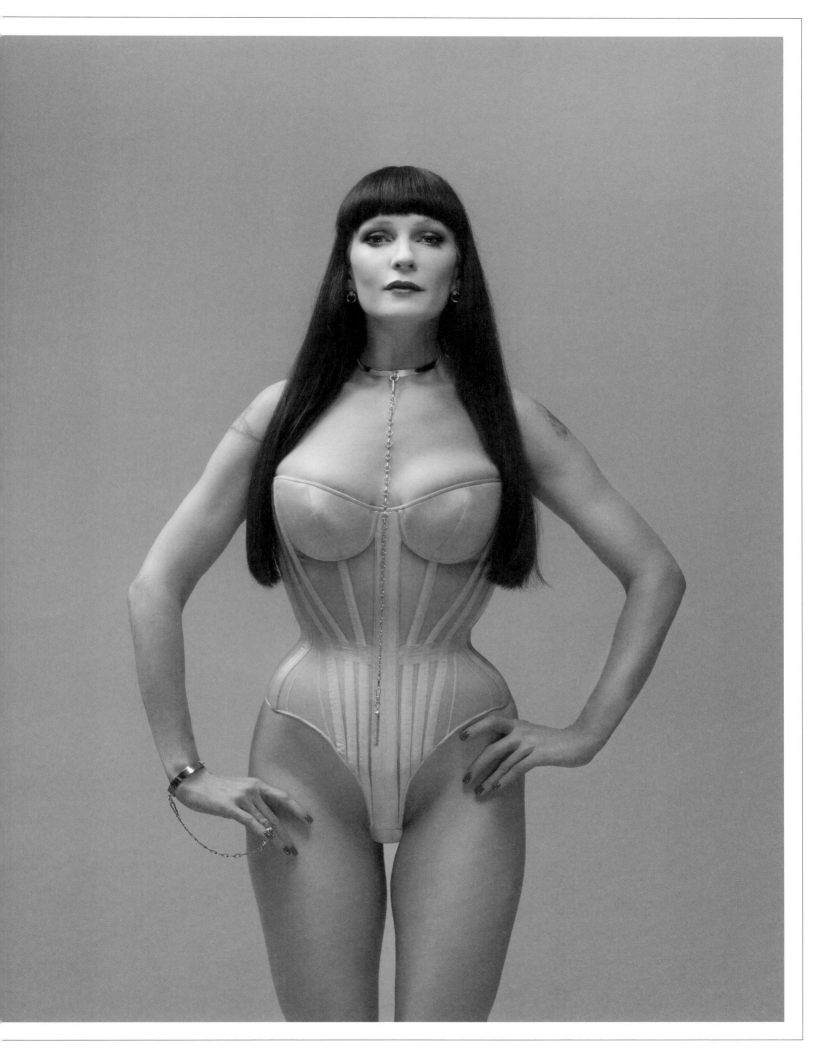

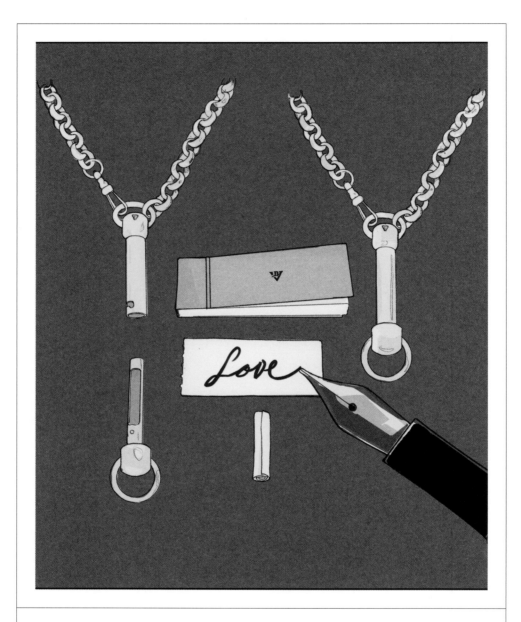

The act of writing your desires is proven to reinforce the likelihood of
their manifestation. Imagine what happens when you wear them close to your
heart! These jewels are designed to help make your dreams come to fruition.

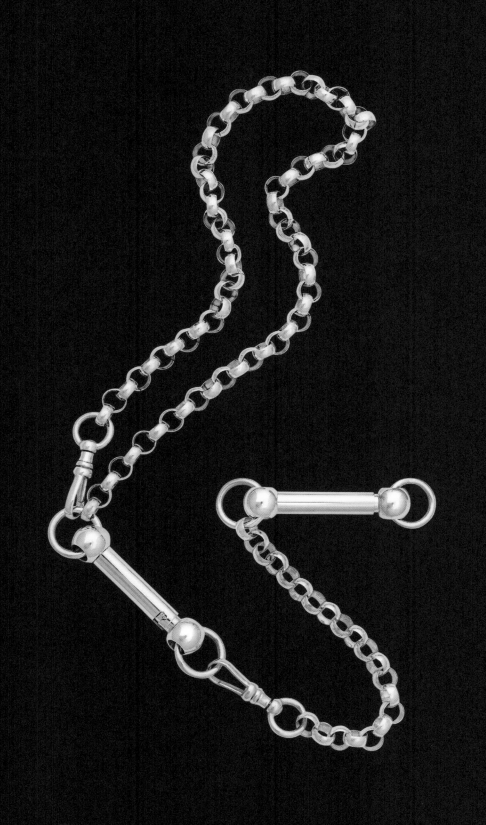

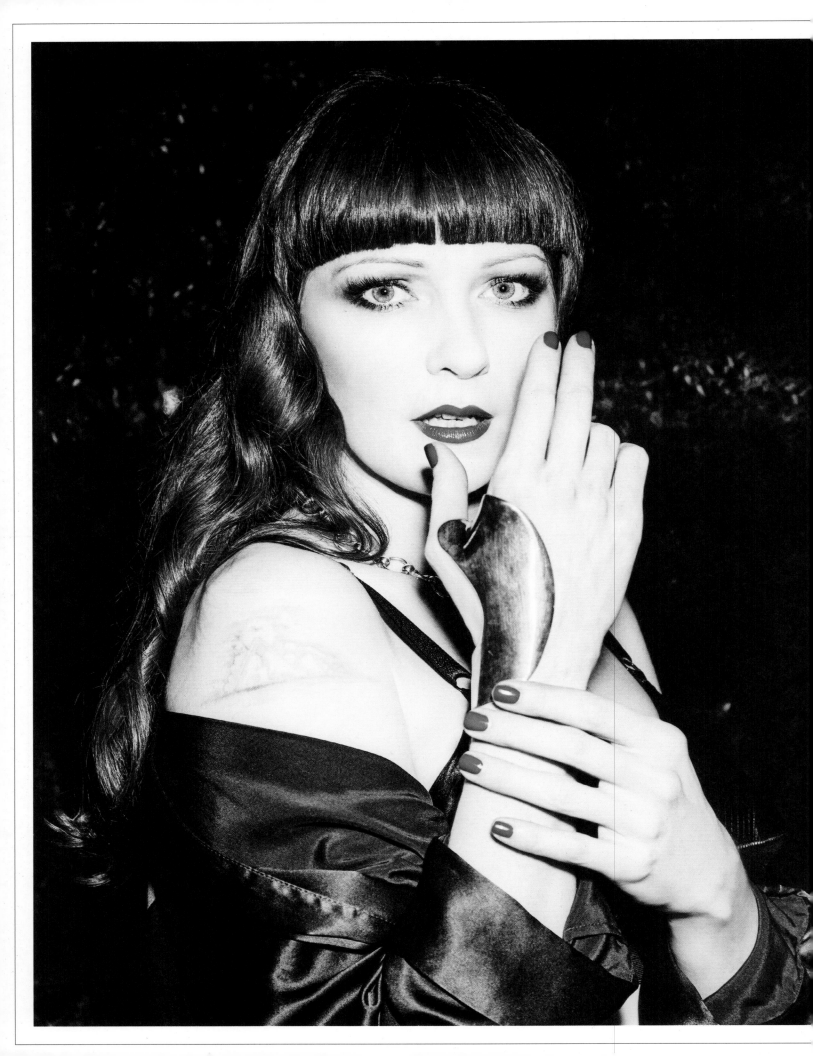

II.
TICKLE YOUR FANTASIES

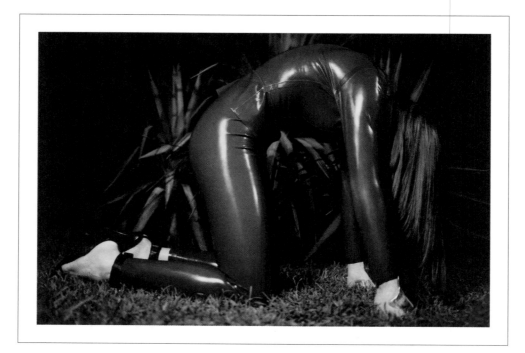

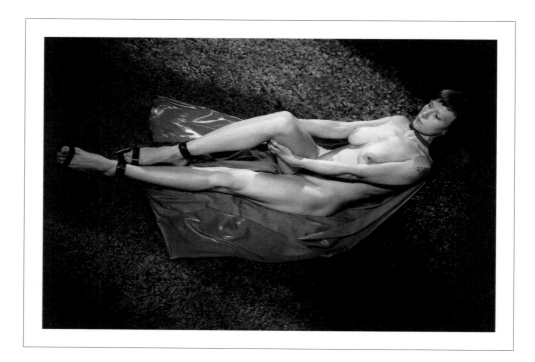

Fantasies are integral to sexual excitement, and a healthy libido enhances every aspect of our daily lives, not just our intimate relationships. Fantasies are like the ripe fruits of our imagination—delectable and scientifically proven to be good for us. They also trigger global brain processing, essential to good ceremonial planning. Just as the potent fetish symbol of the o-ring inspired Sado-Chic, fetishized fantasies inspired me to imbue body adornment with the power to stroke all of the senses, as well as the imagination. From jewel to tool, my designs communicate erotic appreciation, invite exploration, draw attention to the erogenous zones, and enhance the power of touch. Some, like the Yoni parure (pp. 54, 55), are purely evocative. Yoni means "vulva" in Sanskrit, and these jewels' iconic shapes celebrate the divine creative feminine. They are an invitation to honor and respect the erotic resource inherent to all womankind. Erotic talismans have been used for millennia to charm and protect. As symbolic conversation pieces, the Yoni, Sperm Race, and Sleeping Penis jewels (pp. 56, 57) facilitate important conversations around sexual pleasure that are still considered inappropriate by contemporary society at large. Communication is key to ending the negative impact of taboos and body shaming on pleasure. I empower the wearer through designs that not only honor the body, but also literally mirror it, as is the case for the Second Skin series. Like customized corsets, my silver Second Skins are molded directly on the collector's body over a series of fittings. I have made Second Skins to hug hips, bind feet, embrace shoulders, and hold hands. The meticulous custom process builds anticipation and itself incites a distinct pleasure. The personalized pieces embrace and redefine the body part to be embellished, enveloping it like an outer skin. Like latex and leather, they instill a sense of protection, power, and strength in the wearer. The Second Skins do not have fastenings or closures, but instead adhere to the body, thanks to their carefully studied anatomic forms. These wearable sculptures incite heightened awareness and a sense of presence that is guaranteed to inspire awe. The function of these objects is veiled by their polished, mirrored surfaces. In the case of the Offering hand pieces, the area that lies on the palm can be used to serve delectable amuse-bouche in the context of the sexual ceremony. While these Second Skins can be worn discreetly beyond the boudoir, I designed the Petting and Finger rings purely with masturbation in mind. To experience deep sexual satisfaction, the body, mind, and spirit must be treated as a sensual whole. I consider the Petting Ring (pp. 48, 50, 51) to be the jewel-tool that best represents this philosophy. The ring constrains the index finger and thumb to form the chi mudra—a gesture used by practitioners of yoga and meditation to maintain a focused mind, also essential to great sex. Whether used in good company or during solo sex, the Petting Ring brings an entirely new dimension to male pleasure. The Finger Ring, on the other hand, was designed to enhance the pleasures of female masturbation, and it protects the sensitive skin of the vulva from glamorous, dangerously long nails. Its slick anatomic surface gets to the point, even in moments when getting naked is not an option as it works wonders through clothes.

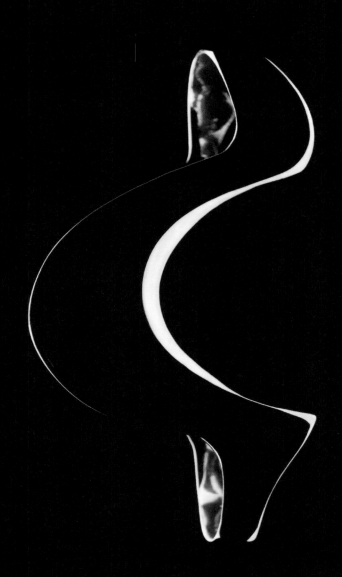

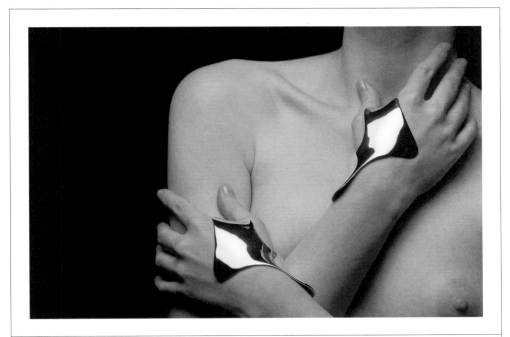

The Second Skins are erotic prosthetics, and their sculpted mirroring surfaces
announce a ceremonial state of affairs. Whether you wear them to accessorize or to
serve your blindfolded lover aphrodisiacal amuse-bouches, you will feel powerful.

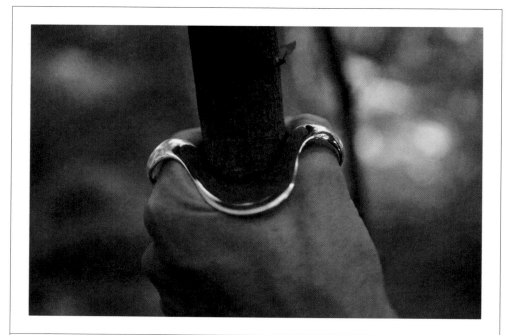

The Petting Ring bestows sensations that you could not possibly provide with your hands alone. With the index finger and thumb forming the "chi mudra" gesture, meditate on male masturbation to unveil the arcane of this ergonomic jewel.

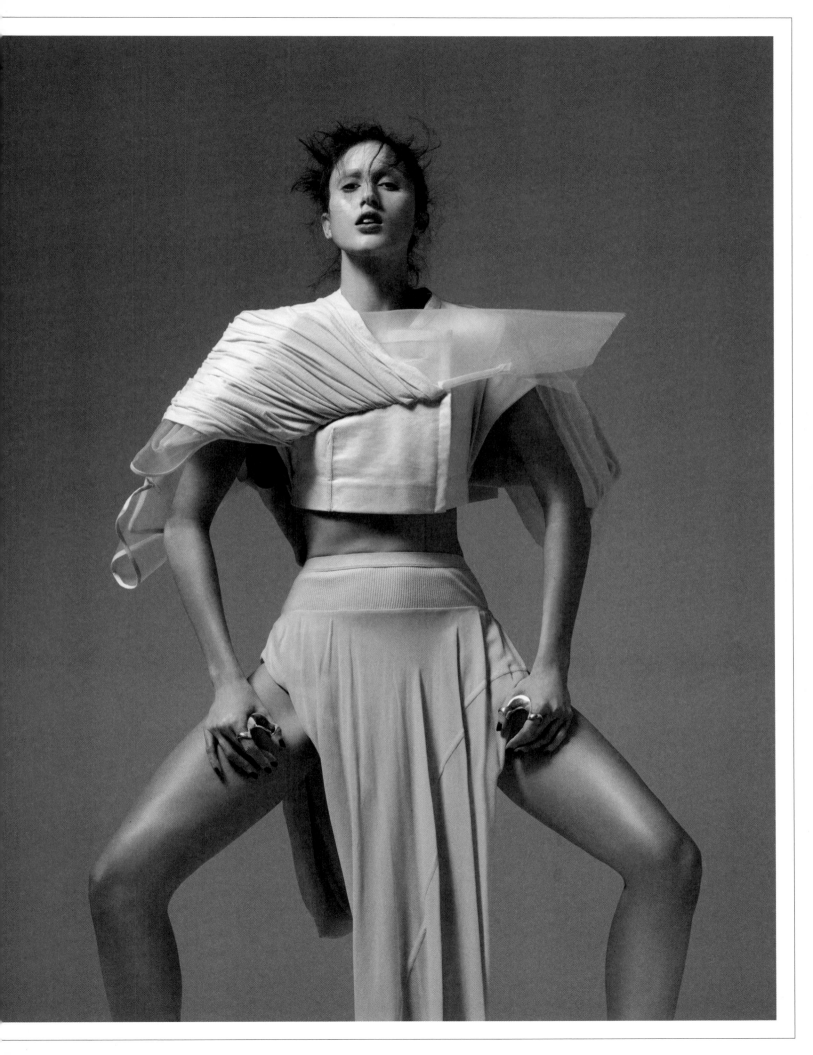

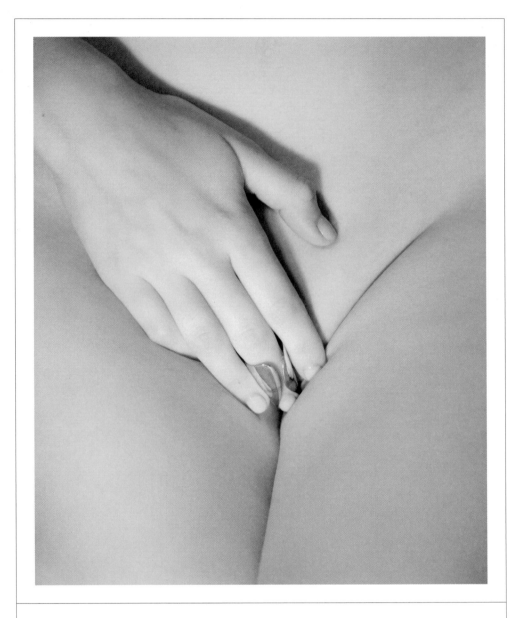

This jewel-tool is designed for the middle finger. Its anatomical construction
creates a very slight suction, placing its pleasure-provoking secrets literally
at your fingertip. The vulva-shaped slit reveals just a glimpse of a varnished nail.

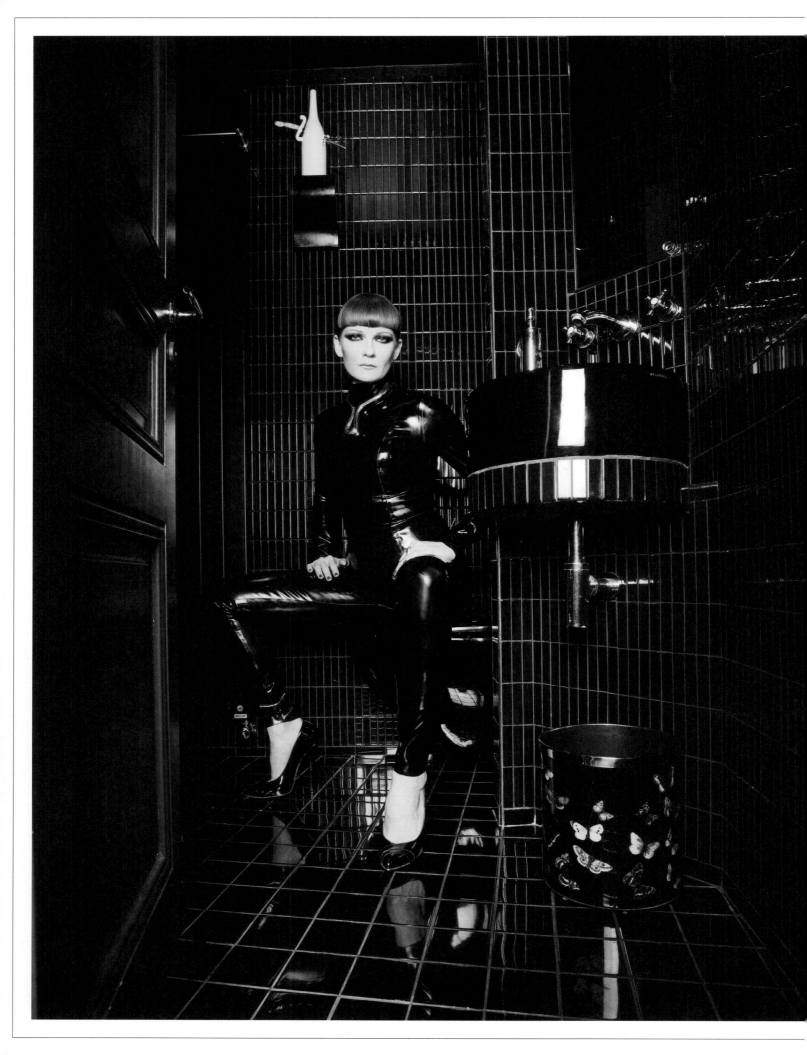

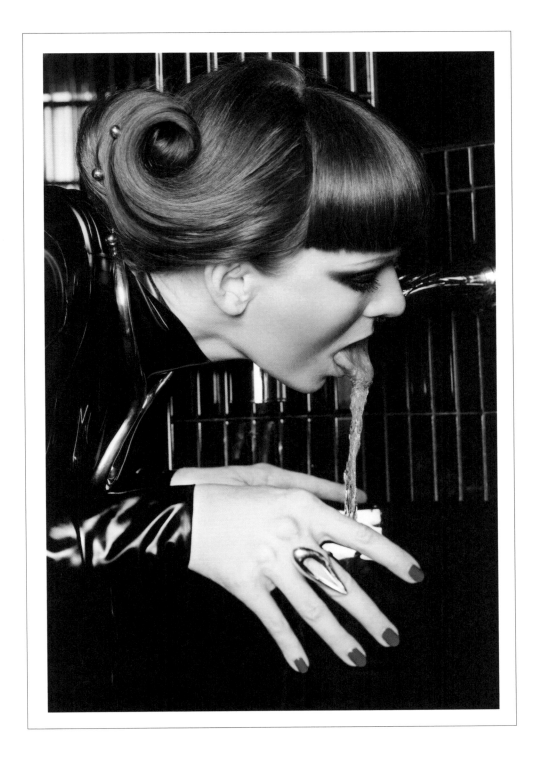

Don't underestimate the power of the sleeping penis. This organ is almost always represented in erection, so I chose to honor its most common state—that during which vital sperm is also generated. Symbols of fertility, pleasure, and sexual freedom, these rings are suggestive celebrations of life.

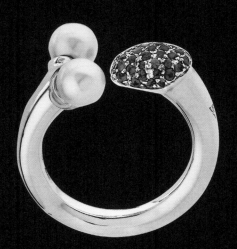

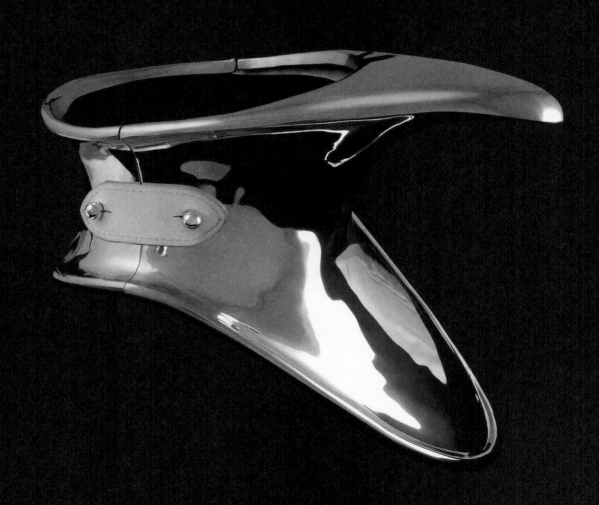

Like any ceremony, sexual ceremonies honor the participants and utilize ritual objects to elevate the ordinary to the extraordinary. Some of my jewel-tools are intended for such occasions only, like the Minerva neck brace and the Soulless Shoes, which are not common objects for everyday use. They are stored in plush jewel boxes that are only opened on special occasions with a sense of the sacred. These precious objects demand respect and catalyze desire for those who are initiated to their powers. They explore the dichotomy between power and vulnerability, strength and fragility. The sterling silver Minerva neck brace (pp. 58, 60, 61) imposes perfect posture and an absolute presence in the wearer, who enters a state of venerable vulnerability. Once the leather closure is strapped into place, both partners experience an undeniable power shift. The bejeweled becomes dependent on their partner. Reduced mobility makes for a rousing scenario, and this jewel is the ultimate fetish for those who enjoy medical play. The Soulless Shoes incite a similar ritualistic rush (pp. 62, 63). What purpose does a sterling silver shoe without a sole really have? It is to make a foot fetishist's wildest fantasy become reality! These impossibly high heels transform the wearer into the divine object of worship and devotion, at the delectable mercy of those who have imposed them on the wearer. Once bound to the feet, these shoes constrain like a tightly laced corset. The heels hold a secret function as well: their spherical extremities may be used to massage and to penetrate the prone devotee. Similar sensual spheres can be found atop many of my rings,

bracelets, attachments, and necklaces, perfectly polished and slick. As a young designer I was intimidated by the perfection of the sphere. I felt that there was nothing that I could do to make spheres better, so why bother? Then, suddenly, spheres in all of their glorious perfection rolled right into my functional jewelry fantasies. Like giant piercings, the Double Sphere series (pp. 65, 68-69) symbolizes sexual freedom. The necklace is a modern take on the torque, an ancient warrior embellishment (p. 67). The spheres unscrew so that the close-fitting jewel can be comfortably slipped around the neck. The same mechanism is used on the Double Sphere bracelet (pp. 68-69). This piece also embodies a delightfully discreet duality. Those who can't resist its sleek, polished design discover that its primary function, that of adorning the wrist, is just as enjoyable as its secondary function, that of embellishing a man's genitals. In order to explore the infinitely more intimate capacities of this jewel-tool, leave the detachable sphere in place and carefully pull the testicles and the penis into its embrace before an erection takes place. This bracelet not only embellishes a lover's "family jewels," but also constricts them ever so slightly, resulting in harder and more enduring erections. I expanded the piercing concept in the design of my Geisha Sphere hairpins (p. 66), which "pierce" coiffures securely into place. Their overtly kinky allure holds a sensational secret too: when you unleash your tresses, you will find yourself holding a deliciously versatile tool. This hairpin's sphere can massage, while the spiked ends can be used to tickle or carefully scratch a lover who enjoys having their limits of pleasure pushed to the edge.

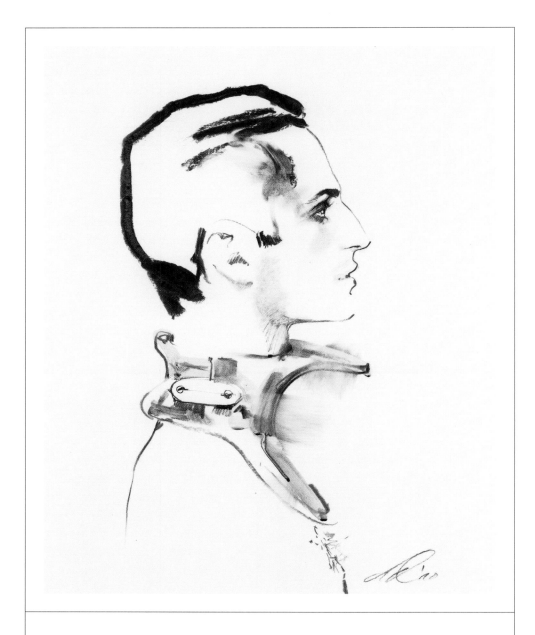

Being obliged to stand tall and beautifully constricted strokes
the mind, and the body willingly follows. Choose a trusted partner
and embrace the benefits of consensual vulnerability.

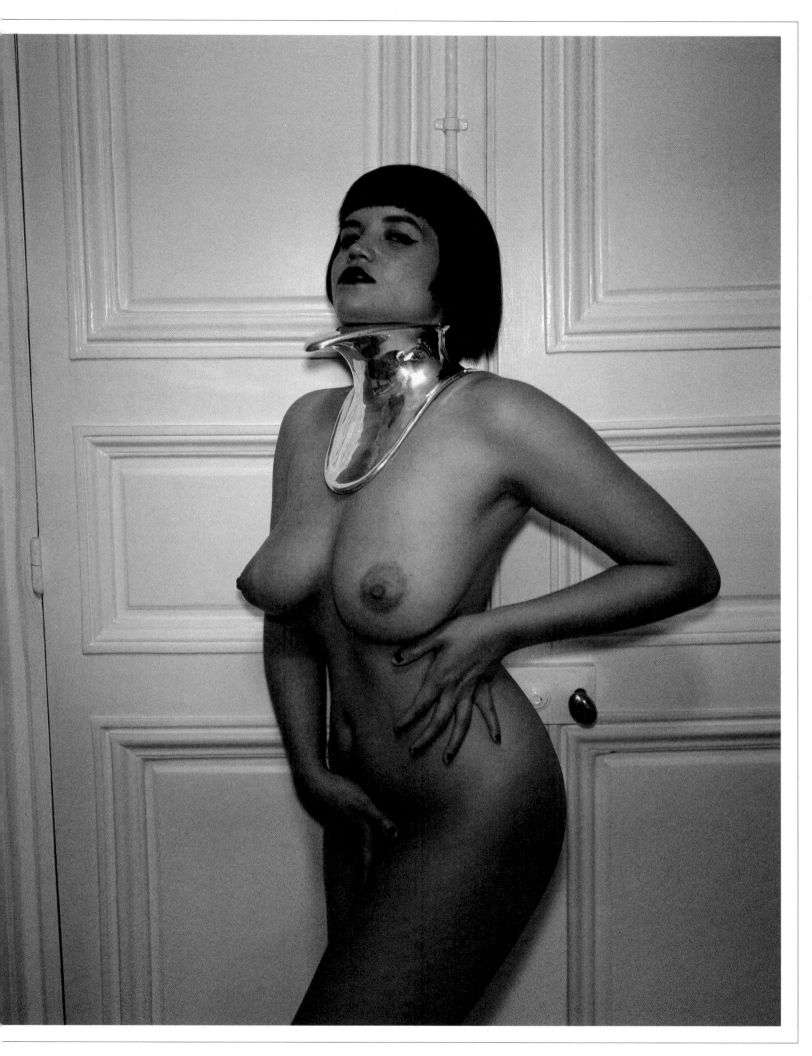

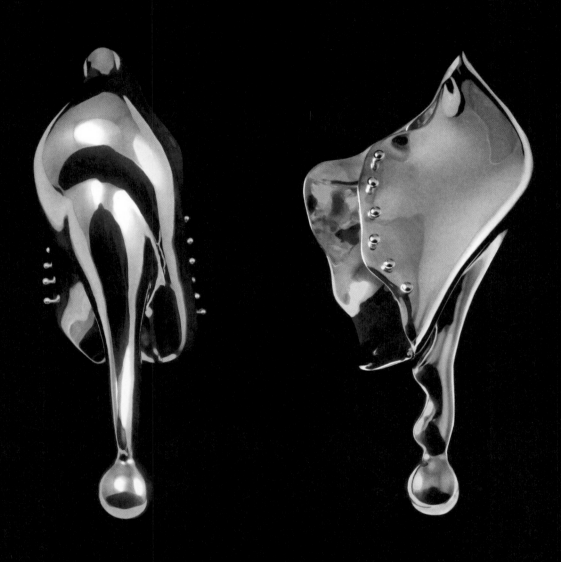

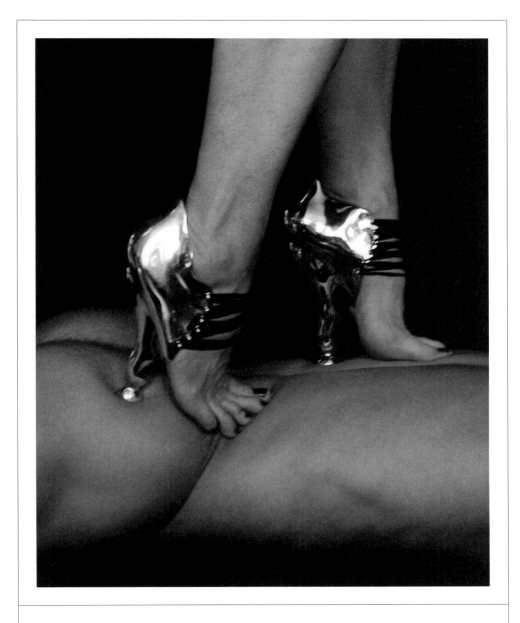

Lacing these silver shoes onto the feet is a ritual that requires devotion,
focus, and intention. Accept the vulnerability that impossible
heels impose... Once they are laced up tight, walking is no longer
an option. The adorned must simply accept being venerated.

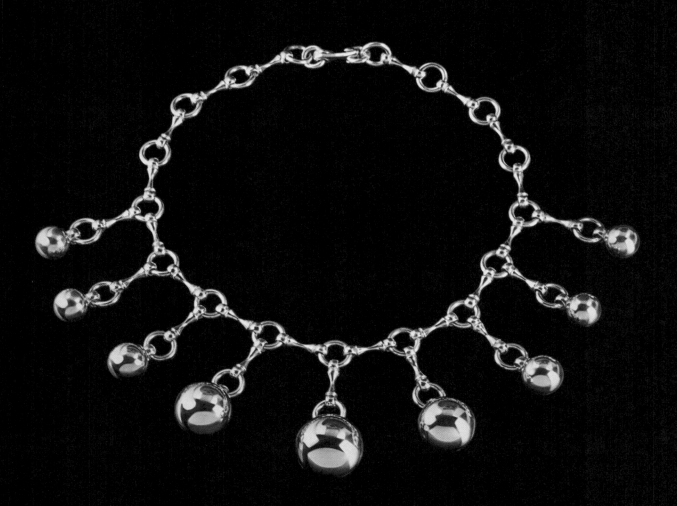

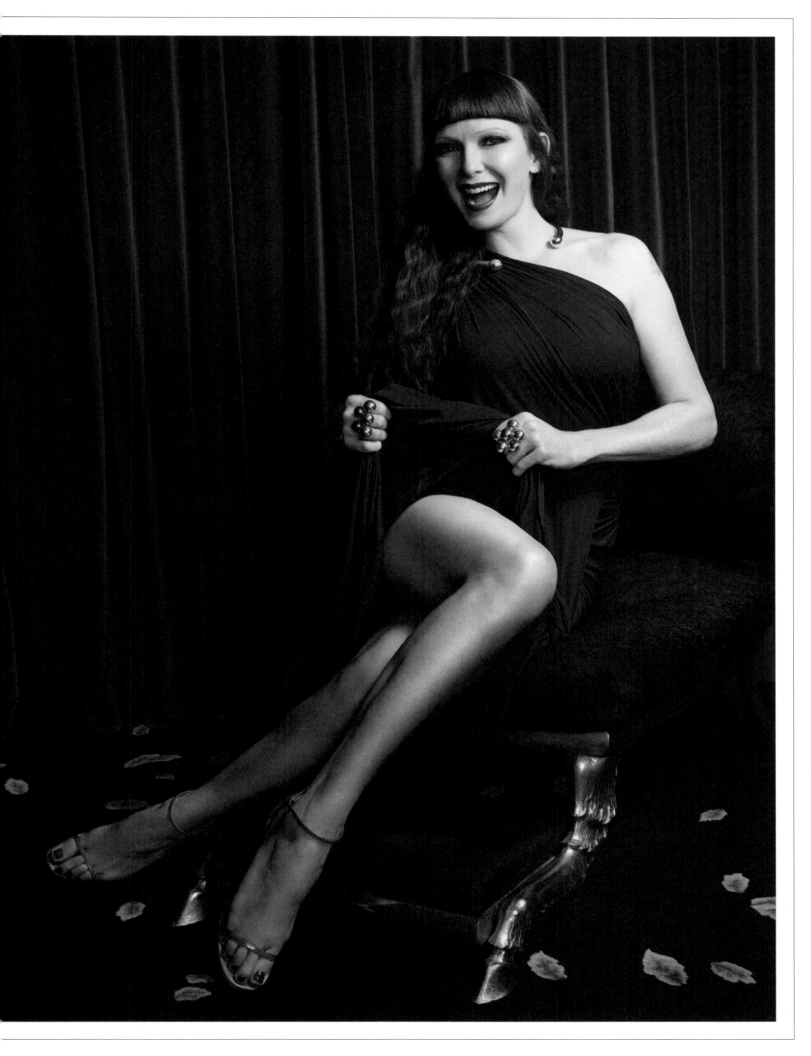

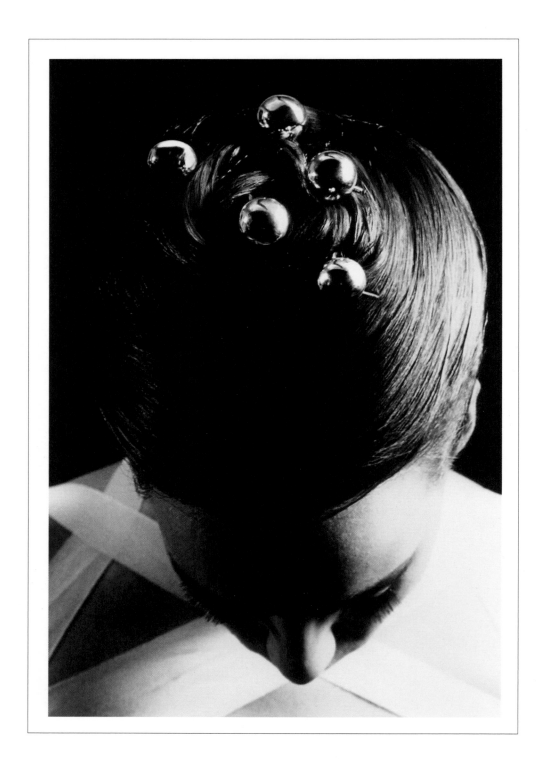

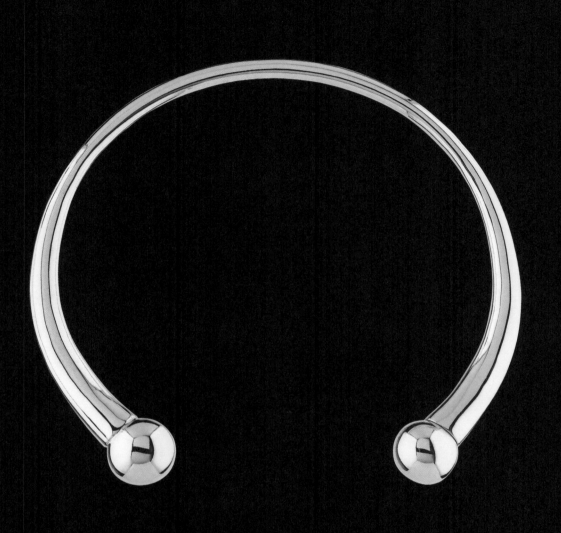

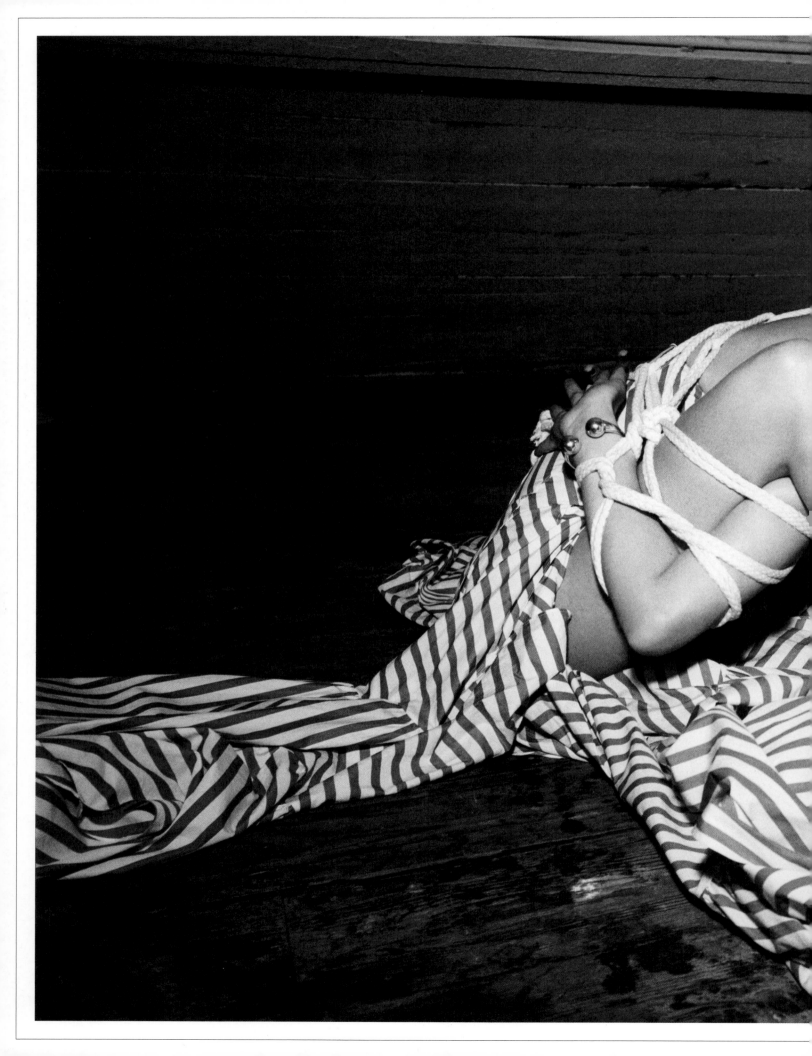

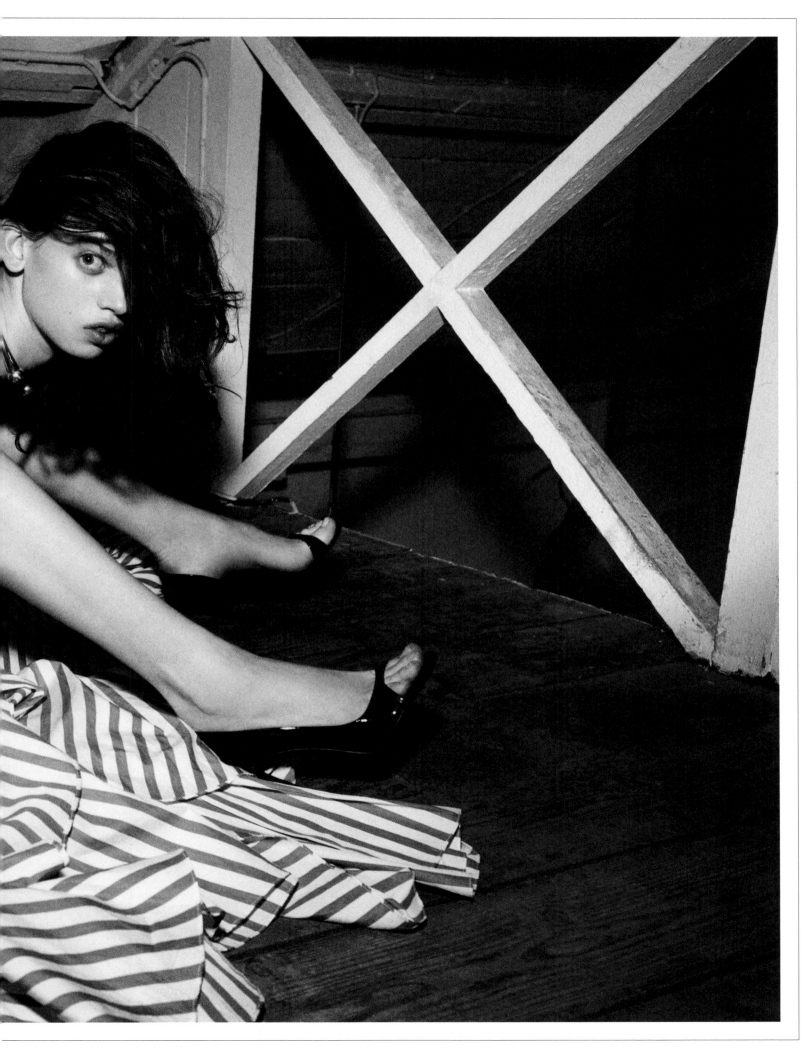

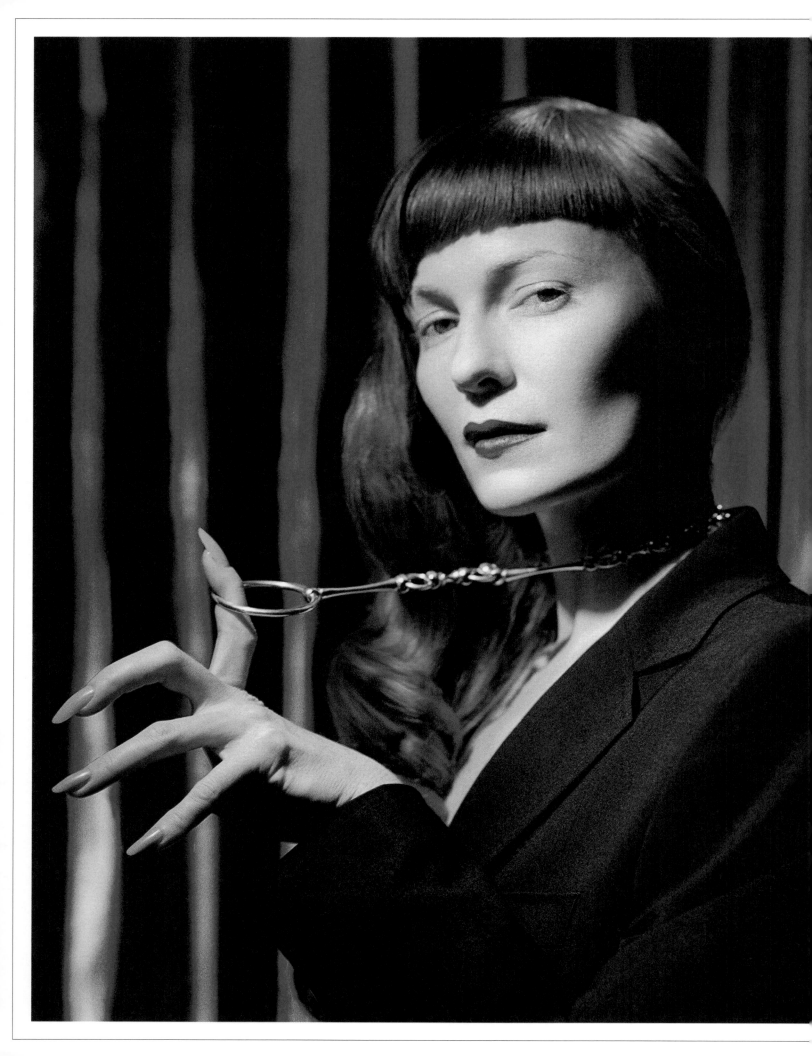

III.
ORCHESTRATING
THE SENSES

The Paradise Found jewels transport body, mind, and soul into the realm of erotic revelry. Adding feather ticklers, horsehair whips, silver tassels, and other attachments to Sado-Chic transforms the designs into powerful, sensual instruments. Wear these statement pieces publicly for all to admire, as few are privy to the secret of their erotic potential. For those in the know, the mere sight of these sensational treasures awakens sweet anticipation of the pleasures the night could hold. My jewel-tools provide the wearer with infinite possibilities to orchestrate the senses. Like extensions of the hands, they help to map out the body's sensual landscape and reveal ecstatic boundaries. The play of a tassel-turned-whip's lashes teases skin, while the soft "click" of a choker being locked around the neck guarantees to thrill. The scent wafting from the Essence ring (p. 83) transports lovers instantly to another dimension, while the mere glimpse of the cocktail rings seduces (pp. 81, 82). And what you don't see might cast you into the arms of ecstasy. When a sense is restricted, the capacity of the other senses is augmented. As paradoxical as it may seem, sensory restriction can be an erotic enhancement. It charges the limbic system, ignites the flames of desire, and leads lovers to experience entirely different pinnacles of arousal. My leather blindfold completely restrains the sense of sight (p. 97). Embellished with a mirroring silver surface, it is an incomparable adjunct to magnified sensations. It helps a lover to "get away from it all" and experience even greater excitement and satisfaction. Once restraints are in place, the body becomes a delightfully sensitive playground to explore and adore, and there is not a single area of skin that cannot be caressed with feathers. Use extravagantly long ostrich or pheasant plumes if you wish to take a provocative step back from your partner to get a better view. Each type of feather offers a distinct range of possibilities. Warm a lover up by charging the less sensitive areas of their body with erotic energy first, using, for example, the Cock Feather Tickler to caress the back and the buttocks—then tantalize more sensitive zones like the neck, breasts, inner thighs, and feet. The Puff rings let you alternate between the warm touch of fingertips and the silky caress of plumes; varying the sensations heightens arousal. The horsehair Pleasure Healer ring (p. 78) can be used to brush the entire body, offering a more prickly, direct sensation than feathers. Erotic tickling is the most subtle form of full-body stimulation, and it can be used in combination with many other techniques. Thanks to jewel-tools adorned with furry, fluffy materials, sensual sensations are accessible at any time. Any feathered accessory raised to eye level becomes a playful mask. Peeking out from behind a feathery puff is sexy, and incites coquette visions of extreme femininity. When attached to the Sado-Chic collar, a Feather Tickler may be the only thing one needs to wear. For a more classical statement, replace it with a Tassel attachment. These seemingly innocuous jewels can also offer a cool metallic tickle, or sting, if attached to a Sado-Chic ring or cuff and used as a miniature whips. Worn as earrings, they are just long enough to caress bare shoulders, and any part of a lover's body that they may touch.

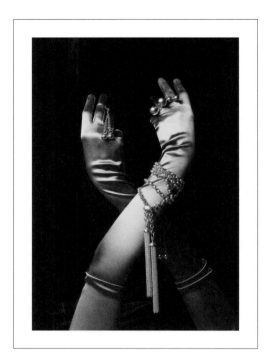
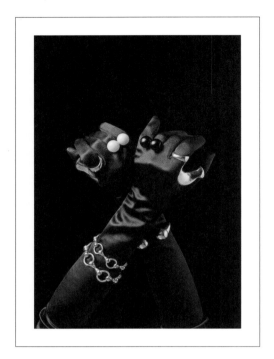
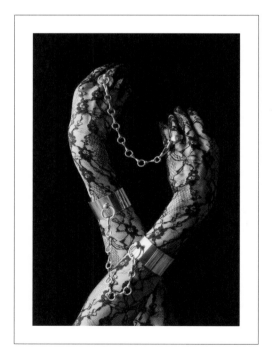
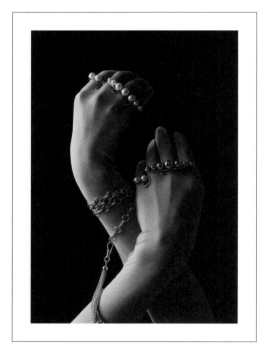

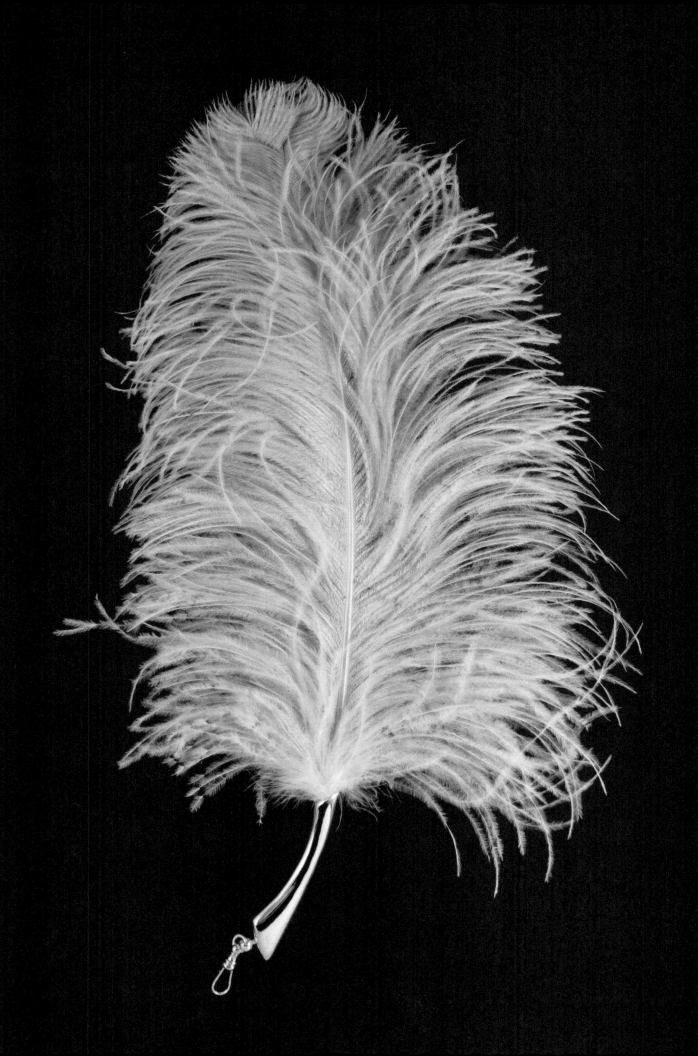

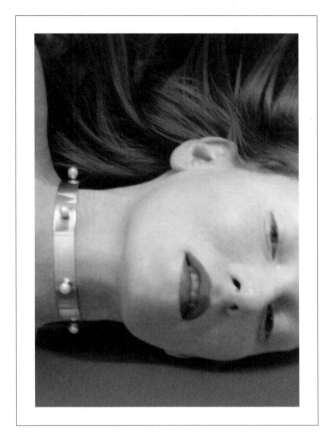

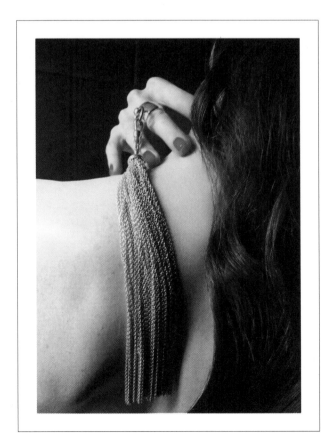

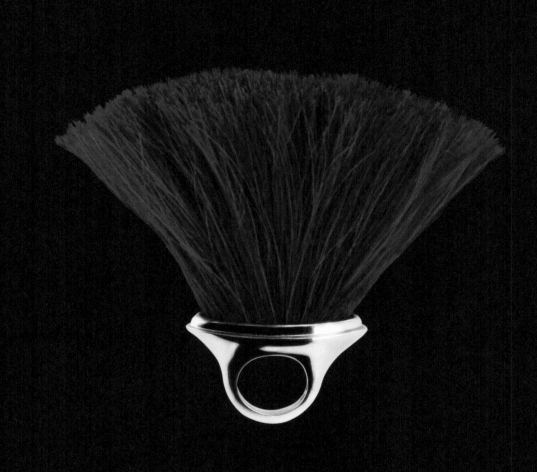

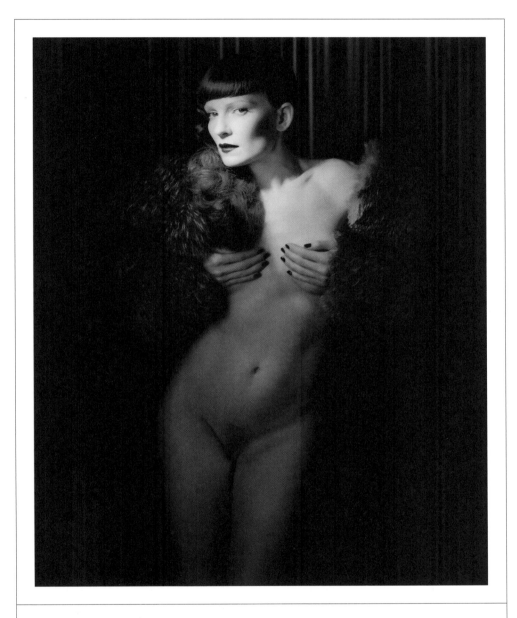

Do you want to feel my ring? I want to share it with you... My adornments
trigger desire and turn the senses on. Think of this horsehair ring as a "pleasure healer"
and use it to tantalize and tease your partner's most erogenous zones.

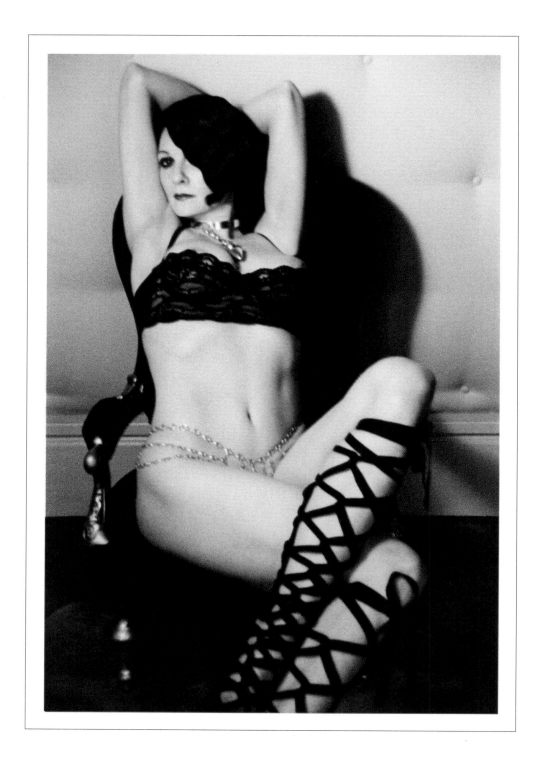

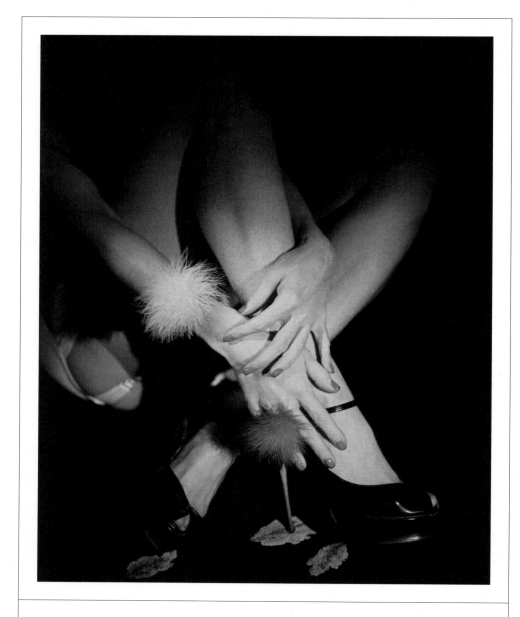

Scent has the power to deepen the breath and transport the mind. Spray fragrance onto the Feather Puff rings or open the Essence ring and reveal its sensual secrets. The power of scent is always at your fingertips with these jewels.

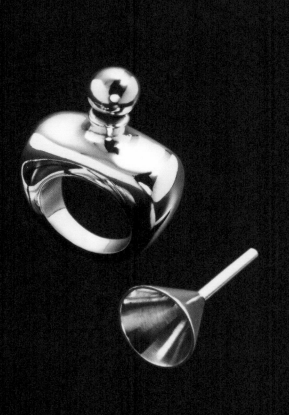

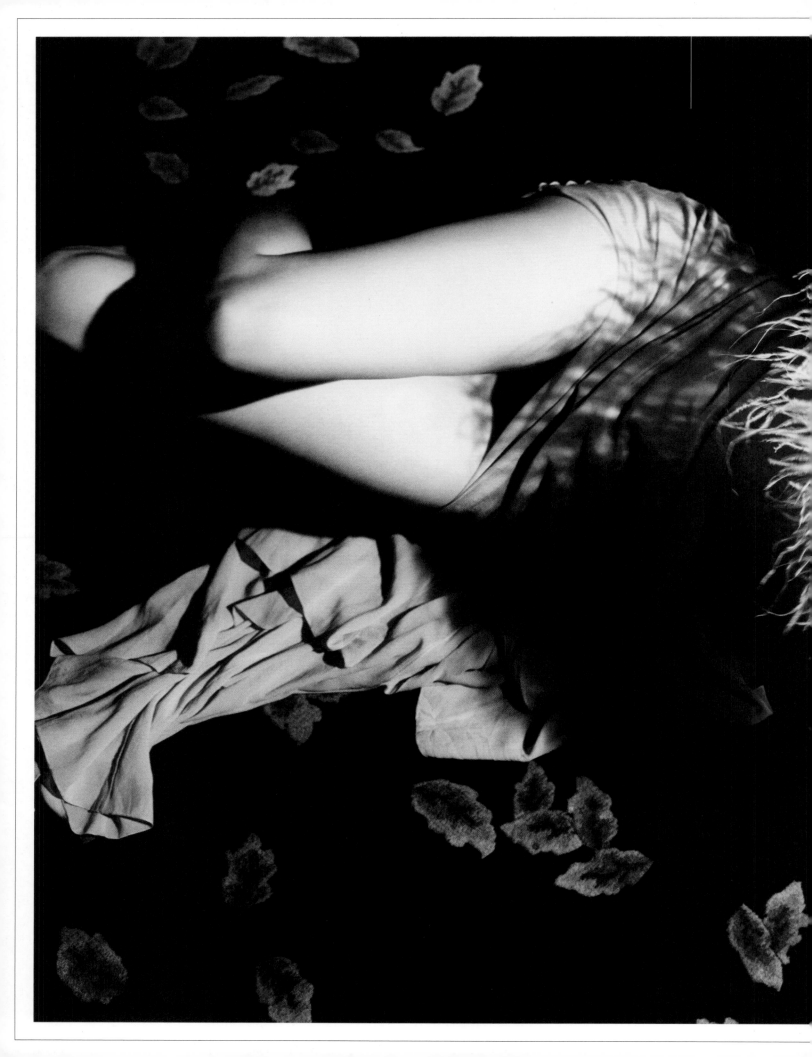

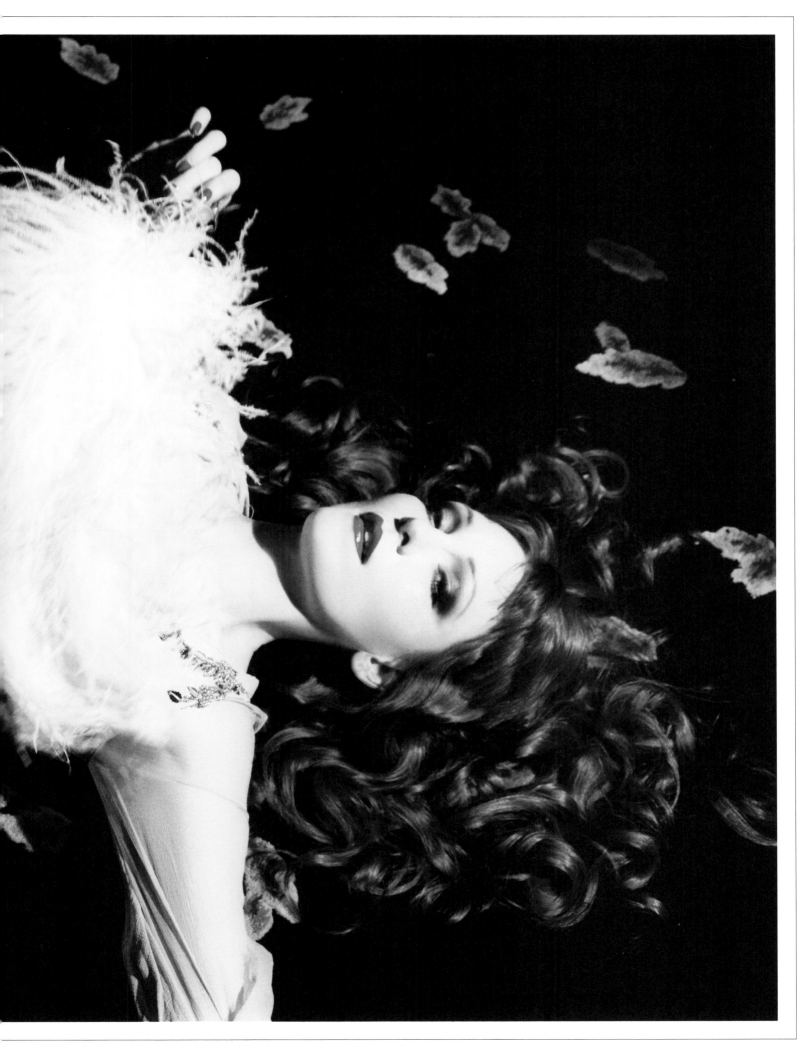

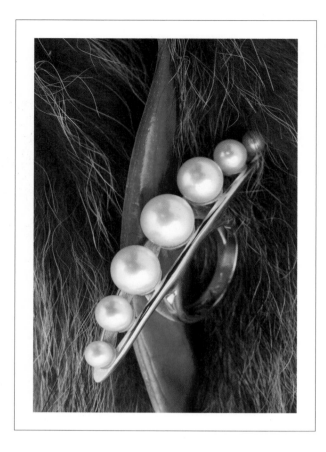

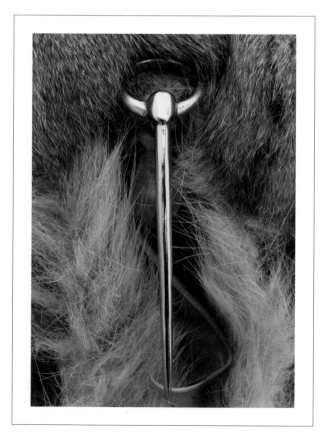

My jewel-tools transform the hands into artful instruments of erotic bliss. At your fingertips, they are ever ready to provide new and different sensations. Massage relaxes a tense partner, but if the goal is to initiate the sexual ceremony, try a more invigorating approach, with a focus on erogenous zones. I designed the Sphere massage rings to empower anyone with the ability to provide a skillful and unparalleled massage. Temperatures rise when the spheres of the massage rings are turned to the palm of the hand—the cool silver or gold spheres heat up against warm skin and they may be used for both intimate and deep-tissue massage. Focus attention on the muscular areas of the body, applying light pressure, avoiding zones where bones lie closer to the surface. Wear the Double Sphere rings to caress and stroke yourself or your lover (p. 89). After more than twenty years of wearing my precious pair every day, I feel naked when I leave home without them—it's as if they have become part of my body. The String of Pearls ring takes the sensational experiences to more luxuriously intimate levels (pp. 86, 92), as it is specifically designed to massage the genitals, whether male or female. All of these massage rings are intended to be worn on the middle finger, in order to provide the best balance and stroking power. On the other hand, both the Yo-Yo and Eva (pp. 90, 91) are wearable massage tools that slip between the index and middle fingers. These stately pieces heighten mental concentration and incite conversations. Their sleek, unmistakable presence focuses the bejeweled lover's awareness on their hands as sensational lovemaking tools.

In the boudoir, these jewels may be used for both intimate and full-body stimulation. Use the flat surface of the ring to massage and apply pressure or remove the ring from between the fingers and roll the "objets d'art" over any part of the body that craves loving care. Feet particularly favor these innovative wellness devices. The gold and silver jewels work fabulously well over light clothing, but massage oil or lube is recommended when they are used on naked skin. With the Pod ring, alternate between a sleek massage and a spiky scratch simply by spinning the jewel on the finger (p. 90)—the element of surprise is an advantage. Not everyone enjoys pushing the boundaries between pleasure and pain, but those who do appreciate its hidden benefits. The Cat Claw rings turn anyone into a purring pussycat (p. 93). While some might fear their sharp appearance, others will be drawn to the rings' orgasmic scratch that sends shivers up the spine. I personally handcraft every prototype in my workshop and test each object with the help of my partner to ensure not only that they are safe, but they will also endure the test of a lifetime of exquisite use. Fine craftsmanship and the use of noble, natural materials have made the Paradise Found collection timeless. Sterling silver and 18-karat gold, precious and semiprecious stones, wood, marble, leather, feathers—all resonate within their depths and harmonize with the vibrations of the body. These organic materials are body-safe and durable, qualities that I find essential to my design work as well as to our sexual well-being. The power of touch to excite, heal, and unite is undeniable. Sharing these sensual instruments with another imbues them with meaning... and potent memories of Paradise Found.

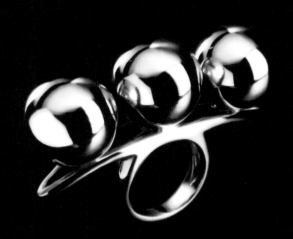

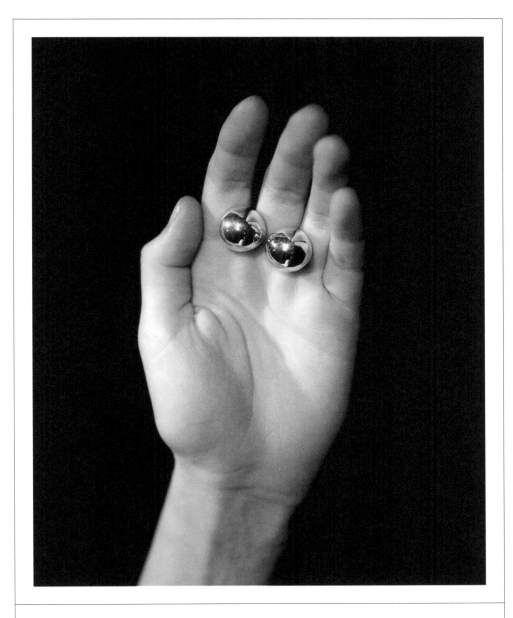

Give these iconic massage rings a twist into the palm of your hand
to activate the transition from jewel to tool. The distinct sensations
that they have to offer are guaranteed to enthrall.

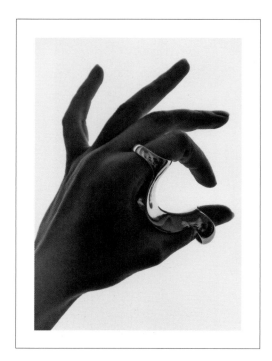

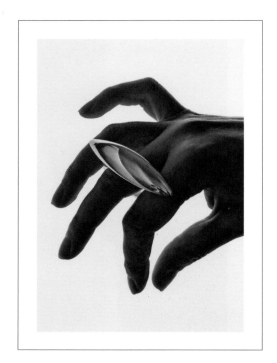

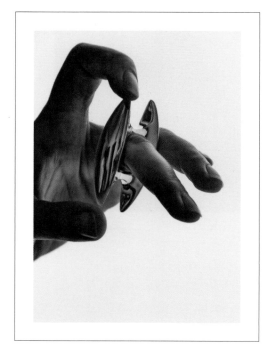

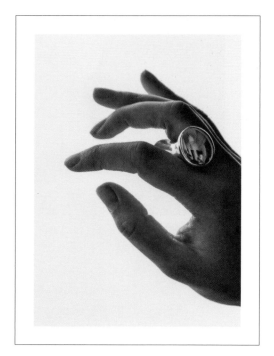

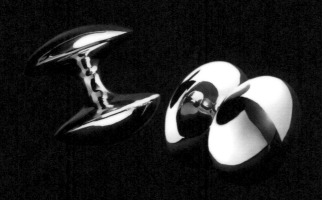

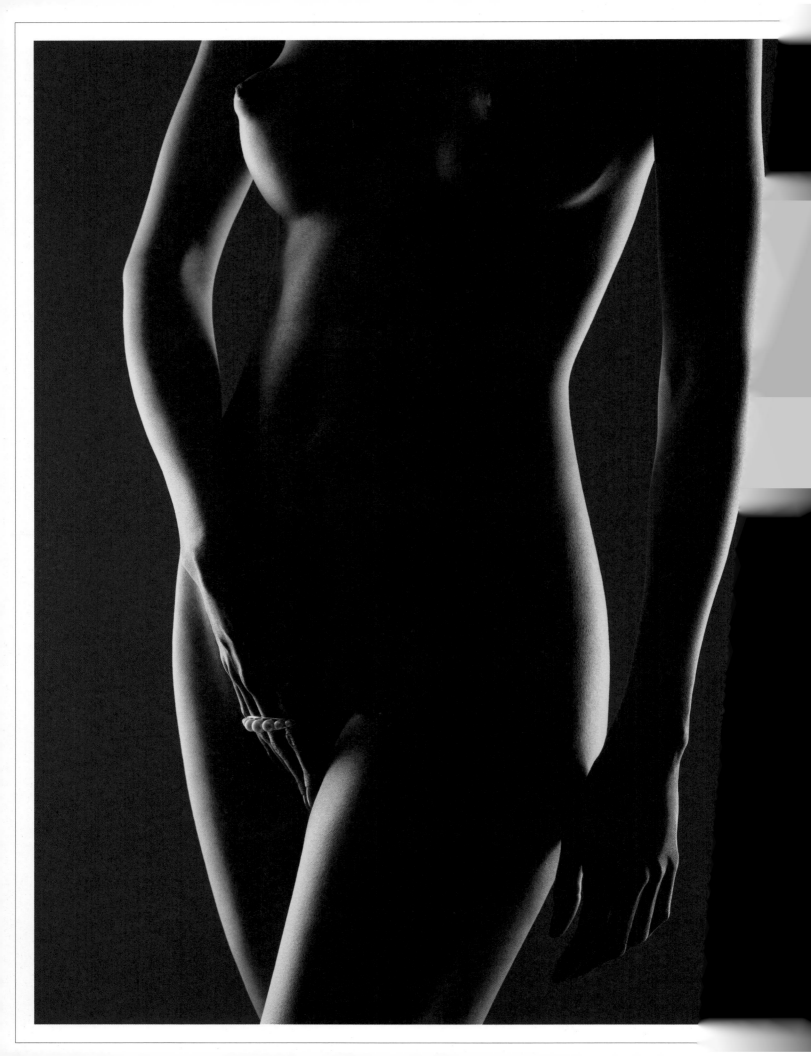

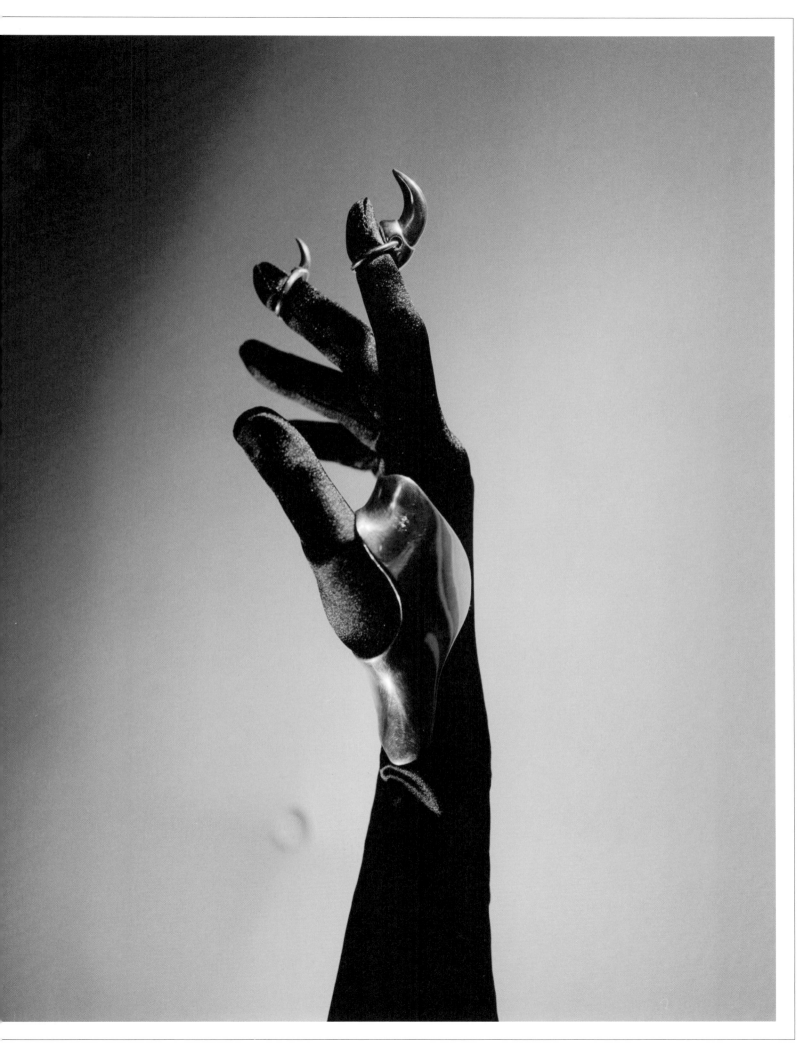

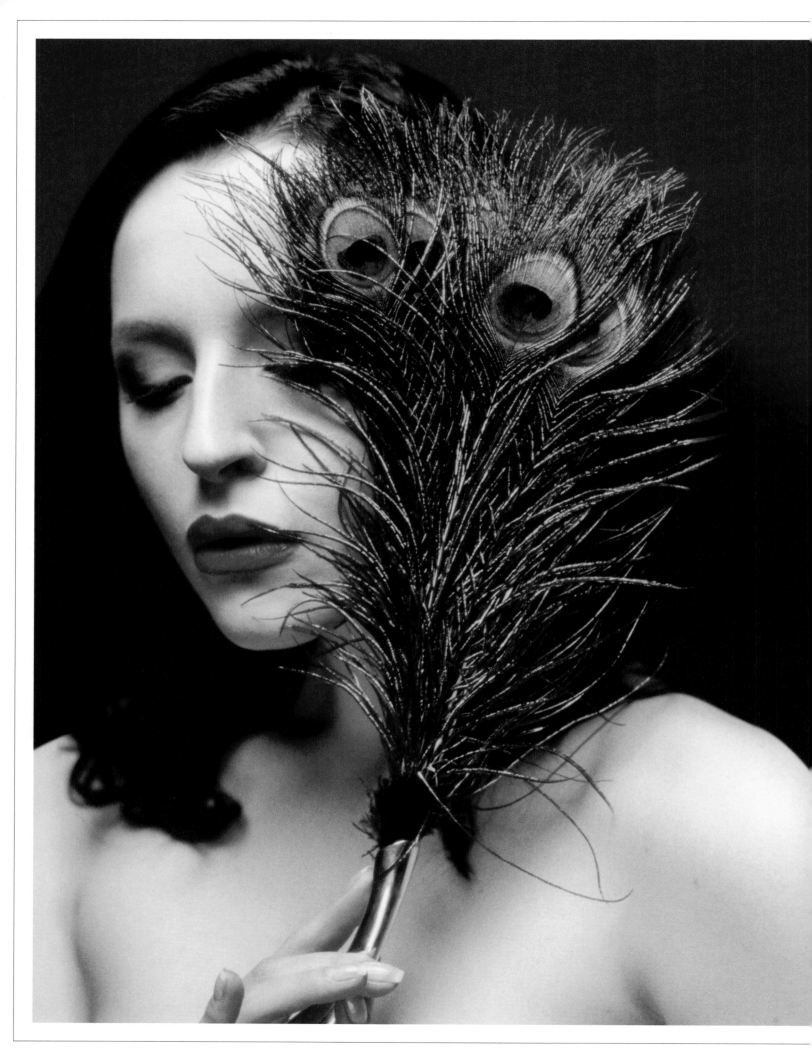

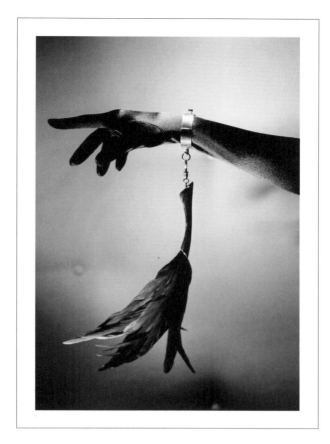

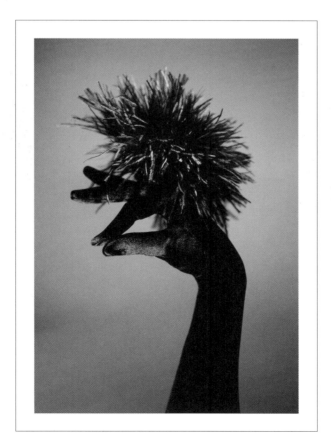

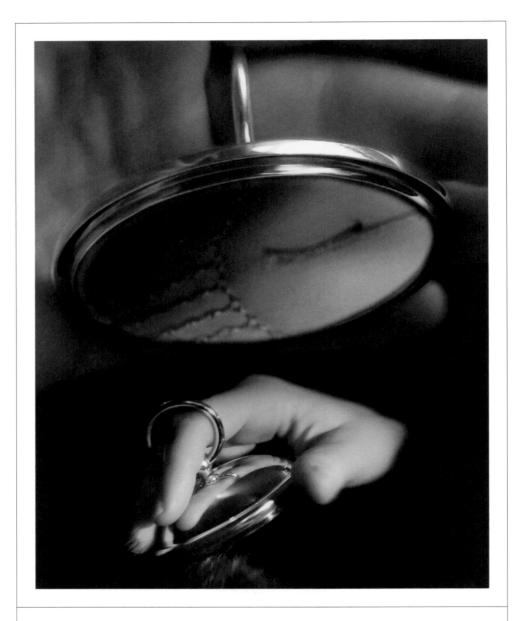

The silver mirror offers a front-row seat in your very own private X-rated theater. Thanks to the Sado-Chic ball-and-ring mechanism, this mirror won't fall and break the heat of the moment, so lie back and enjoy the show.

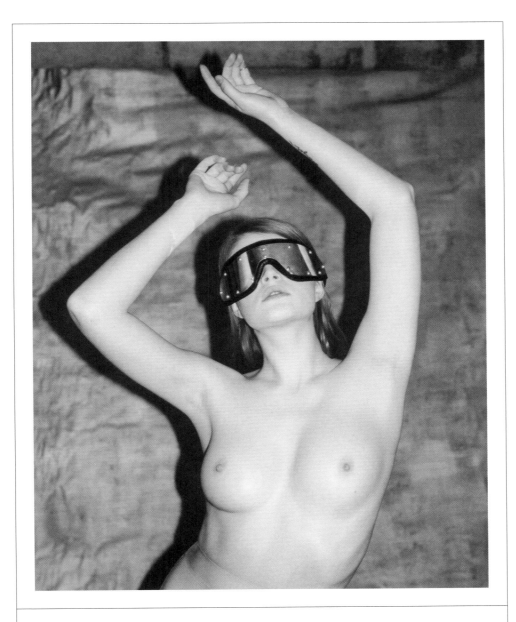

A blindfold heightens your lover's sensorial perception. Guide them
to new dimensions of pleasure using visual restraint in tandem
with other tools and techniques of full-body stimulation. Love is blind...

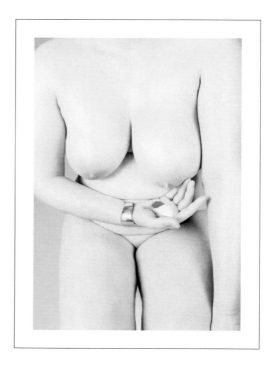

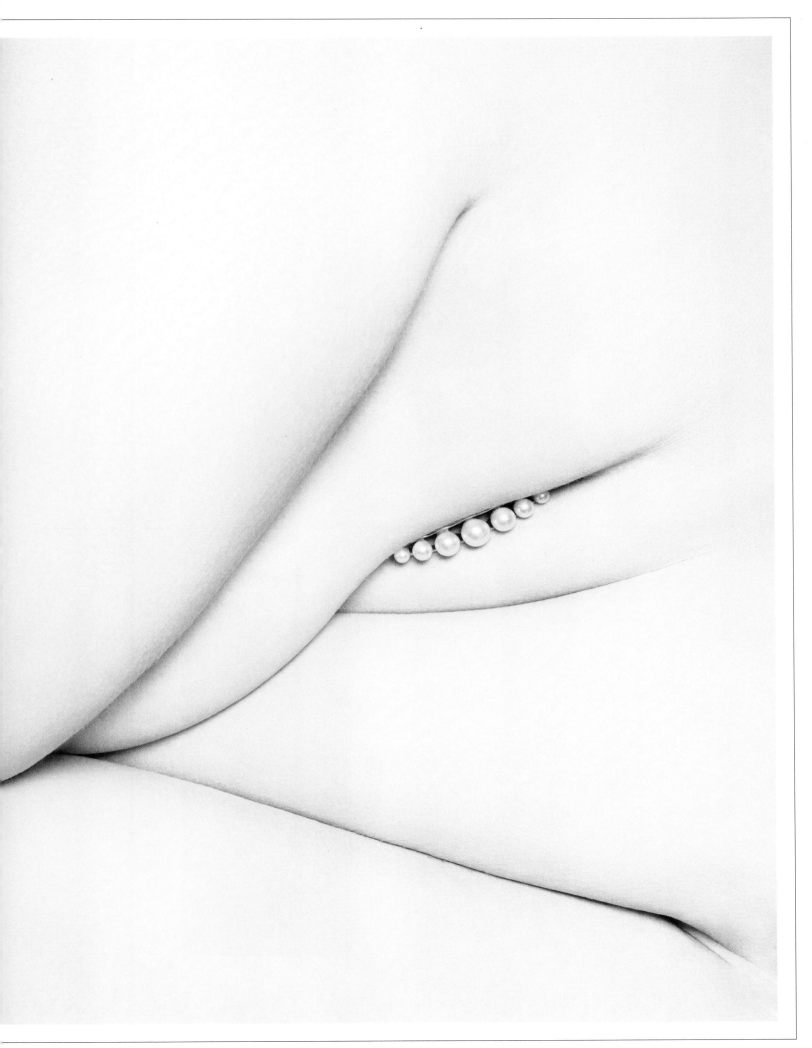

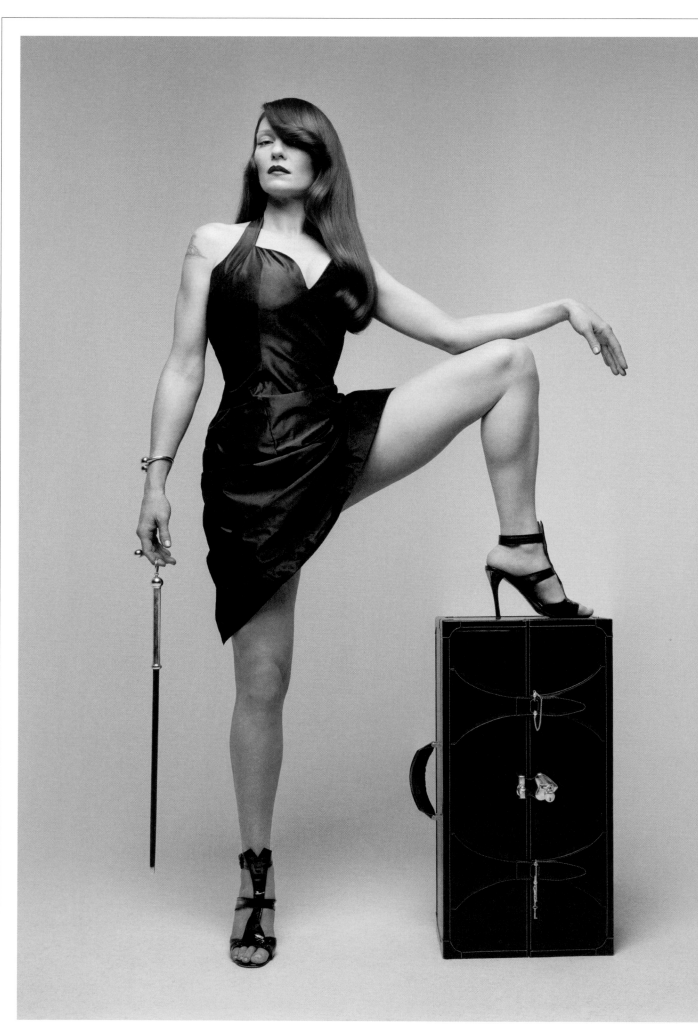

IV.
ERECTING
THE TEMPLE

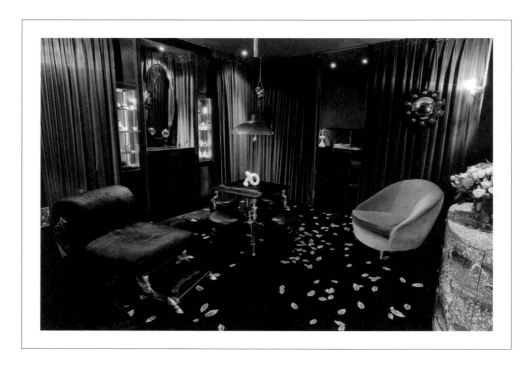

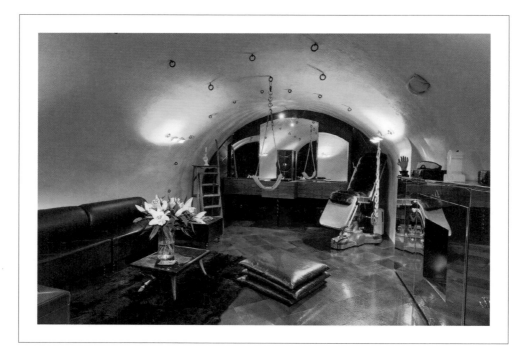

I believe that when we confine sex to the bedroom, we become creatures of habit. Erecting an erotic temple serves to break the routine and charges the libido. The temple does not need to be large to be transformative or in a fixed place to bestow the benefits of the sexual ceremony. My Boudoir Box (pp. 108, 109) was designed as a portable temple. It serves to transport the essentials of my rituals and, like a traveling gallery, I use it to showcase my jewel-tools around the world. It elevates everyday environments to the ceremonial, from discreet hotel rooms to private homes. The Boudoir Box is a central part of my vision to encourage the exploration of the sexual realm. Prior to the exhibition at the Musée d'Art Moderne de Paris in 2017, I only opened it privately for my collectors and small groups during my sexual well-being salons. The handcrafted leather case has silver closures that pierce the finely tooled straps to keep them closed. In the center of the box lies a heart-shaped locket—with a set of silver keys. The triptych is filled with gleaming erotic instruments nestled within luxurious, brushed-suede alcoves. There is a hidden compartment, and miniature drawers enable the discreet storage of other sexual accoutrements. Like all ceremonial objects, the Boudoir Box has a presence that hushes conversation, invites wonder, and prompts curiosity. When it is not traveling, the Boudoir Box sits upon an "altar" designed expressly for its display in Eden, my private temple in Paris. Paris, where "tout est permis, et tout est permissible"—the foundation of my vision, my favorite source of inspiration, and the city from which I felt I could most efficiently evolve my concept and my mission. Eden is like an extension of the Boudoir Box: plush and luxurious, seductive yet sophisticated, it makes visitors feel honored yet at ease, as if they have entered another dimension, a safe space. Enveloped in this intimate environment that caresses the senses, viewings of the Paradise Found collection take place by appointment only. While the first floor is draped in forest-green velvet, the basement, which is accessed by a staircase that spirals into the Parisian underground, is clothed in deep purple leather (p. 102). Few are those who make the descent into what I call "Heaven," and fewer still are those who have had the privilege to experience the infinite possibilities that it has to offer. It is a place where much sexual healing has also taken place. Fire sets a ceremonial tone, and so flames lick the reredos of the fireplace built into the center of the polished steel display cabinet that doubles as a mirror. The vaulted ceiling is dotted with steel o-rings, allowing me to do "top-down" rope work. My passion for suspension bondage led to the conception of the Theta Rig, a portable suspension system that induces a trance state. The brain of the suspended subject almost instantly emits the associated theta brainwave frequency, also emitted during mediation and orgasm. Engaging mind and body, this work has a calming, therapeutic effect. During Theta sessions, I record the brainwaves with electrodes and synthesize them for playback in real time. When I exported this experience from Heaven to the Musée d'Art Moderne, the public was transported by the deeply relaxing sound of my subject's entrancing brain waves (pp. 104-5). My aim is to create experiential objects and spaces that ultimately transform fantasy into reality.

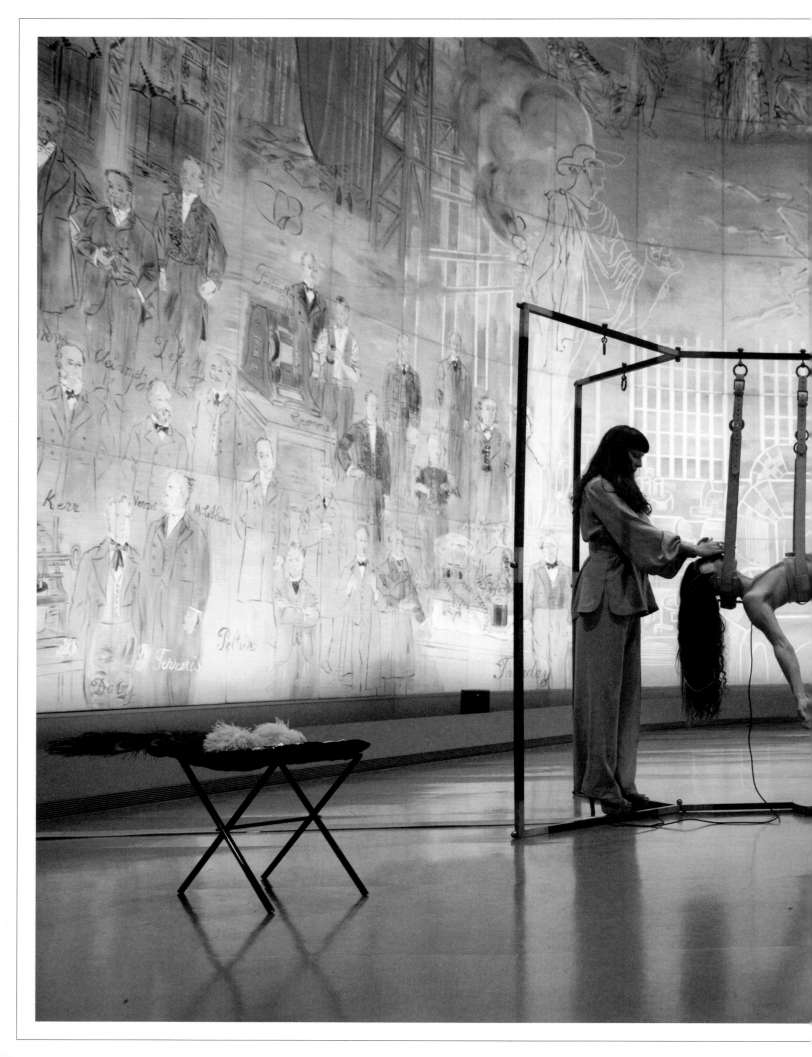

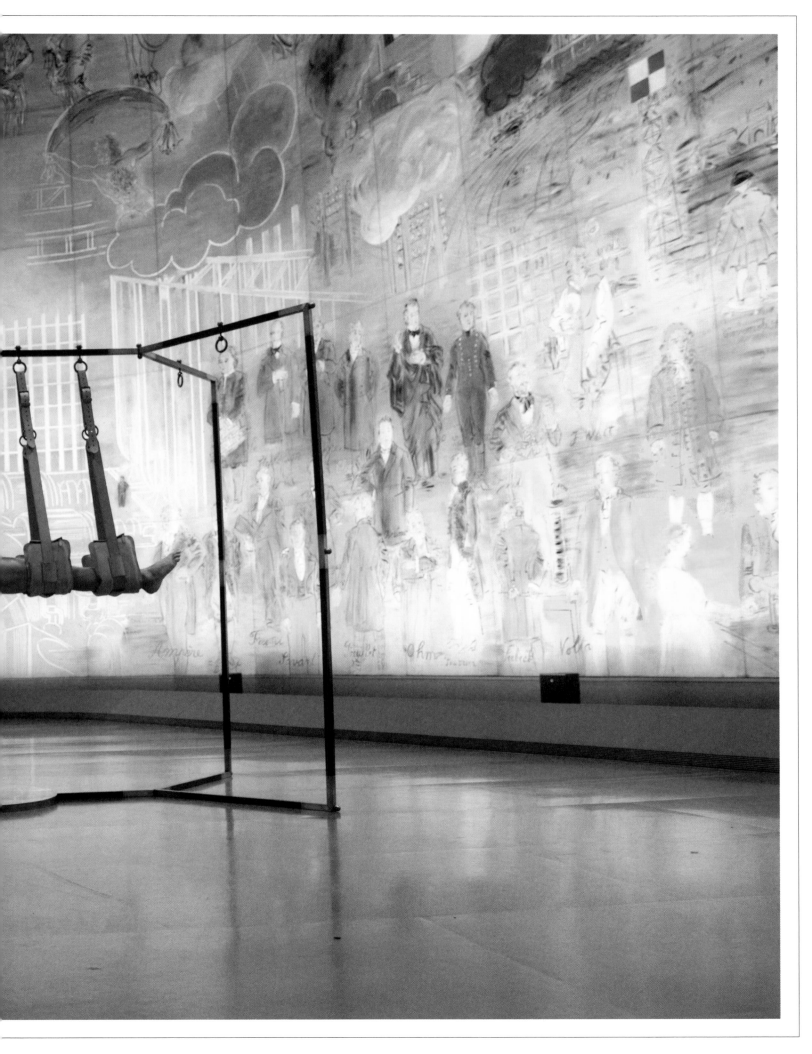

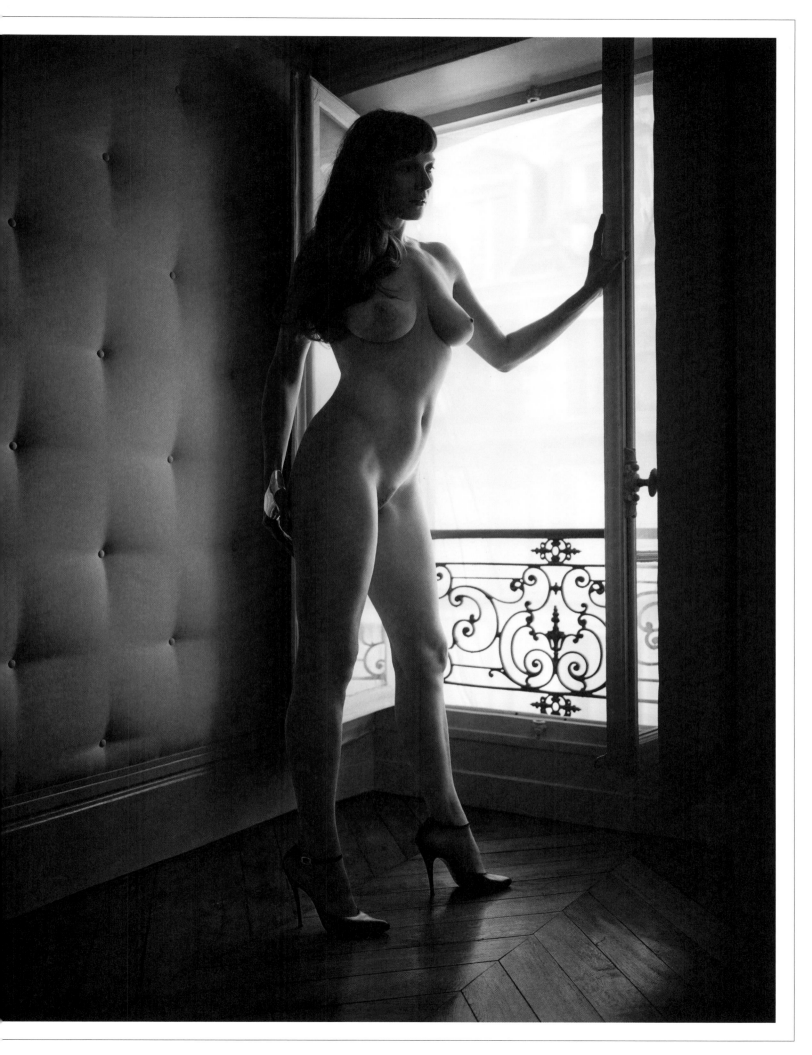

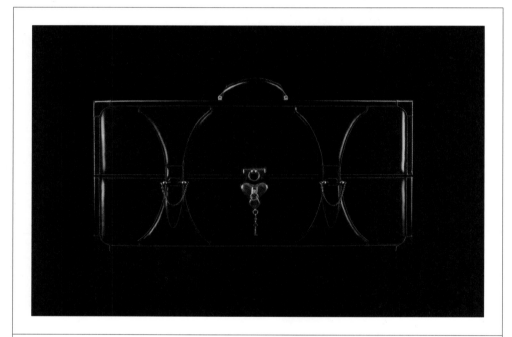

I open the Boudoir Box and unveil its erotic treasures with a sense of the sacred.
The room instantly becomes a temple of erotic inspiration. When the ceremony
draws to a close, I reverently put the objects back into their assigned spaces
and lock up the Boudoir Box until it's time to share again.

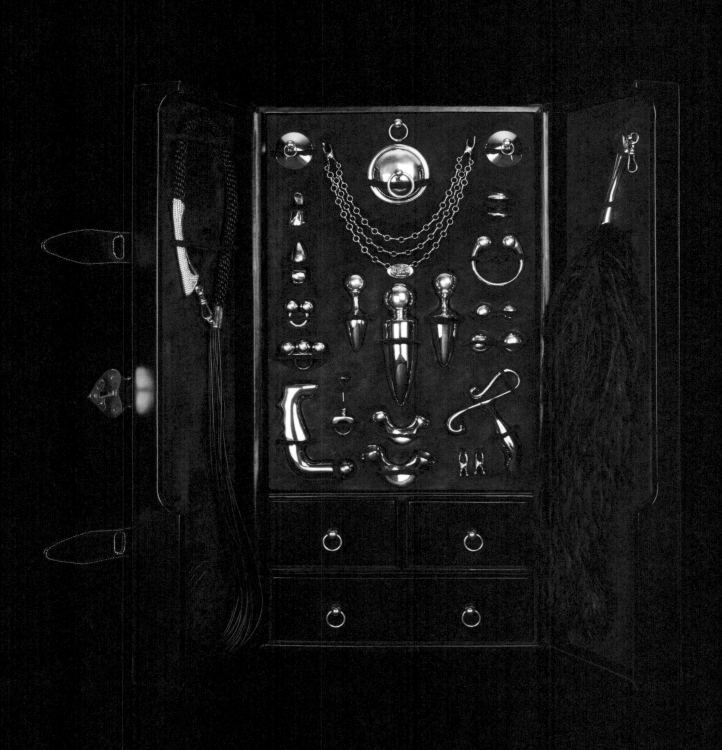

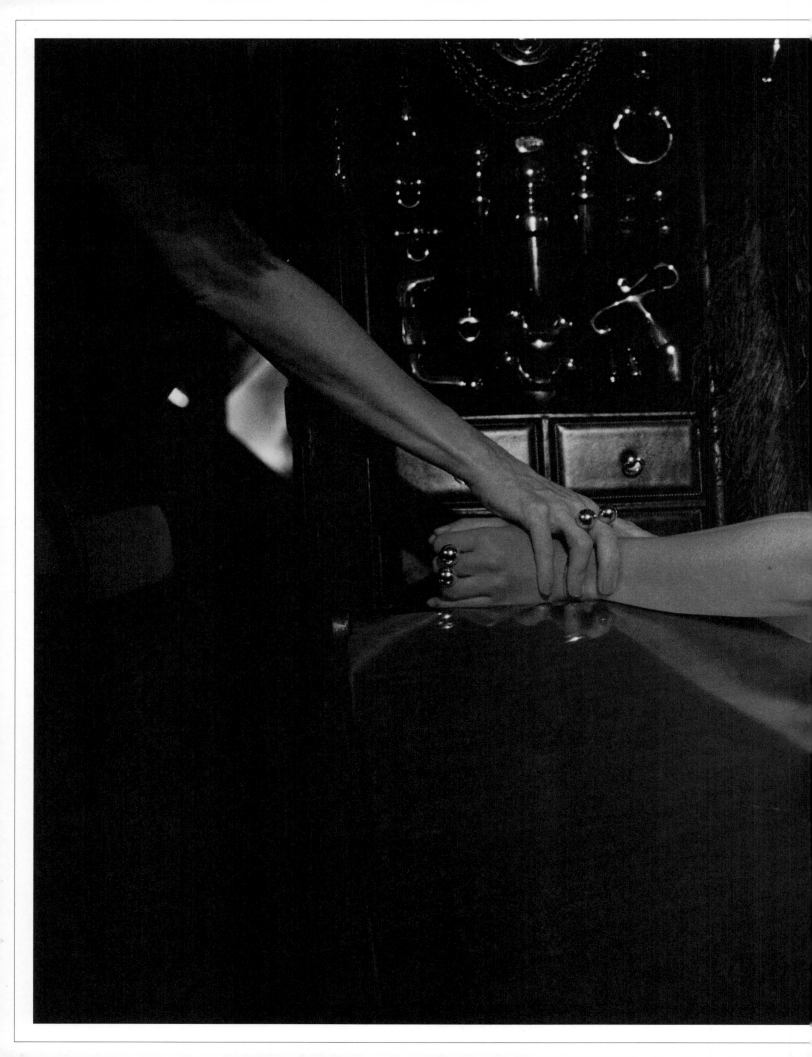

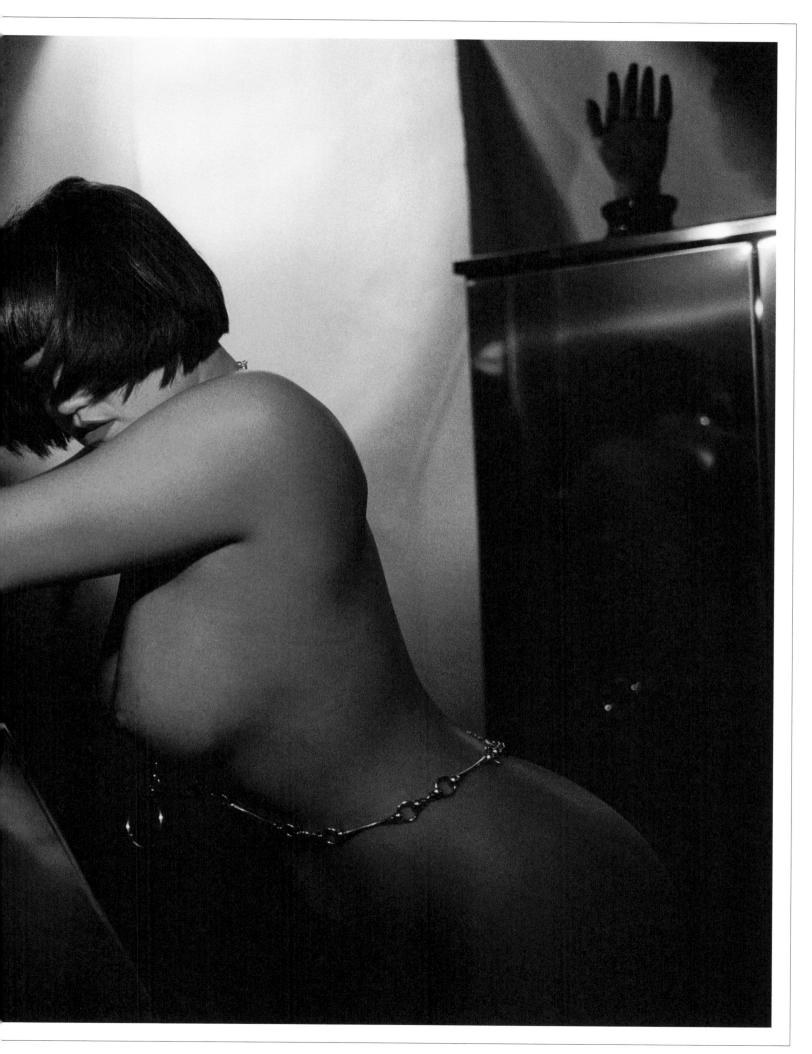

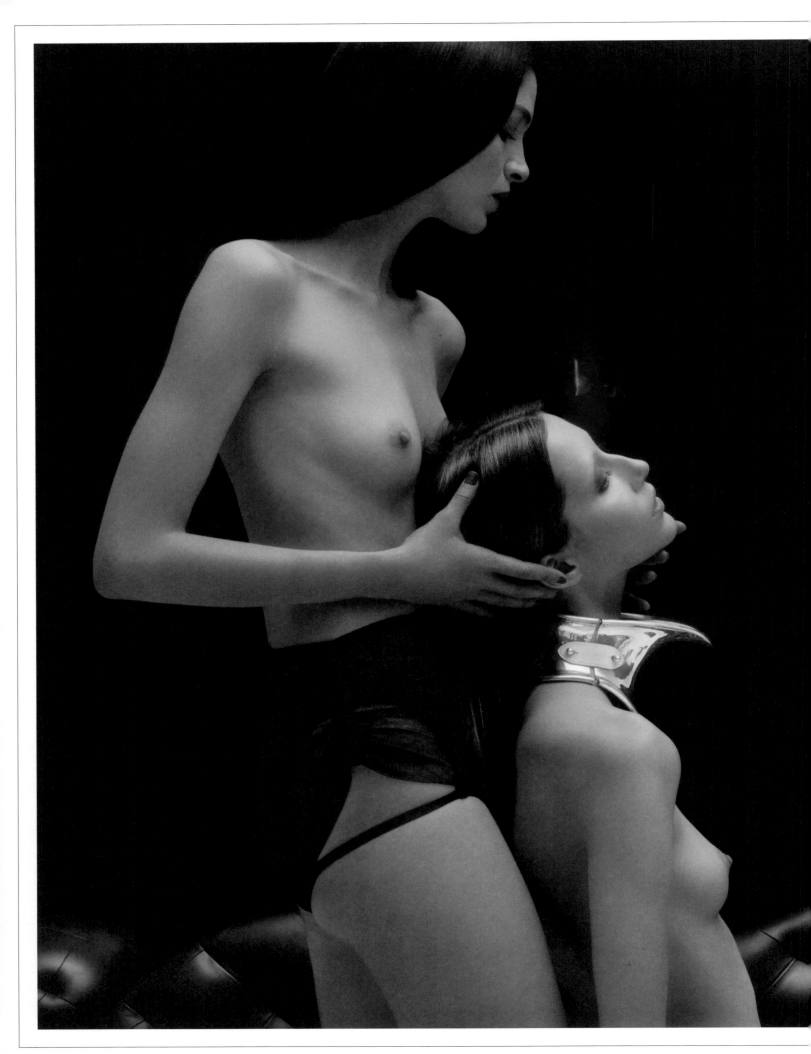

The erotic temple can be any private place charged with euphoric possibility. Most importantly, it is truly a feast for the senses! Light and shadows dance to the glint of diamonds sparkling on gold Sado-Chic cuffs and collars. A lover in the grasp of a perfectly polished sterling silver Petting Ring is reflected to infinity in strategically placed mirrors. When the Mastress of ceremonies chooses the Teacher's Pet (p. 100), the temple may transform into a kinky school, but if she prefers the Unicorn Whip (p. 176), then equestrian fantasies are likely to take shape. Even to blindfolded eyes, the temple does not vanish. Perception of space is also defined by the sound of jewel-tools being carefully placed on a silver tray, the soft jingling of chains, the click of the key turning in the locket of the Slave to Love Collar (p. 117), or the assertive slap of a Sado-Chic crop (p. 167). The scent of leather, the touch of feathers, the creak of cords, the slip and slide of silver on dewy skin... In the temple, souls unite as bodies converge in ecstasy. It is a sensual dimension where the real world is at the mercy of play. Good organization is essential to the realization of a truly seductive mise-en-scène, and loving attention to every detail ensures the ecstatic flow of the ceremony. After all, only when an erotic treasure trove is lovingly prepared and organized in advance, with everything at arm's reach, can the focus remain on pleasure. My jewel-tools, perfectly polished, and right at your fingertips, may be the only adornment—and possibly the only tools—needed to make your fantasies come true. Orchestrate the environment as an invitation to succumb... make the experience as sexy, fun, and mutually satisfying as it can be. In 2009, Nick Knight created his own visionary temple in which my jewels shone. The renowned fashion photographer worked with set designer Gideon Ponte and Knight's long-term collaborator and graphic design icon Peter Saville, to create "Soft Furnishings: The Erotic House of Peter Saville." The shoot for Wallpaper* magazine was inspired by Saville's legendary and infamously sexy home in Los Angeles in the 1990s. The set was a lush erotic temple of Saville's own fetishistic design where a post-modern dystopia met an ironic 1970s playboy bachelor pad. Elements of fetish culture, design, architecture and high fashion were fused together to create a hedonistic space. Saville described the experience of re-creating his LA "temple" in Mayfair, London, as an "exercise in self-mythology." The set evoked a sensual dream state where ceremonial scenes were played out for Knight's camera... and a mysterious voyeur: Jewel-tools are placed on a silver tray by one of the participants, Mariacarla Boscono, who reverently presents them to Alanna Zimmer, her partner for the scene. Resonant with sexual fantasy, the Minerva signals the direction of the visual narrative. In the video, languid, seductive shots gradually reveal precious, intimate gestures. The silver Sado-Chic collar becomes a ritual portal into the sexual dimension of this exquisite collaring ceremony. Here the stark, monumental scale of the set exalts the important elements of the sexual ceremony; no detail is irrelevant. In such a space, even a single jewel-tool can suffice to incite a shift in power and provide direction throughout the duration of the entire ceremony.

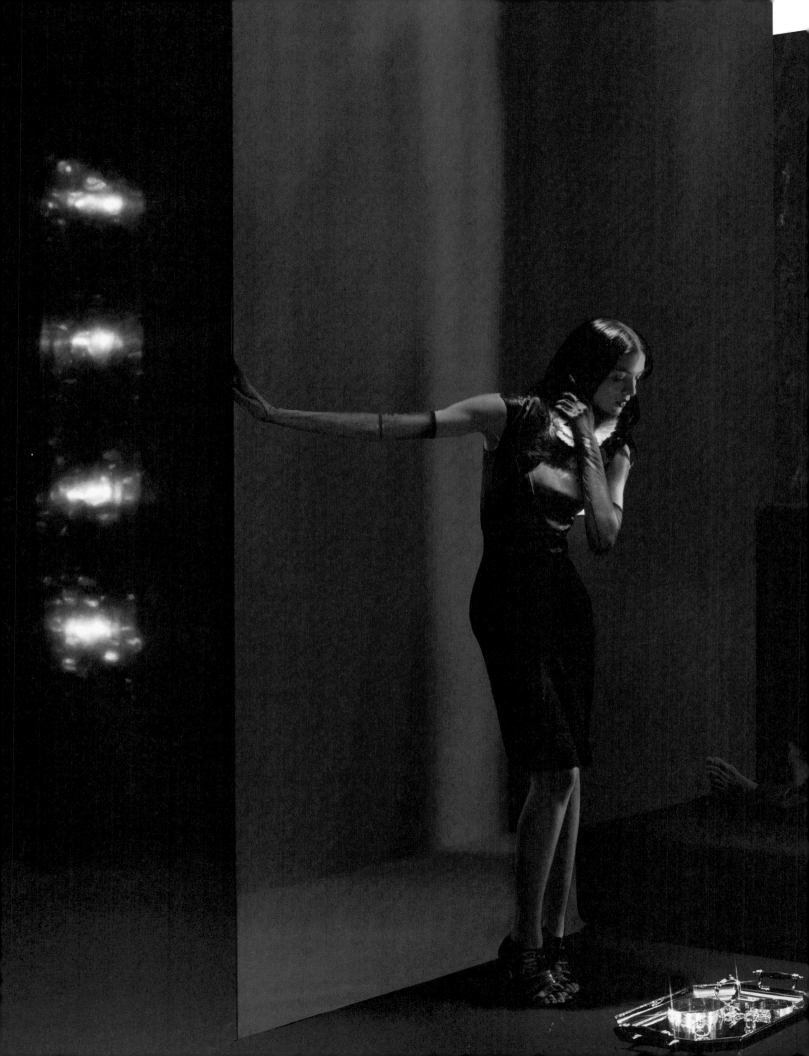

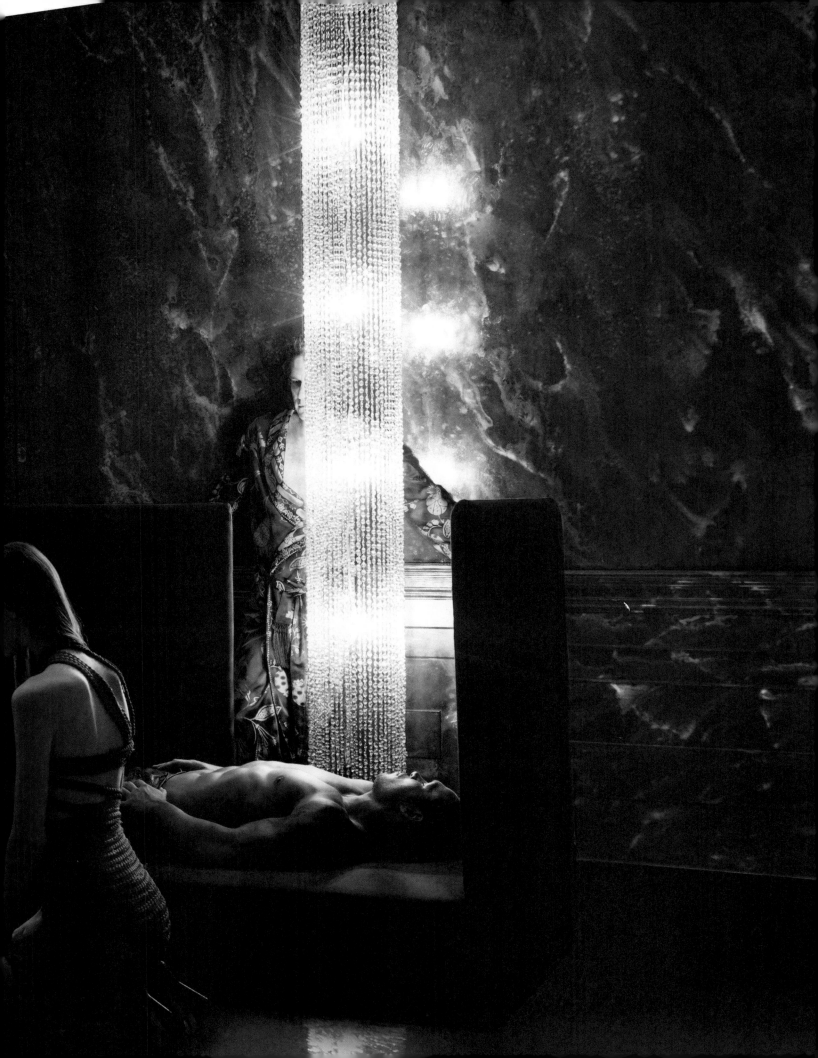

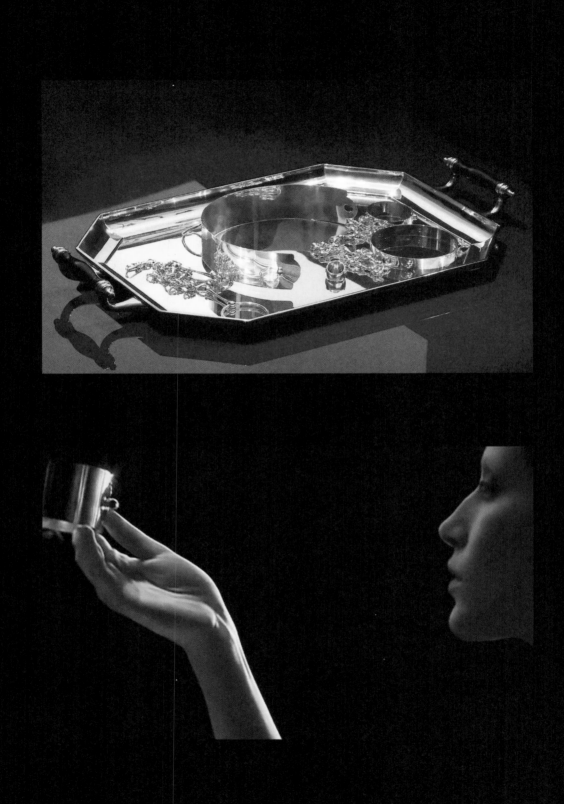

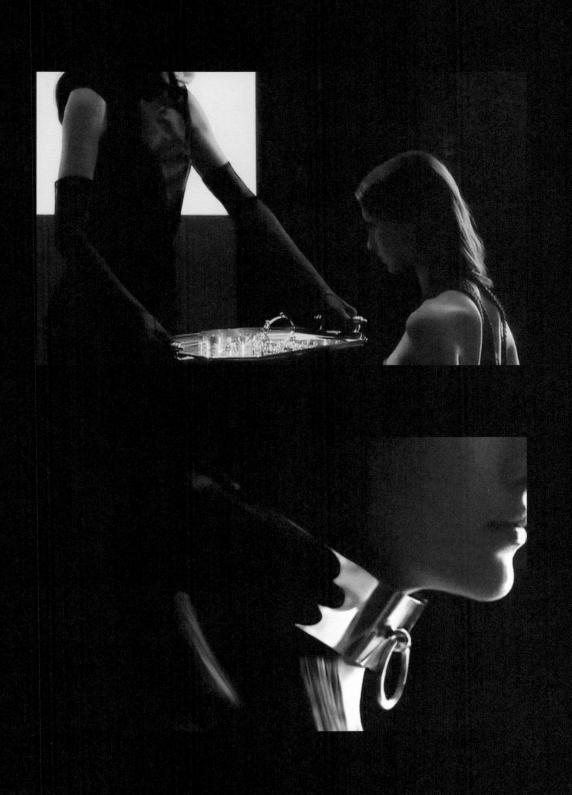

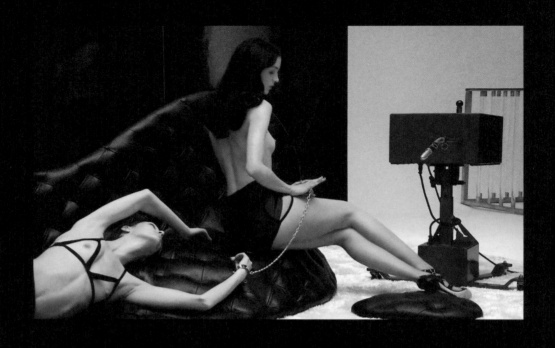

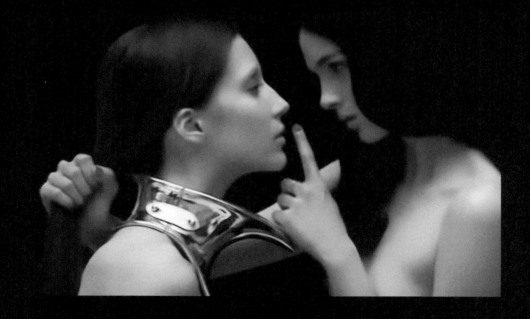

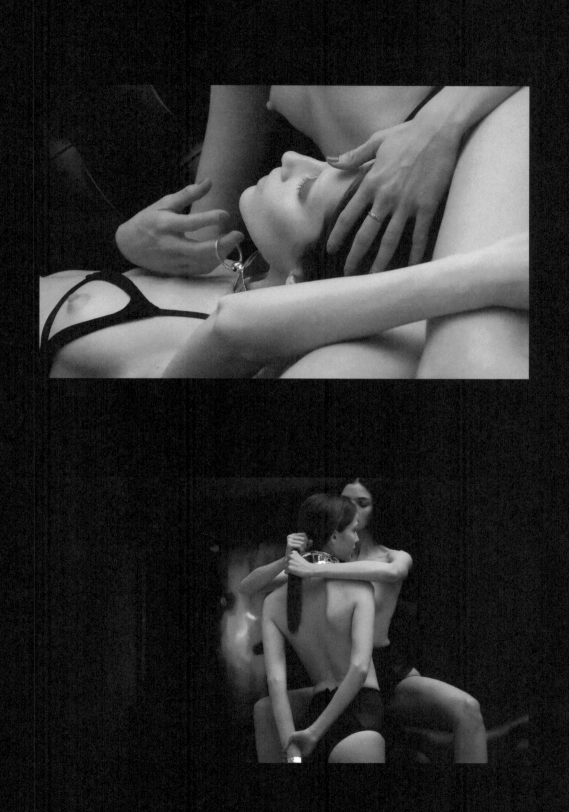

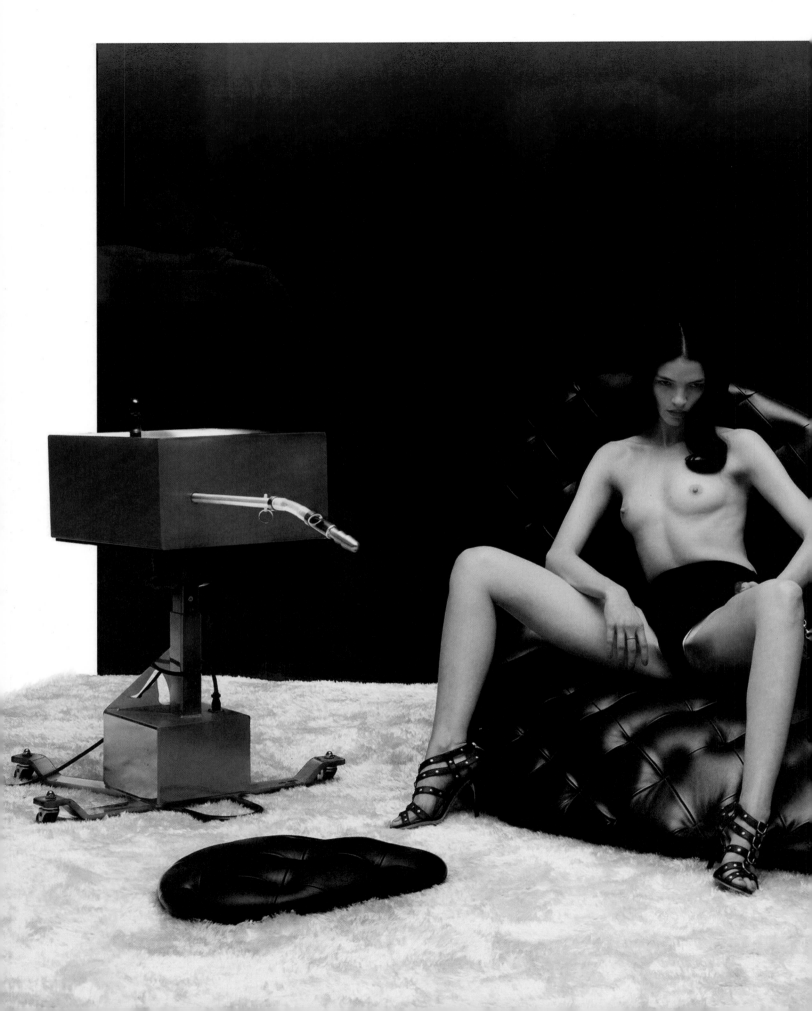

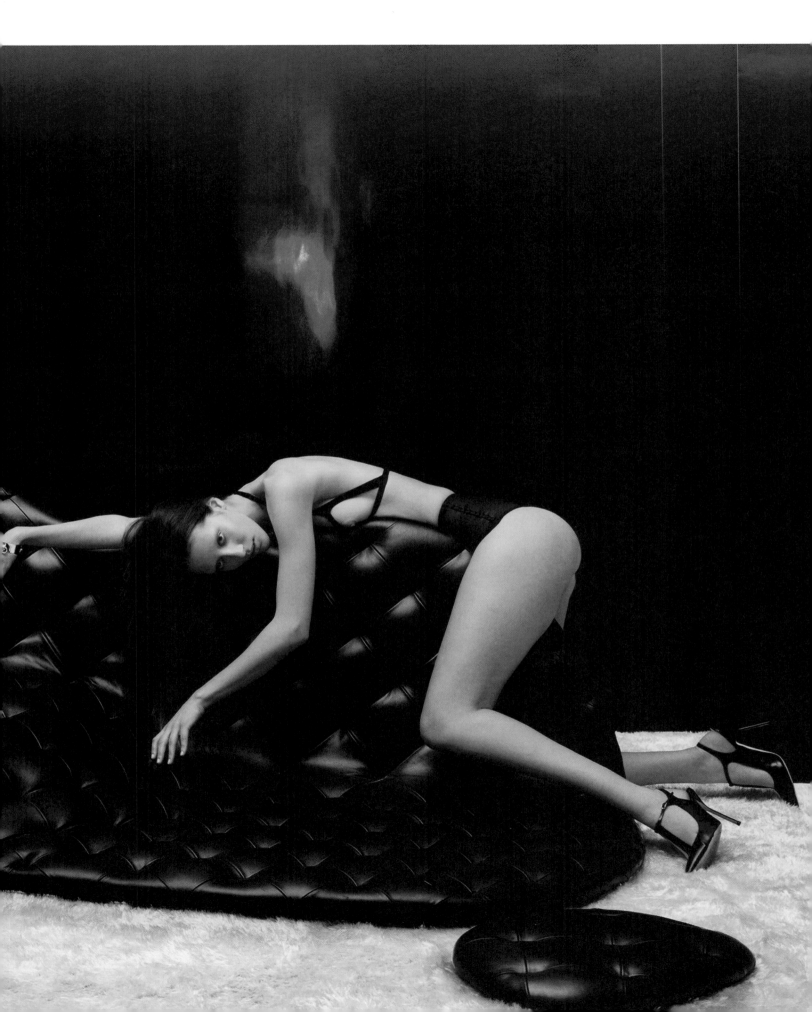

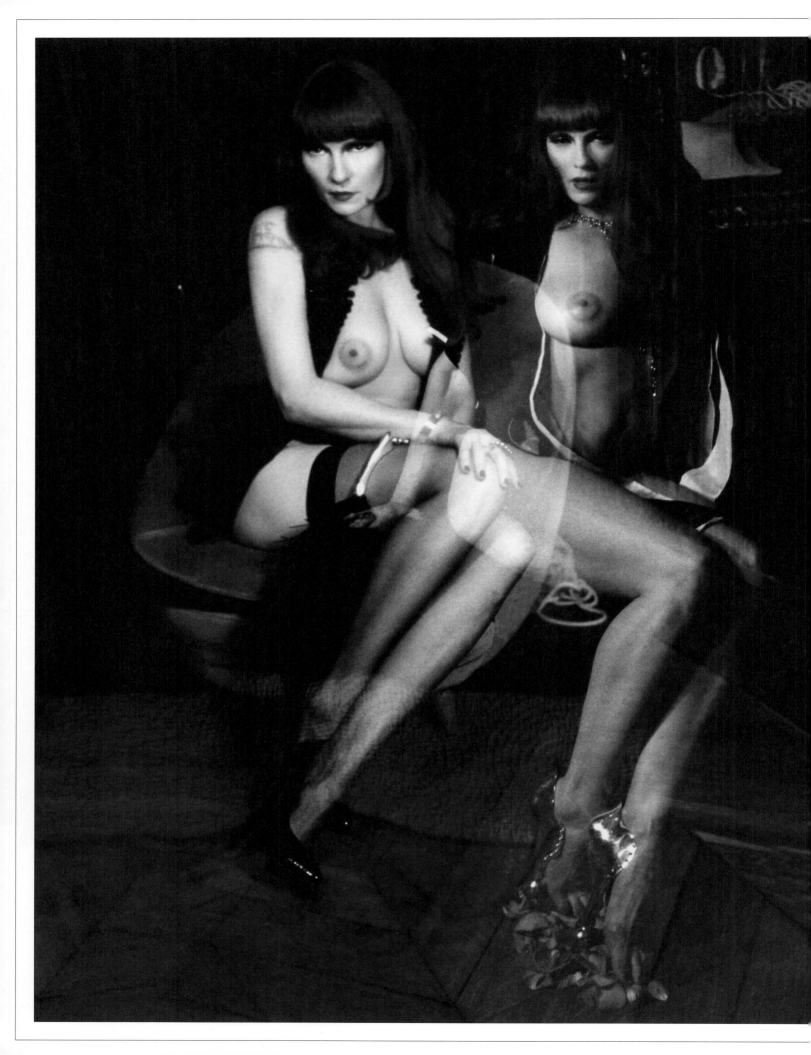

V.
ROLE-PLAY

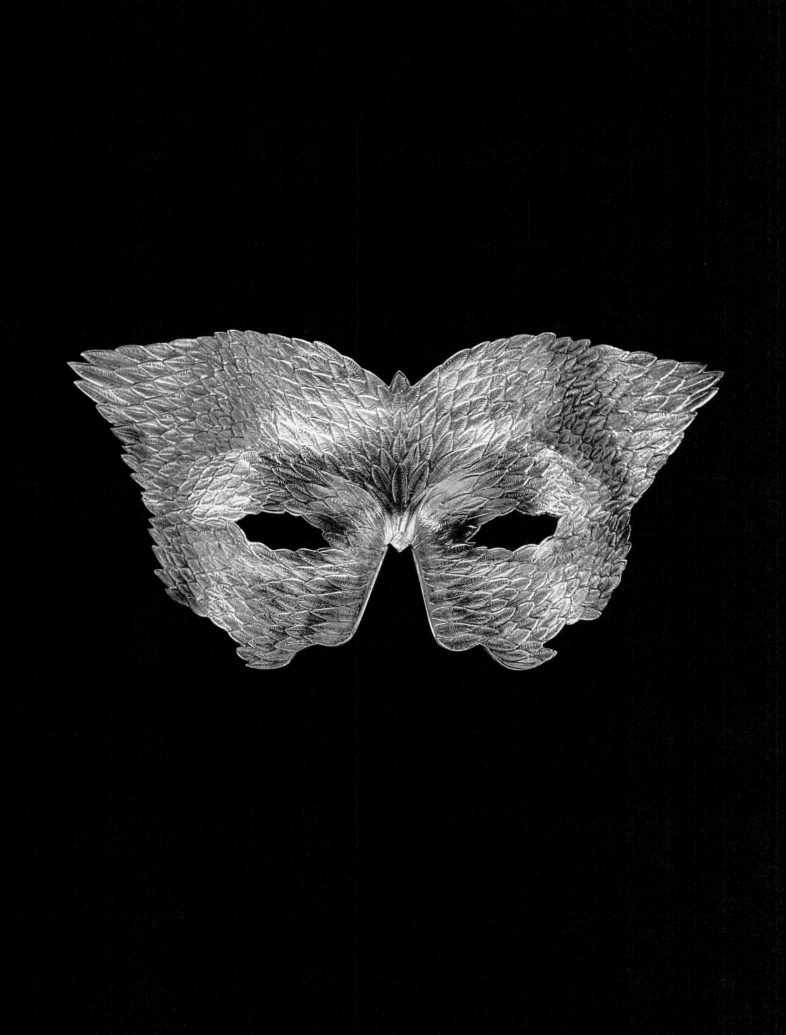

Role-play is a ritual art that elevates the sexual encounter by tapping into the creative mind. Playful domination and submission satisfy our deepest needs and unleash cathartic emotions. Bringing erotic fantasies to life not only gratifies us; it also contributes to the sexual "high" evoked by the kind of ritualized play that engages the body and all of the senses simultaneously in a controlled and protected environment. As children, we all played the role of subordinate or dominant, helpless captive or captor, bandit or uniformed authority, teacher or naughty pupil, master or pet. Children embody adult roles naturally and with ease—this kind of playtime is crucial to human development. Role-playing permits us to experience the juxtaposition of strength and impotence, power and lack thereof. Assuming the role of one's choice and developing the character has the power to tap into and reveal the deepest aspects of the self. But adults who enjoy the transformative power of erotic role-play are often pigeonholed as "perverted." Over the past three decades, I have worked to dissolve restrictive categories and dismantle pleasure-inhibiting taboos. In adult play there is consent, trust, beauty... and infinite possibility. It awakens the child-spirit that lies deep inside every adult. Whether the roles played are specific or not, whether scenes are clearly planned in advance or completely improvised, my jewel-tools accompany partners and empower them to express themselves spontaneously. My vision proposes a refined sexual aesthetic—consider it an invitation to play! Costumes, accessories, and props help us to develop and assume our chosen roles,

and so I created my jewel-tools with role-play in mind. Building an erotic character is like erecting the related play space or temple: it triggers a pro-pleasure mindset. Freed from all inhibitions, with a trusted partner in an intimate safe space, we can assume the roles that excite us most, and they often have nothing to do with our everyday lives. My collectors appreciate the transformative power of their Paradise Found jewels to elevate routine to ritual. Incorporating such adornments into adult play can help to determine the focus of the sexual ceremony's elaboration. Assuming a role and accessorizing to become "other" incites an exciting energy shift; indeed, deciding which jewels to wear in accordance with the meaning they will encompass and the purpose they will serve is a potent form of foreplay. Jewels are also a form of communication. They may hold obvious meanings or very private secrets and codes, and in the case of my jewel-tools, they also signal the intention to play. Sado-Chic pieces symbolize the desire to let go, to be lovingly commanded, and to belong to the significant other. Whether you are wearing a genital-shaped jewel, or one dedicated to intimate pleasures, the message is clear—it's time to enjoy. Second Skins endow the wearer with a super-human attribute, as they amplify the body with pleasure-providing abilities. Sensational materials like plush feathers, woven leather, supple horsehair, and shimmering chains ignite the imagination and build anticipation. From the moment you adorn these jewels, you will feel a shift in your attitude—sexually empowered and self-confident. Seduce yourself first and the gateways to desire open wide.

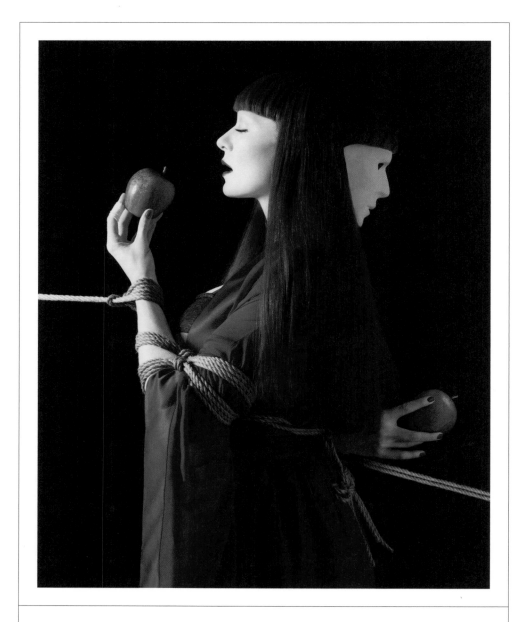

Masks unleash the playful side of our souls and help us to play more
convincing roles. Choose the right props to become "other"—human-animal,
mastress or master, cyborg or heavenly goddess or god... The stories
may be universal, but the way you bring them to life is your own.

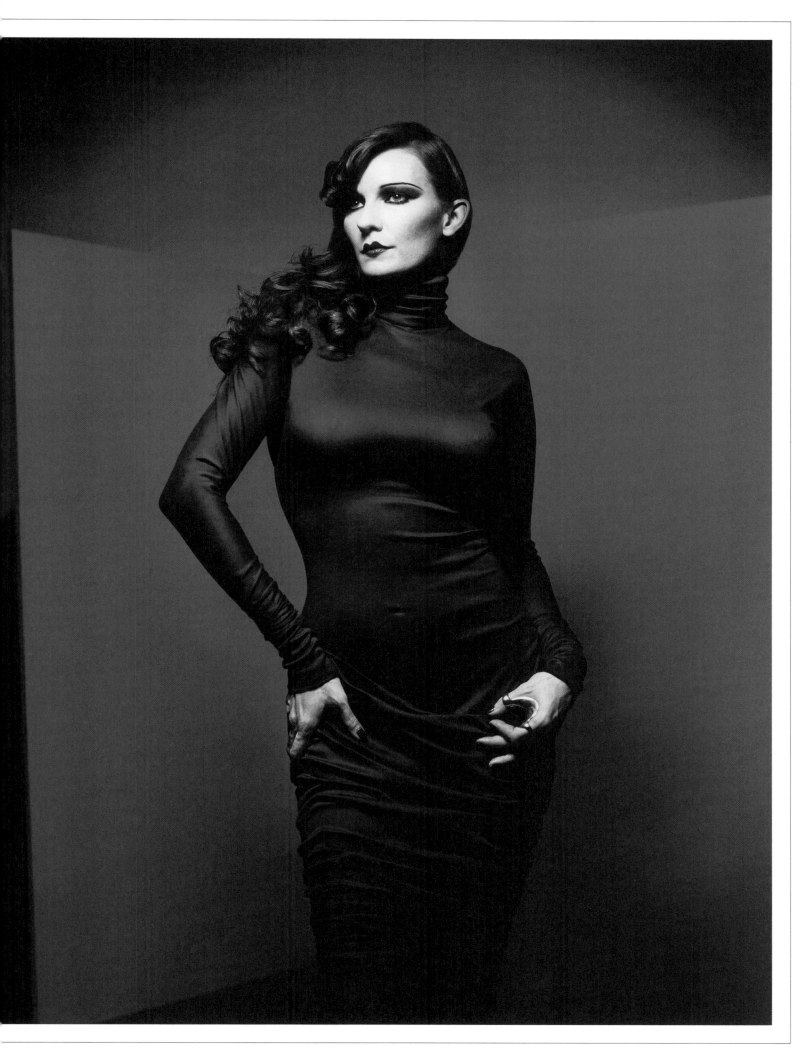

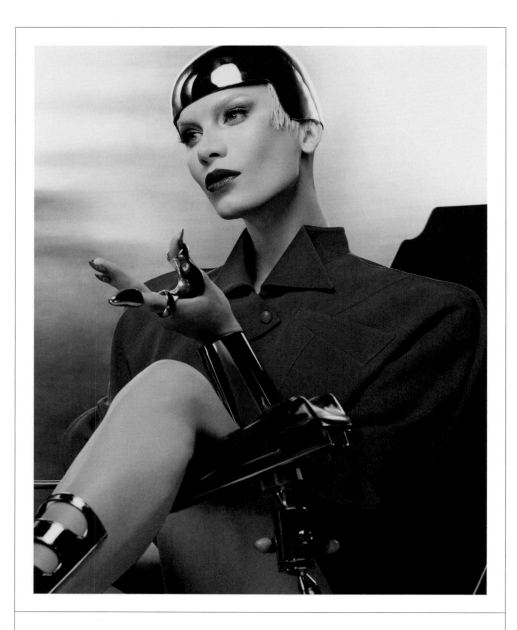

Create erotic stories using jewels and tools to build a specific character.
Set the rules for the scenario then improvise freely to discover the power
of adult play. Each design holds countless secrets just waiting to be revealed.

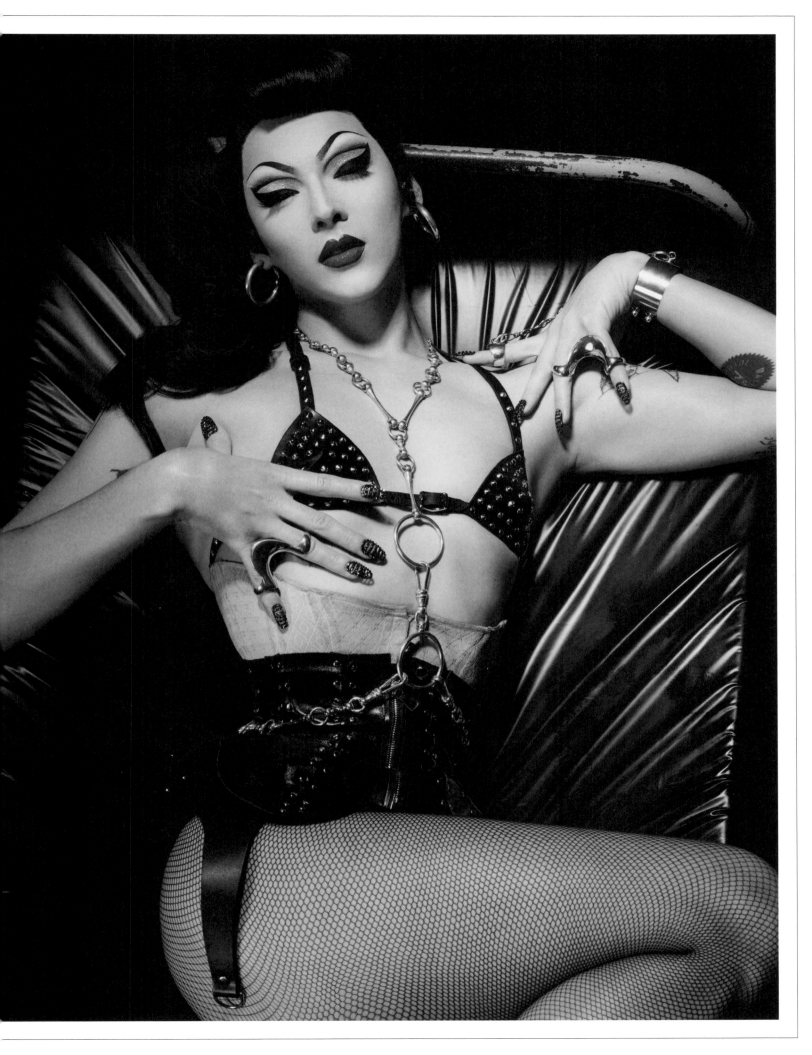

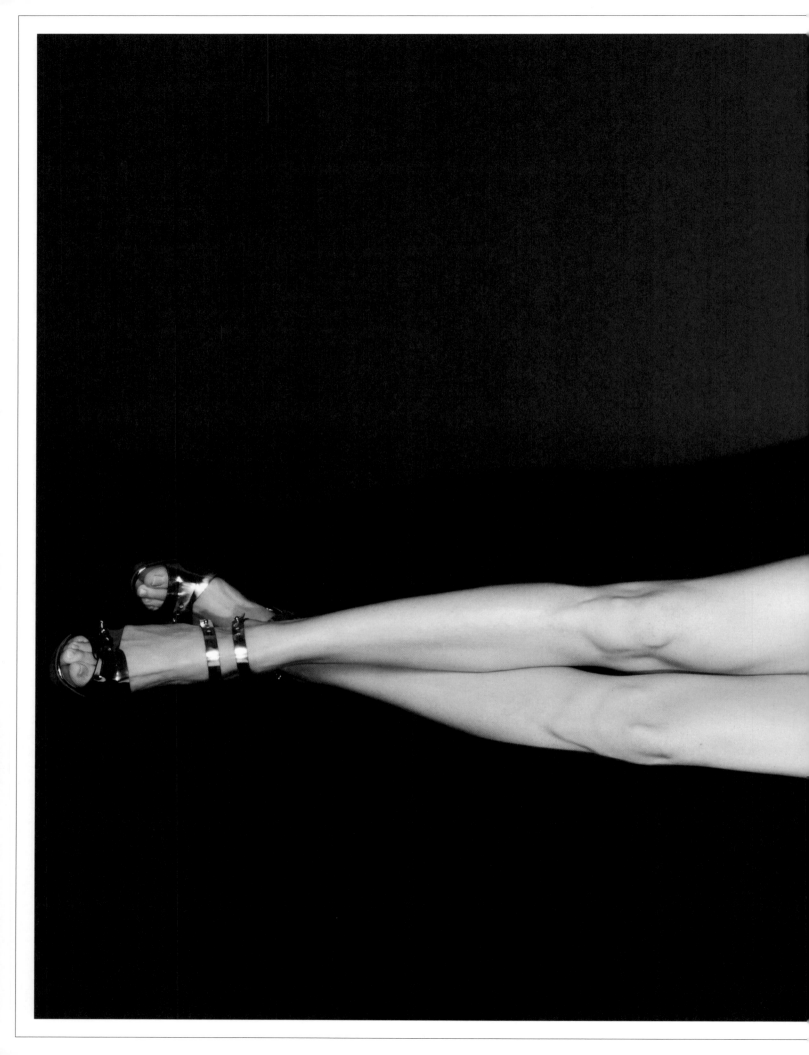

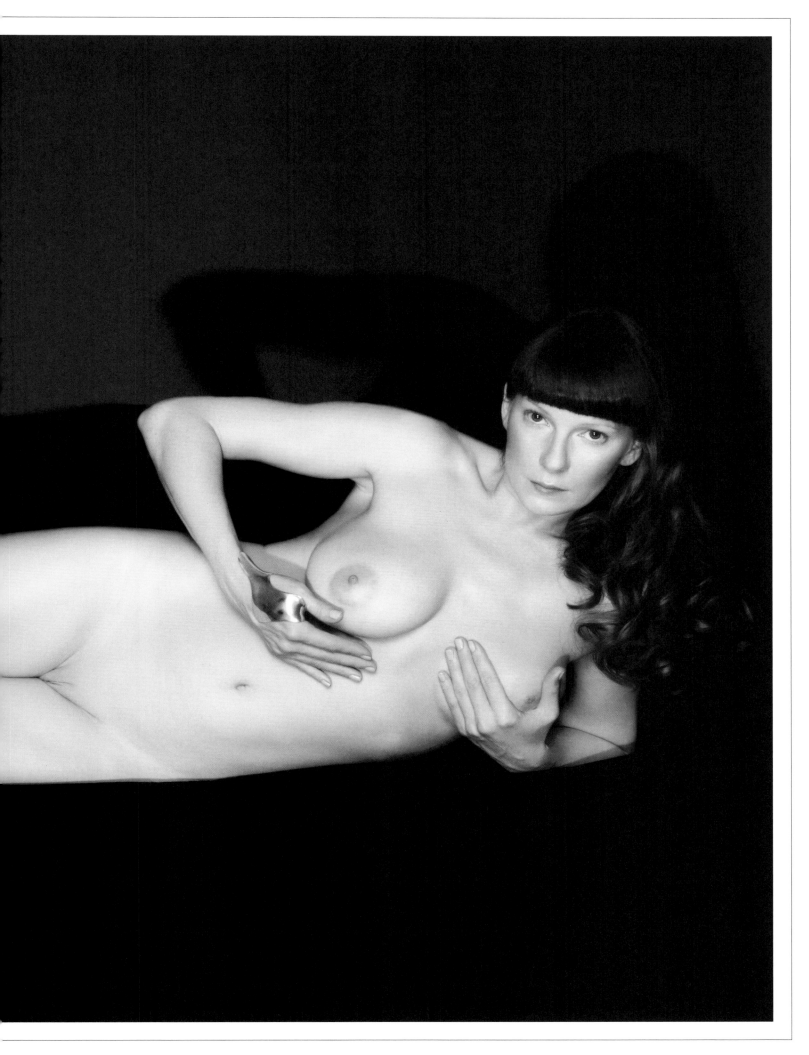

132

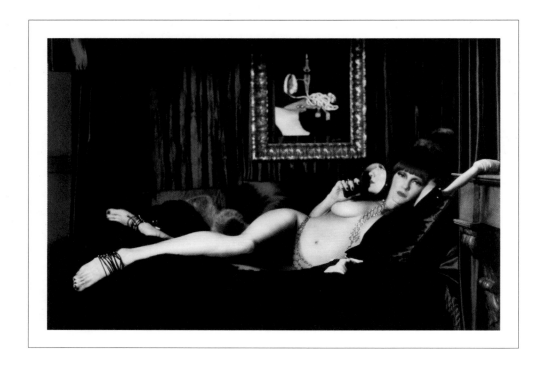

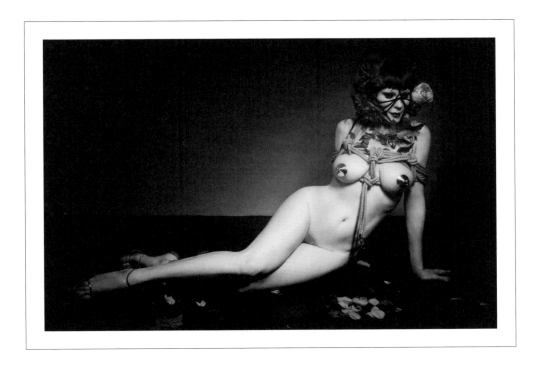

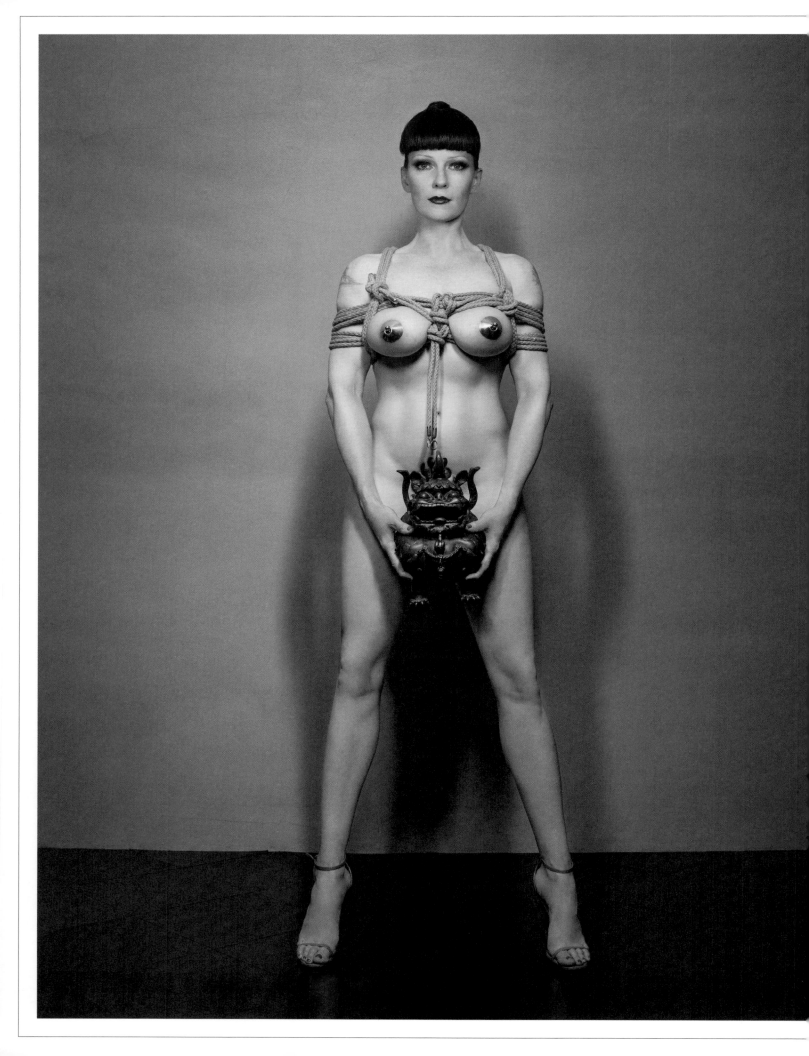

Experience sexy power shifts and explore the juxtaposition of strength and
vulnerability, masculinity and femininity, servant and served during role-play.
It may reveal unknown facets of your and your partner's inner worlds.

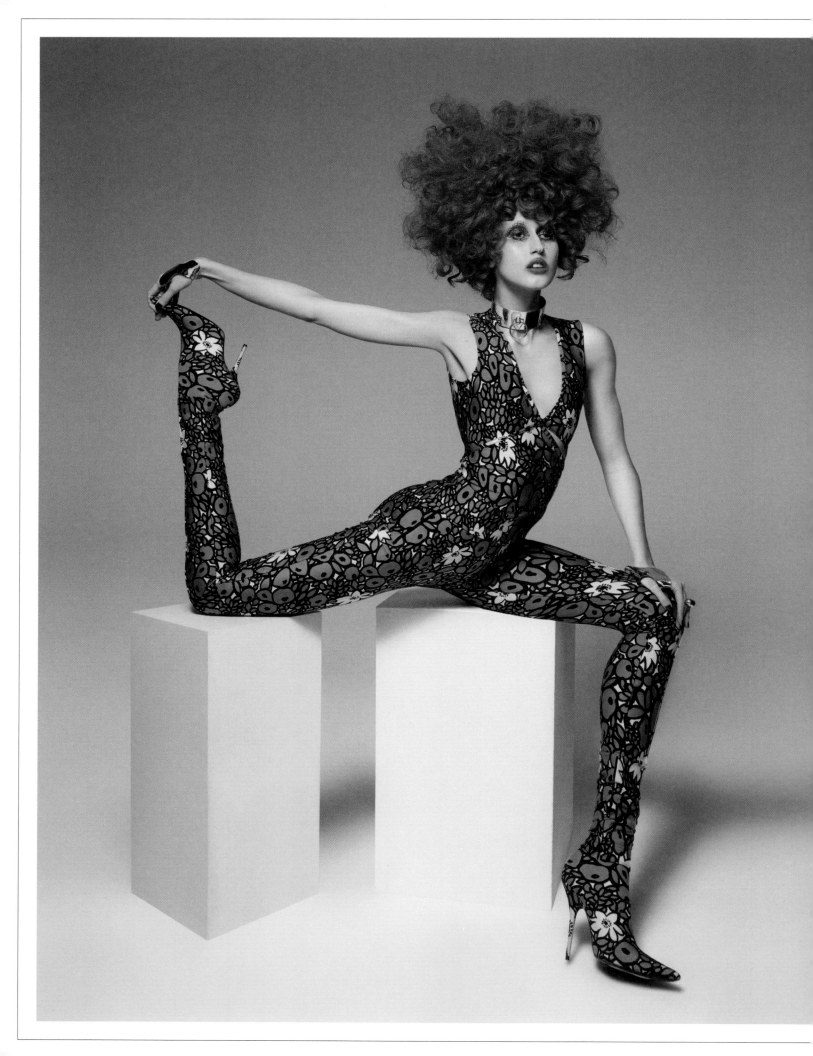

Role-play is one of my favorite pastimes, and throughout my career, I have been invited to embody many different characters for the camera as well. My jewelry is an important part of my ritualized transformations. For one photo shoot, I was asked to become a "medical doll," a diagnostic tool of ancient Chinese origins once used to help women communicate their ailments to male doctors (pp. 130–31). In Gilles Berquet's interpretation of "Portrait of the Dancer Anita Berber" by the German painter Otto Dix, the Petting Ring was a catalyst for my embodiment of the infamous dancer, author, and actress (p. 127). I have been made Snow White for a night, transformed into the mythological two-headed god Janus, and portrayed as a powerful Dominatrix as well as a captive Glamazon. Even though I thoroughly enjoy collaborating with artists to capture the act of transformation, nothing is more exciting than seeing how the jewels inspire others to embody different roles. Each time a model wears my jewelry to elaborate a role, the meaning of the collection is further enriched. Drag queens Miss Fame and Violet Chachki (pp. 128, 129) combined many jewels to develop distinct characters from their own extraordinary imaginations. Fashion at its best is also a form of drag; stylists and photographers often use my designs purely as accessories, without revealing their sensual potential. But no matter the occasion, the use of masks instigates an immediate transition from reality to role. The chiseled Wing Mask (p. 124) metamorphoses the disguised wearer into a mysterious bird or deviant angel. The desire to fly both physically and spiritually has always fascinated me. Mythological winged creatures like Nike, Chronos, and Mercury used their wings to abandon the earthly world and fly into the heavens. Wings are the symbol of freedom and it is in this spirit that I also designed the Non Sufficit Una Winged Tiara (pp. 140, 141). Just as a single wing is not enough to fly, we are more likely to experience greater heights of pleasure when we pair up with a skilled lover. Wearing the Whip Collier (p. 180) as a necklace—or as a tool at the hip—announces the dominant posture one will assume. In the context of role-play that involves ritualized flagellation—the bottom should be put into a position that reflects the motivation for the spank, whip, or flog. If the bottom is wearing a Second Skin Offering, they will be in the perfect disposition to serve their deserving top. To play with gender expression, accessorize with the masculine Tuxedo Bondage cuffs (p. 30) or the glamorously feminine Feather Ticklers, mandatory accessories for a private striptease along with the Sado-Chic pasties (pp. 133, 134). The appeal of these tantalizing tips is undoubted when worn under a silk blouse or fitted sweater, particularly when vintage burlesque fantasies are waiting in the wings. People who are not familiar with the world of cabaret may wonder how they stay in place. It is not magic; they are fixed with body glue or adhesive patches. The divinely fluid Soulless Shoes (pp. 62, 132), whose high heels bind the feet, delight the most discerning, devoted shoe and foot fetishists. Bring Ingres's Odalisque to life, and she will expect to be served! Or just bejewel your naked self like Baudelaire's beauty. When it's time to "come down," the removal of the jewels will signal the end of the ceremony.

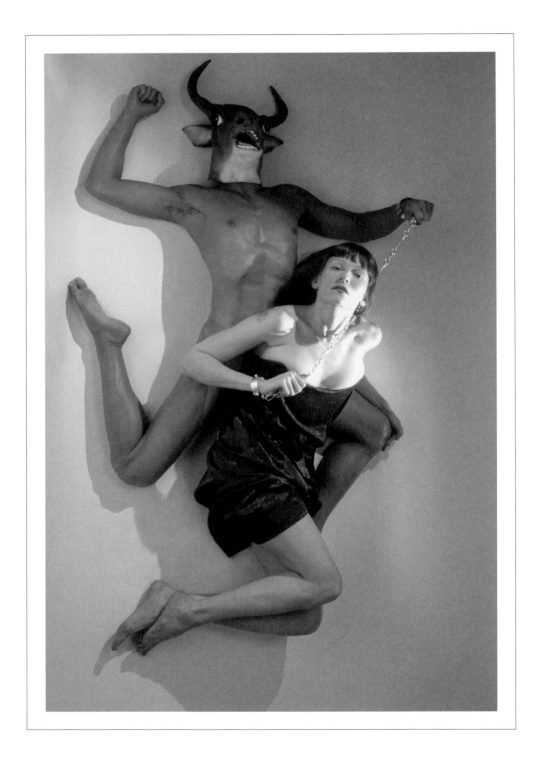

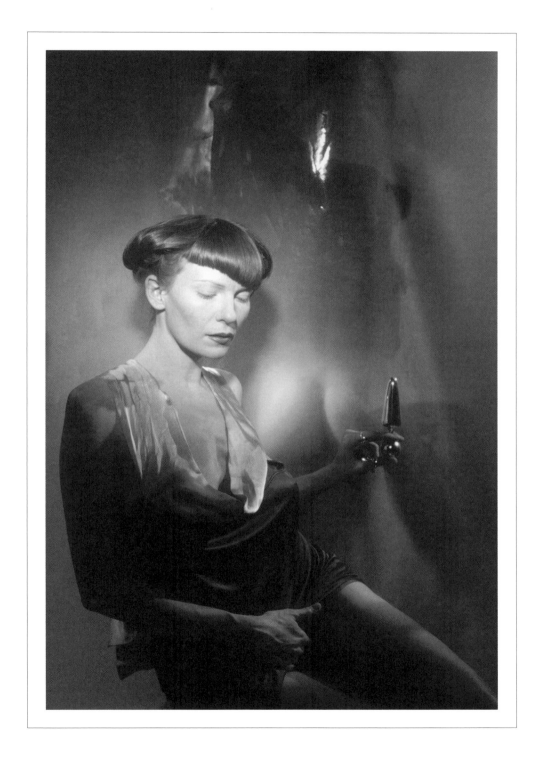

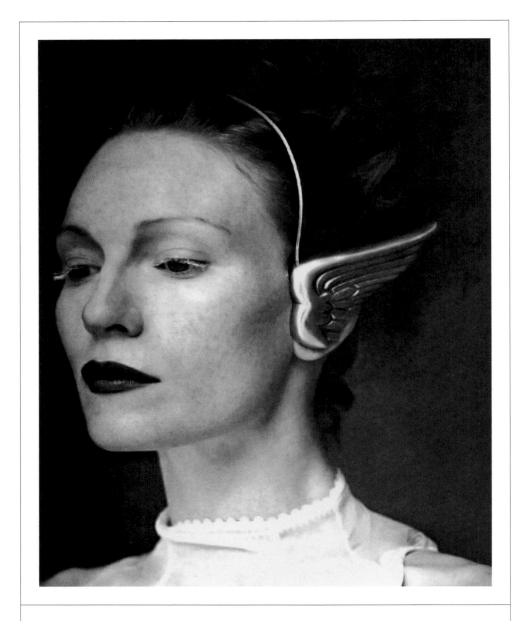

Follow your erotic whim and become angel or demon, Cupid or Hermes.
With the winged tiara, whether you are the target of love or the messenger
of secret pleasures, a mythical erotic encounter will ensue.

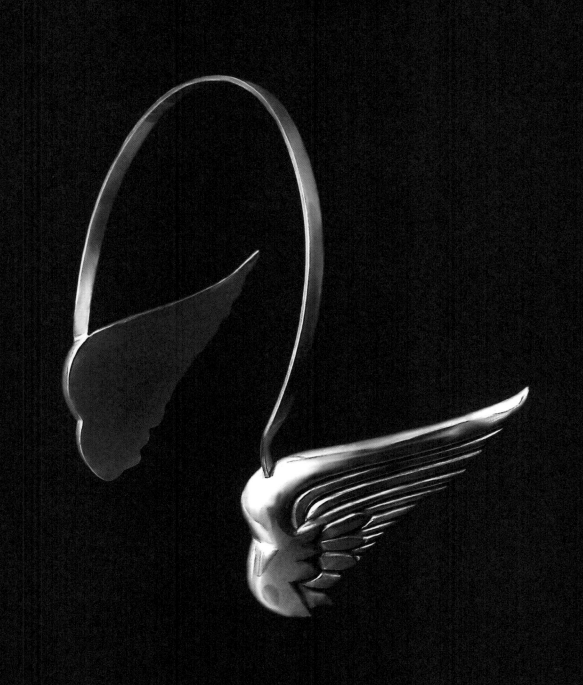

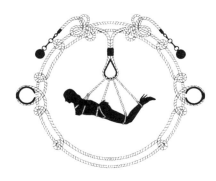

VI.
INTIMATE
BONDS

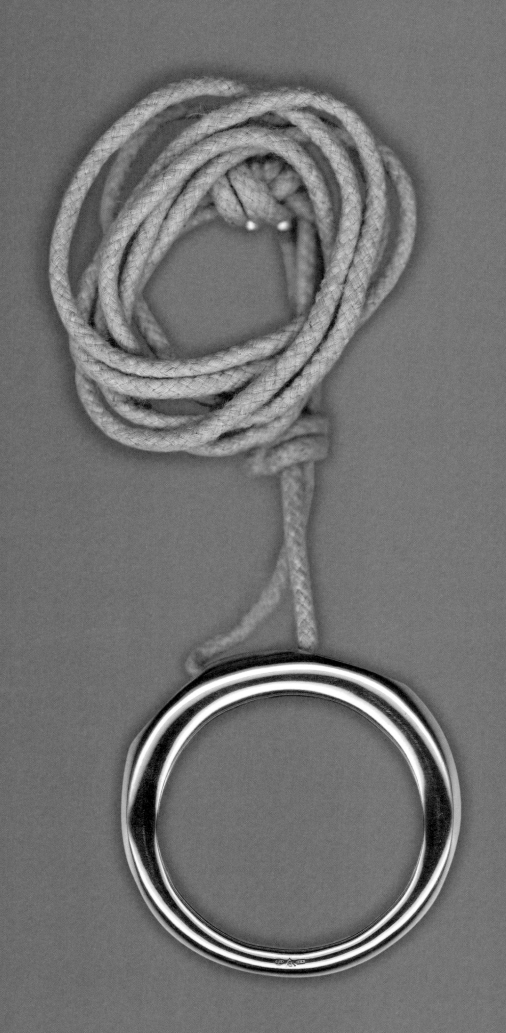

I am usually the "Mastress" of the cords, but in 2006, Katerina Jebb photographed me bound and suspended from the ceiling of Purple magazine's Paris headquarters (pp. 146, 147). These glamorous photos crushed strict bondage categorizations, creating quite a stir in the highly influential fashion industry. The reason wasn't just because of the negative preconceptions that surround BDSM (Bondage/Discipline/Sado/Masochism) practices, but also because the portraits evoke strength and power, pleasure and freedom—and not vulnerability and pain. A few days after the article hit newsstands, I began to receive invitations to bind for fashion and lifestyle magazines around the world. I had finally reached a milestone, as one of my ongoing goals has always been to publicly break down misconceptions about full-body stimulation. Indeed, shortly thereafter, I noticed that bondage was being used by corporate entities to advertise totally unrelated products from cars to cocktail mixers and from pasta to bathroom tiles! And as more people began to reevaluate the aesthetics of sexual play, I felt increasingly responsible for initiating collectors to my work and to the tools and techniques of full-body stimulation. Bondage is a demanding art. It requires instruction, practice, and skill to be enjoyed safely. In The Boudoir Bible, I dedicate a chapter to a few of the techniques, but it takes years to become a Master or Mastress of the ropes. Once the skills are acquired, the dance of the cords is a sensual "pas de deux" between the bound person and the trusted one who takes control of their pleasure. It is at once exhilarating and calming, and the sensual dichotomy charges body and mind with desire. Bondage incites the flow of sexual energy, elates, and even heals, while the sensation of cords gliding over bare skin is unparalleled. Cords caress, tickle, and whip—a delightful preliminary to constraint and restraint. The ends of my ropes are capped; the added weight of the silver tips facilitates their manipulation and avoids unwanted tangling. Silver spheres, tassels, and o-rings embellish the bondage work while preventing the ends of the cords from unwanted unraveling—and they also transform the cords into bejeweled belts that can be worn beyond the ceremonial context. Equipped with gliders to swiftly bind wrists, ankles, or the waist without needing to tie a single knot, the silver, bronze, and gold cords of my Noble Knots collection provide incomparable sensations (pp. 158, 159, 160). These delightfully constrictive jewels are made with kinbaku-style twists. Kinbaku, which means to "tie tightly," is a Japanese technique that uses as few knots as possible. The aesthetic of cord work is also an important part of the excitement, so I developed precious metallic ropes woven with microfibers of silver and gold using a 1940s-era machine that originally served to knit nylon stockings. While some of the Noble Knots designs can be laced around the body just like a common rope in hemp or other material, others have predetermined shapes. I used these ropes to make ornamental knots that are fixed with stitching to elaborate belts, necklaces, and bracelets (pp. 164-65). Other very simple jewels allow the intricately woven material to take the spotlight, such as the Noble Rope necklace, ring, and earrings (pp. 164, 165). O-rings adorn this collection to connect, attach, and transform.

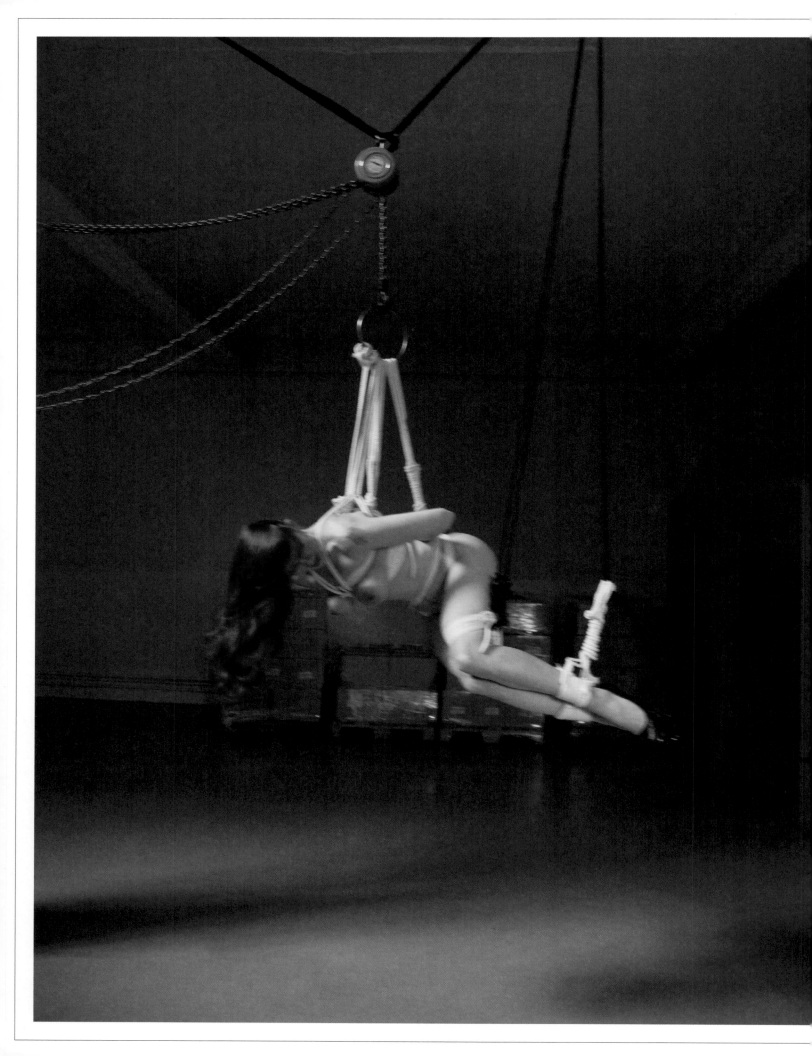

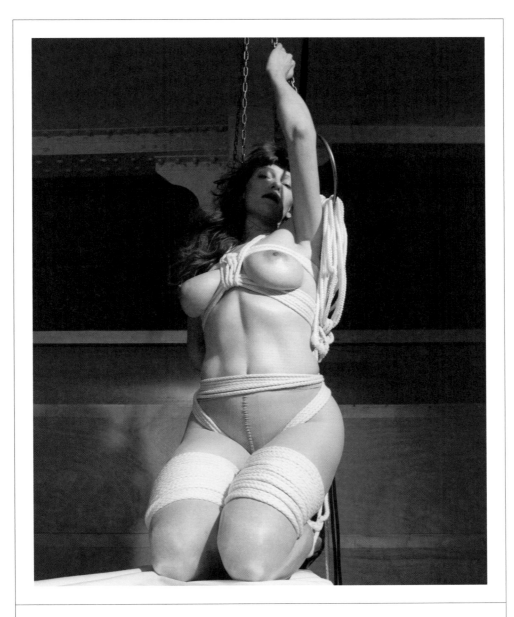

Erotic suspension instills a sense of freedom. With your hands tied and body
fully supported by the ropes, your instinct will be to rock, writhe, and challenge
the cords. Safety knots are the lifeline of thrilling bondage sessions.

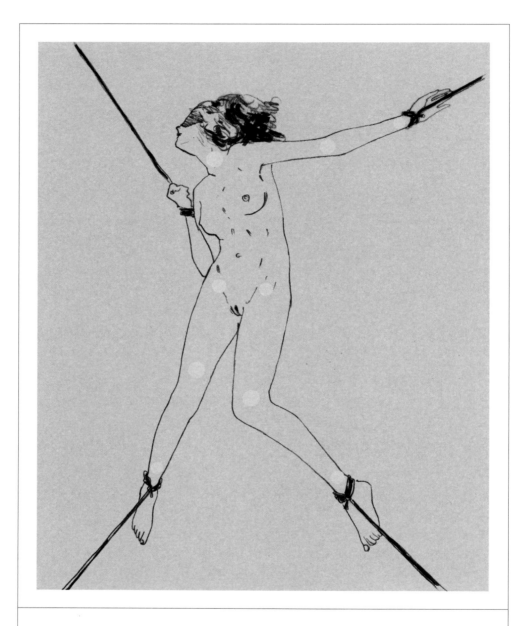

A good bondage artist is cautious of no-zones and prepares
every session meticulously. Novices can ensure the pleasure and safety
of their partner by practicing first on inanimate objects.

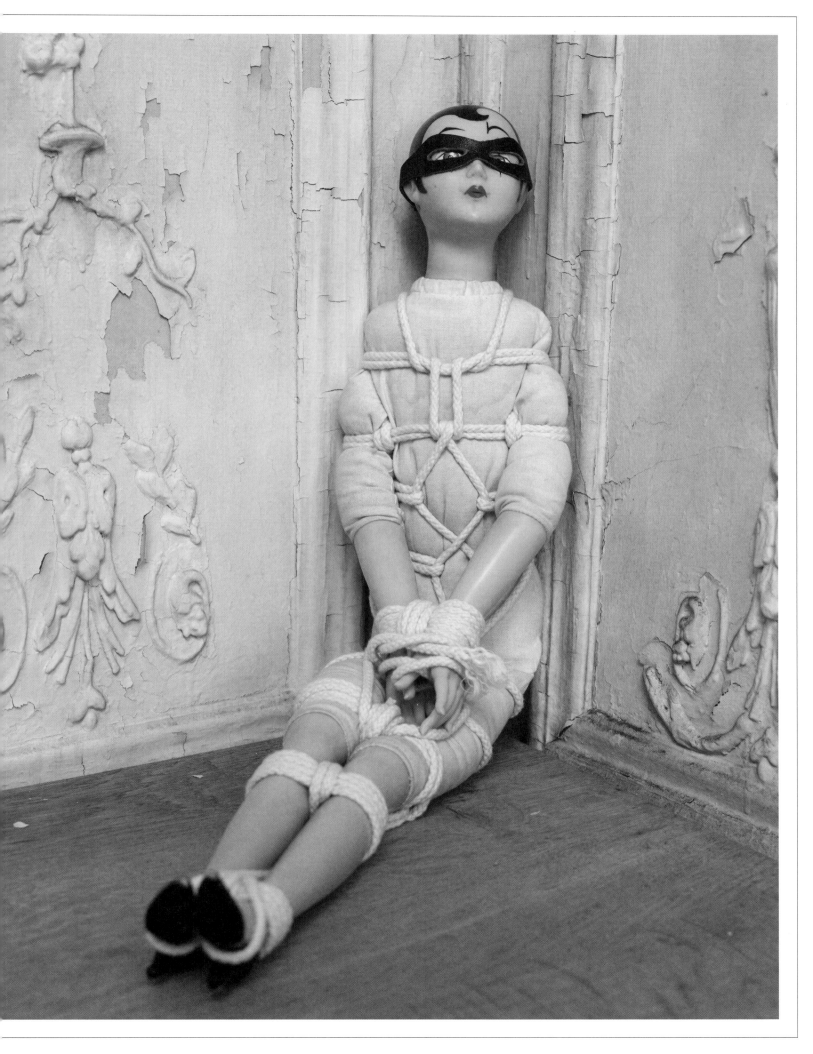

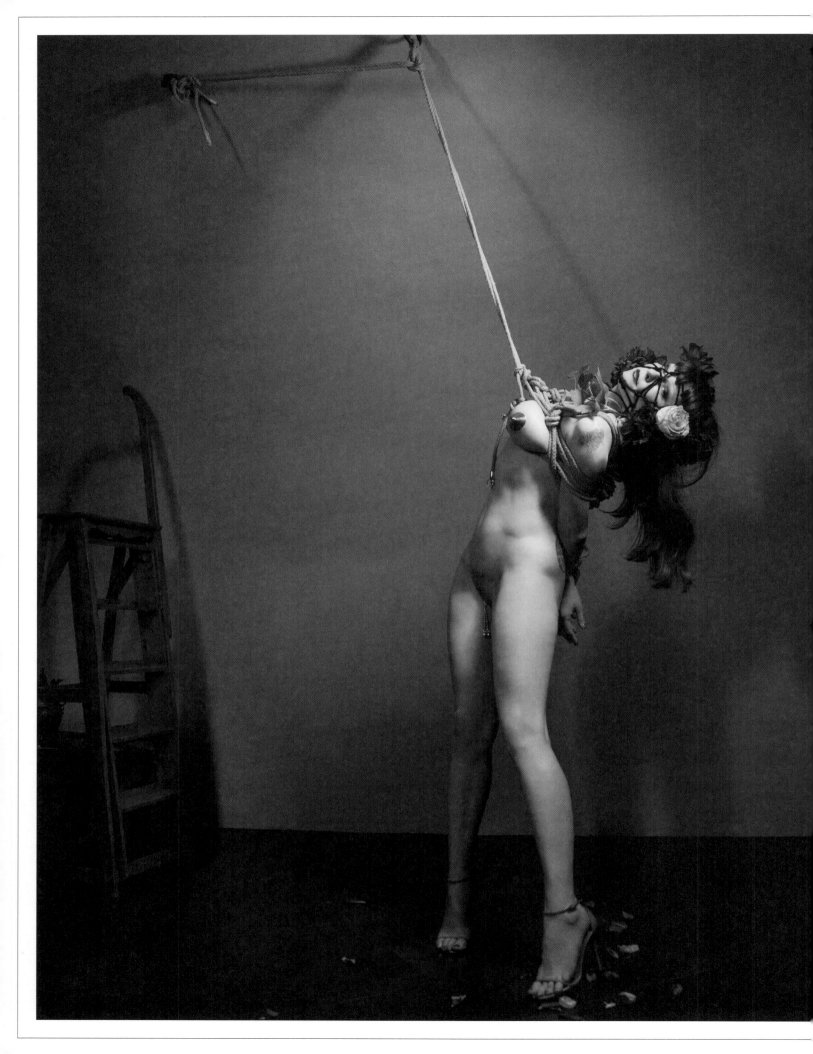

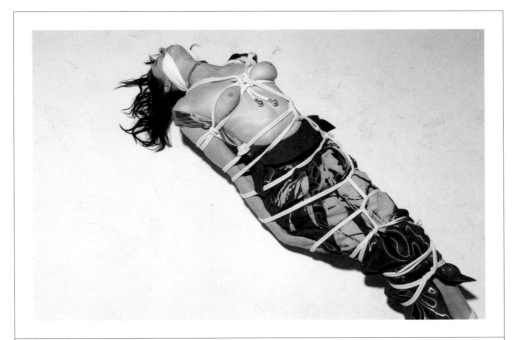

The bottom is not passive but instead highly in tune with their top,
who is at the service of the bottom's pleasure. The feeling of being constrained
may lead to a liberating sense of release. The contrast between the texture
of the cords and sleek intimate jewels creates an arousing "tableau vivant"!

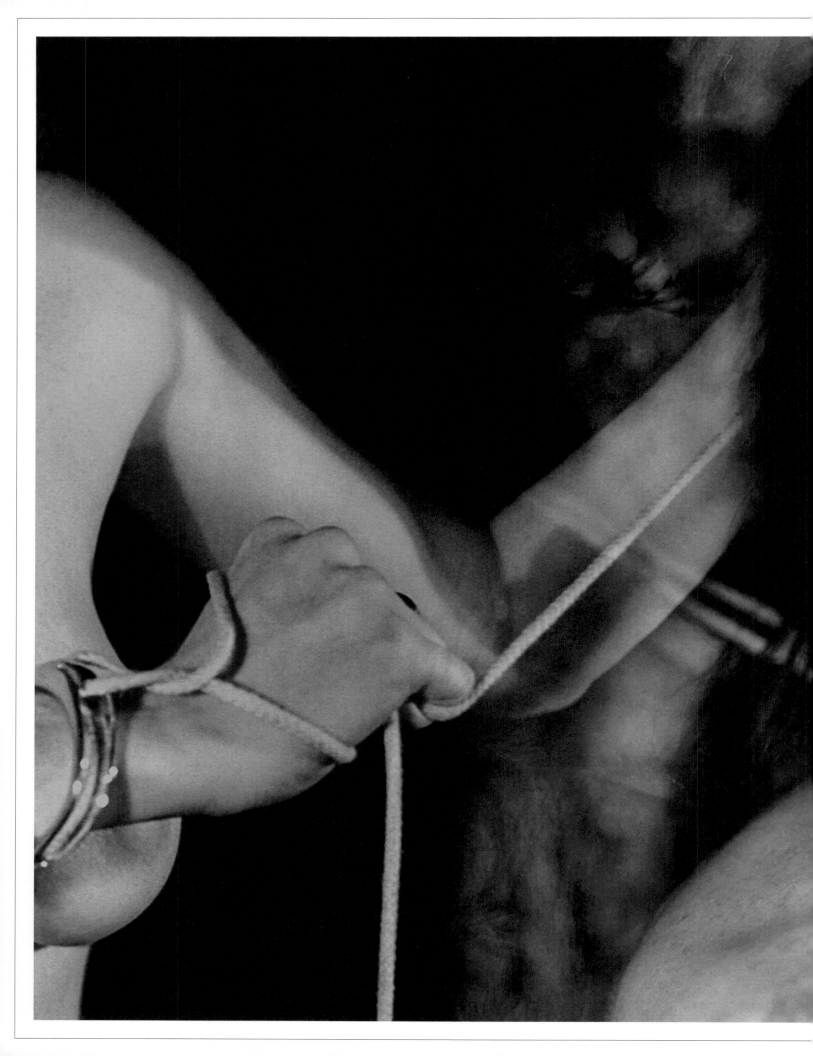

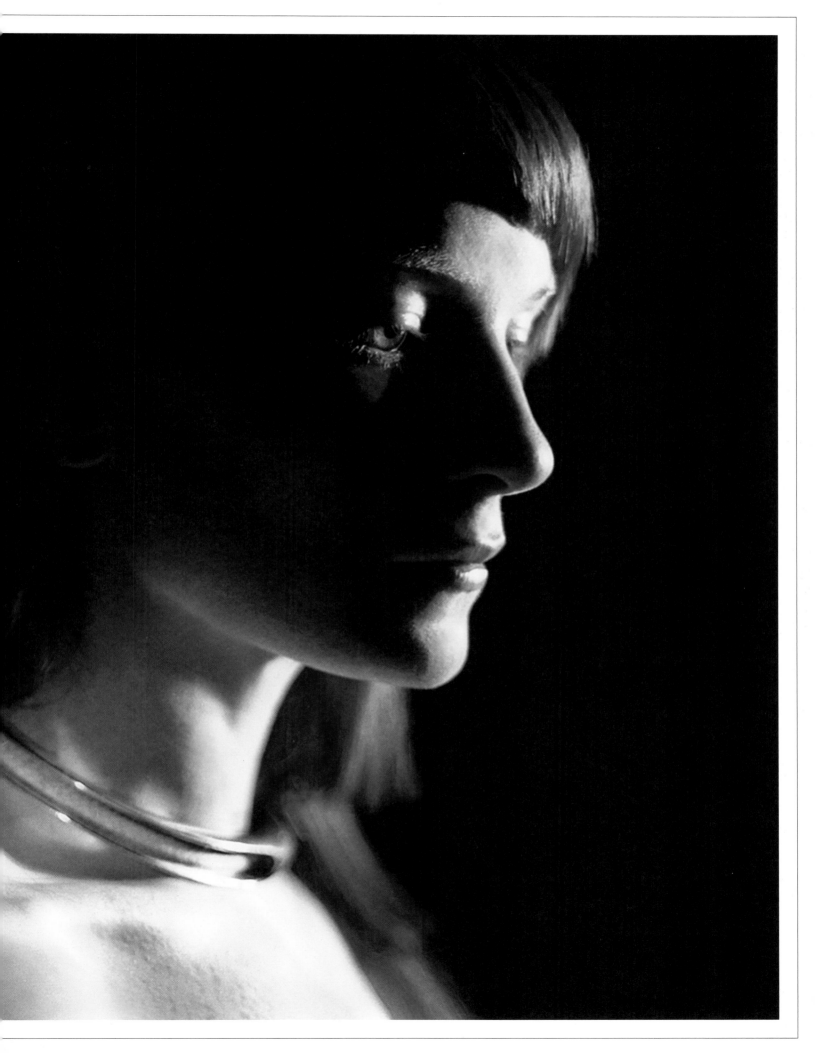

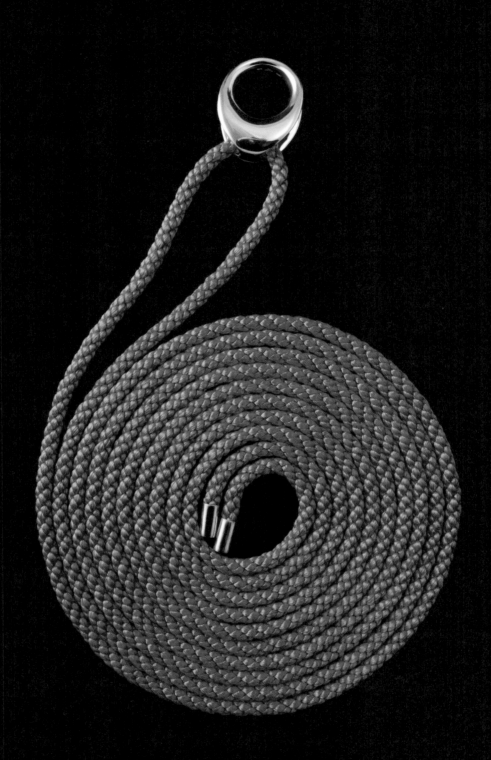

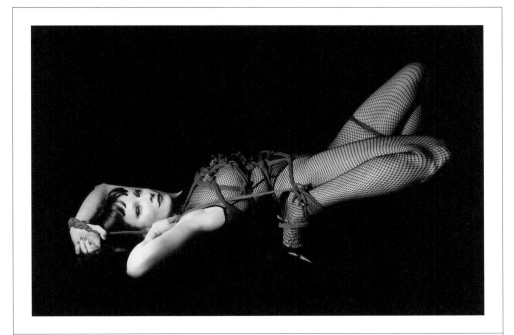

Each bind, knot, and twist of the cords on the skin creates a connection,
whether you are wielding your knowledge of bondage or submitting
to the restrictive embrace of another's skillful whims. Treasure the fleeting
souvenirs of ecstasy that the ropes leave behind.

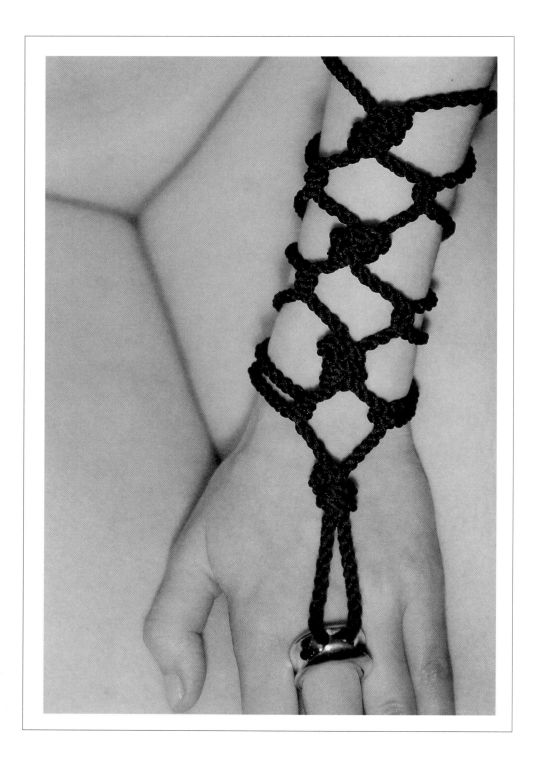

Another Japanese style of bondage that inspires Westerners is shibari, which means "to tie." Practitioners of this ancient art seek aesthetic appeasement and mobility in stillness. Bound bottoms may appear passive in images of shibari—but in reality, rope bondage is a very physically and mentally demanding activity for both partners, especially when suspension is involved. Adventurous lovers who enjoy testing and pushing their sensual limits consider erotic bondage to be the most liberating, creative, and empowering technique of full-body stimulation... and I concur! Skillful restraints permit the bottom to remain bound for extended periods of time and the top to focus on elevating sensations and sexual tension to transcendental heights. Knots and twists in the rope create beautiful patterns that exalt the body's every delicious nook, cranny, and curve. Artful cord bondage leads both partners to experience new pinnacles of arousal and satisfaction, a dimension that may be sexual or intimate—or both. It's all about trust... and consenting to transcend the limits of earthly delight together. The moment the invitation to be bound is accepted marks the beginning of the ceremony. Desire builds with each subsequent agreement, from setting the location and the limits of the session to establishing safe words and the choice of implements that will be used—blindfolds, cords, ticklers, whips, and more... Once the bottom is bound, it is time for the top to take the reins of their pleasure with a selection of tools that are in tune with their needs and desires. The role of a masterful top is to attend to the bottom's every need and desire, keeping in mind that binds and constraints augment sensorial perception. So good communication is essential to bondage safety as a bottom may become too high on endorphins to recognize their body's signals of distress. Endorphins are part of what I call the body's natural "feel-good pharmacy," and their ecstatic effects demand that frequent "checking-ins" become part of the journey. The Tie-Me-Up series is safety-focused silver jewels that can be worn on their own or combined with cords in satin, linen, hemp, or even silver (pp. 154, 156, 159, 160). The jewels act as anchoring points on the body from which intricate constraints can be elaborated. Threading the pieces together allows the wearer to take part in the design as well—the cords make for infinite variations on the "tie-me-up" theme. Because safety is fundamental to playing with ropes, certain zones of the body should be avoided. These jewels make it possible to safely engage in sensual ropework around the highly sensitive "no-zones." My Tie-Me-Up bracelet encapsulates the rope so that it glides safely around delicate wrists, while the necklace protects the ultimate no-zone, the neck, bringing safety to extreme fantasies (pp. 152–53). Worn as a glove, the Tie-Me-Up ring is at once an elegant accessory and a handy bondage device. The Cock-and-Balls ring (pp. 144, 167) is dedicated to gentlemen who revel in more intimate forms of bondage. This jewel-tool extends the time spent in Paradise, as it helps sustain an erection and intensifies pleasant sensations by temporarily inhibiting ejaculation. The cord of the Cock-and-Balls ring can be used as a kinky leash, as well as to explore the powers of sophisticated cock-and-balls bondage.

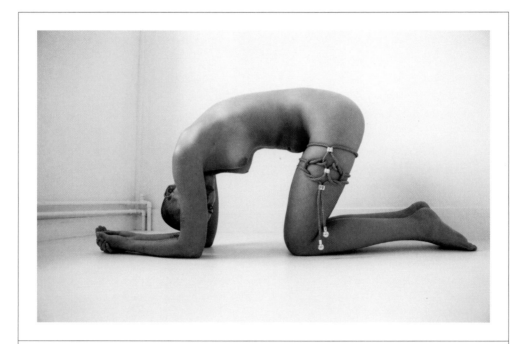

Noble Knots elevate bondage play to a sacred ritual. Supple silver and bronze cords equipped with silver gliders smoothly bind and adorn your lover's body according to your shared desire. Creativity has no limits!

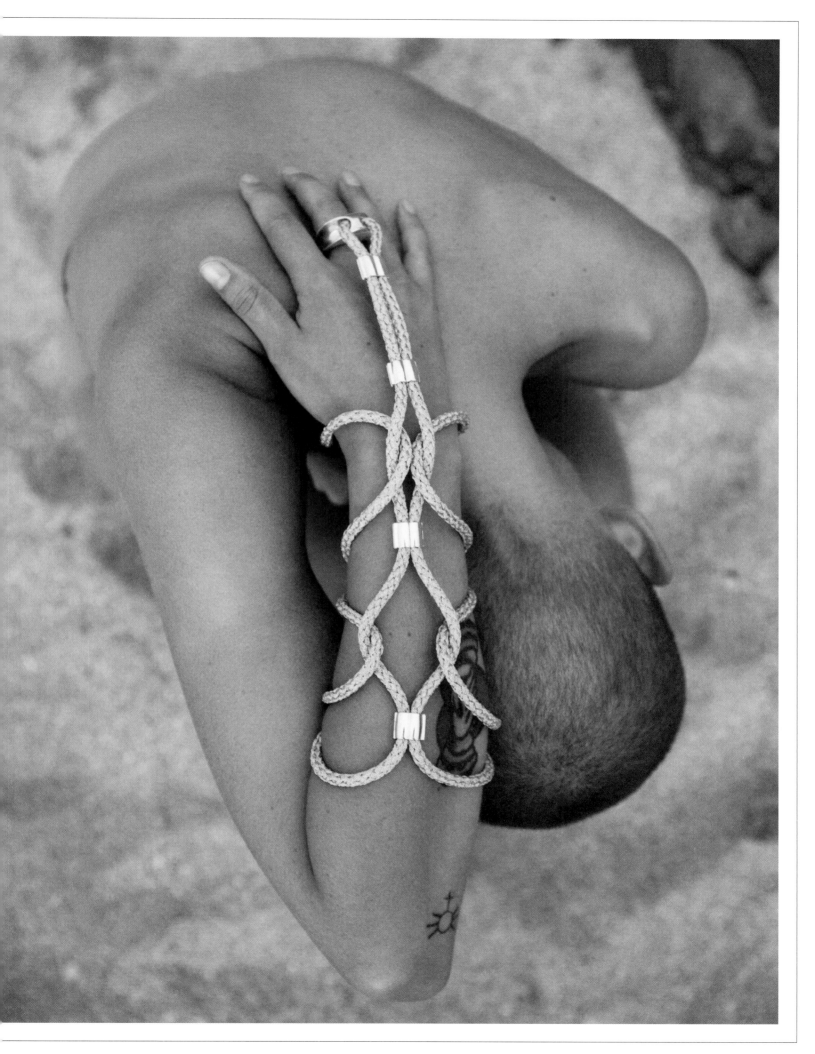

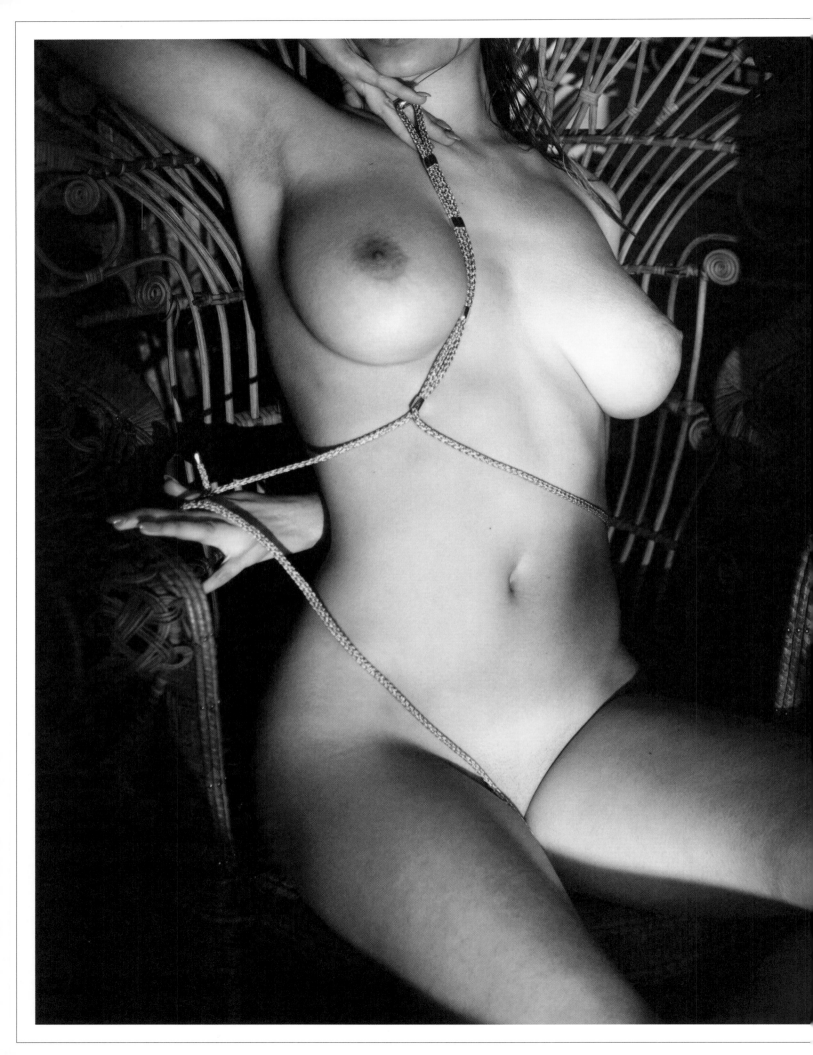

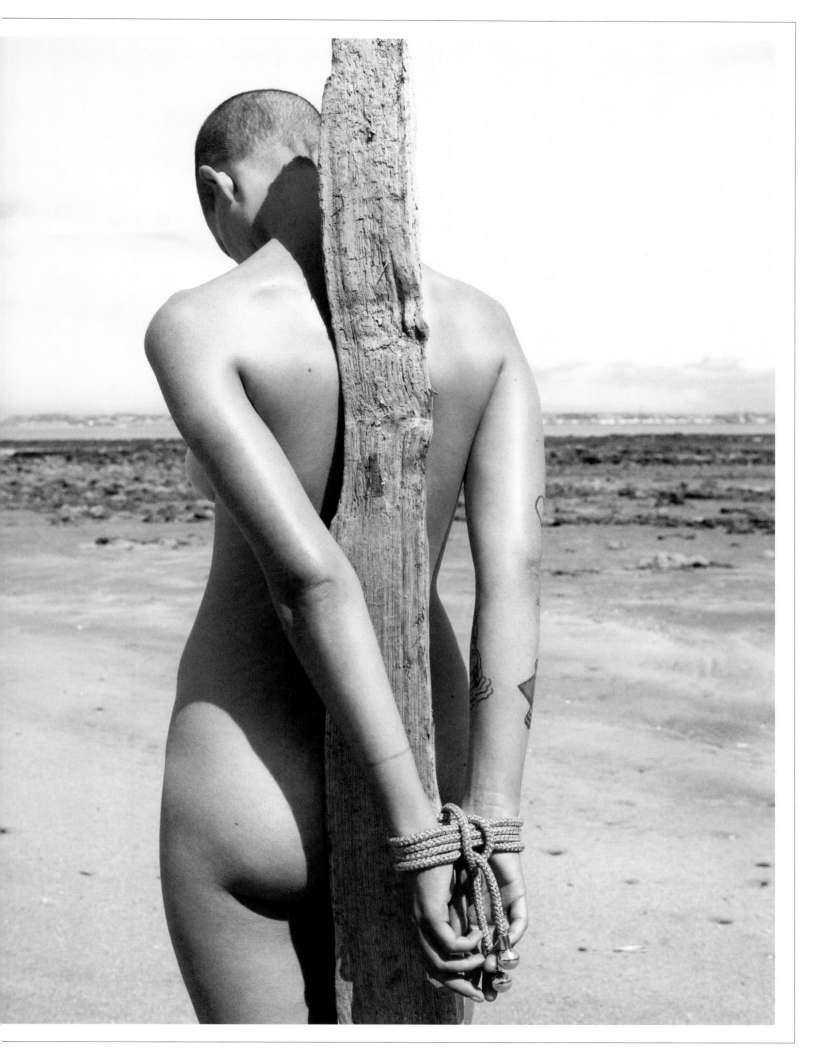

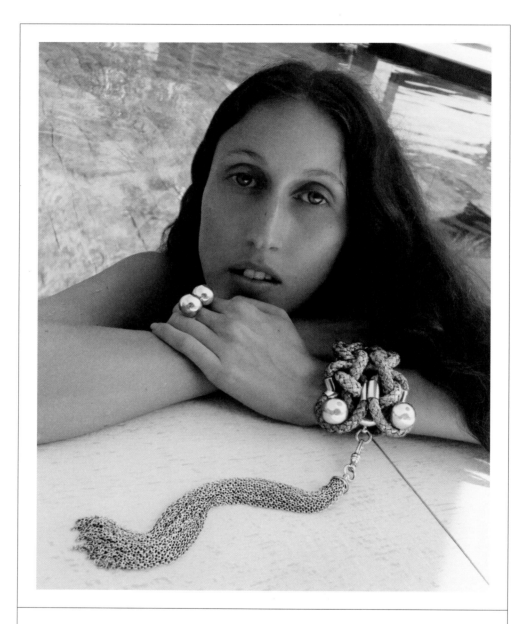

Gold and silver cords are woven together to create what I call
the "Impossible Knot," a complex form made possible
by silver mechanisms that fasten the ropes into place. Slip the
spheres through the knot to secure the bracelet on the wrist.

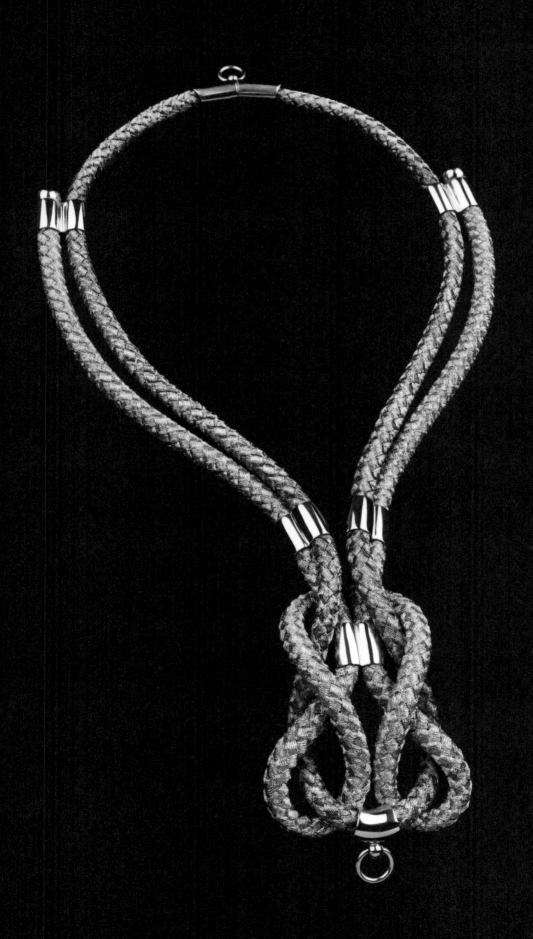

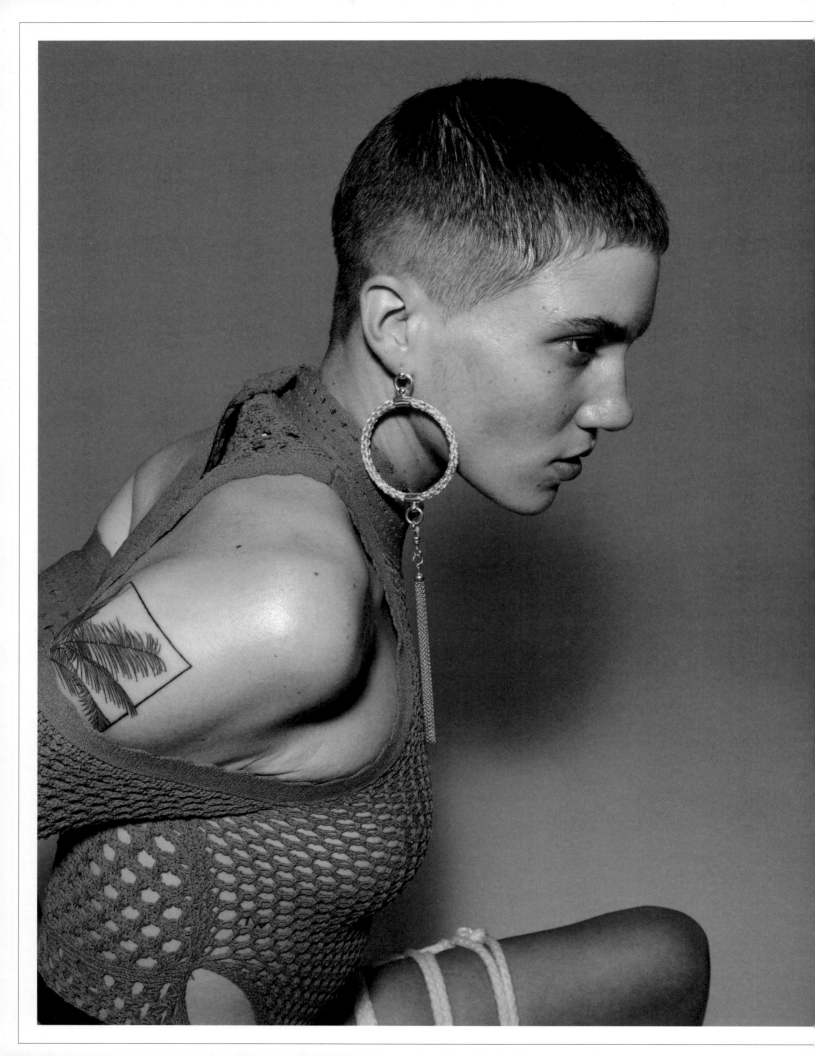

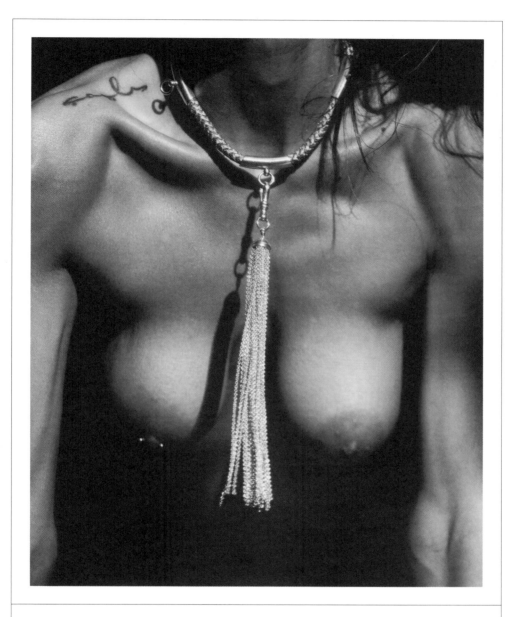

The Noble Knot series is crowned with the Sado-Chic ball-and-ring mechanism
that symbolizes the ultimate bond. It is also the key to the transformative
power of these designs. Connect your lover's collar to your own with a chain
or attach a teasing tassel or feather pendant.

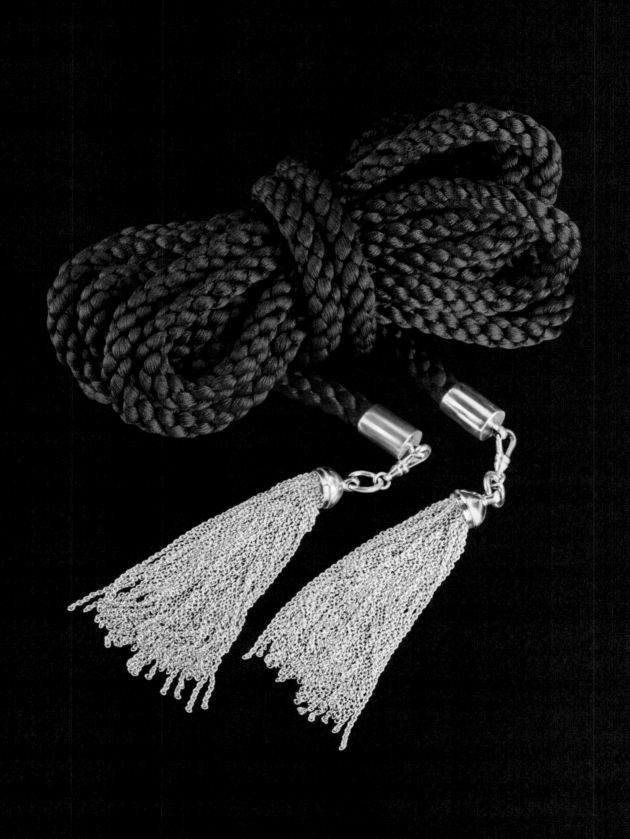

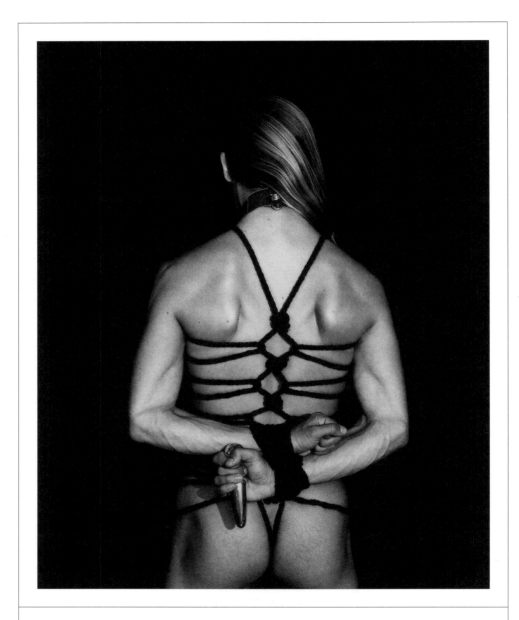

The "turtle-shell" rope pattern provides a full-body hug. Jewel-tools can be used
to provide exciting sensations once a partner is bound. Erotic bondage
has a unique power to heighten sensorial perception and send a lover to Paradise!

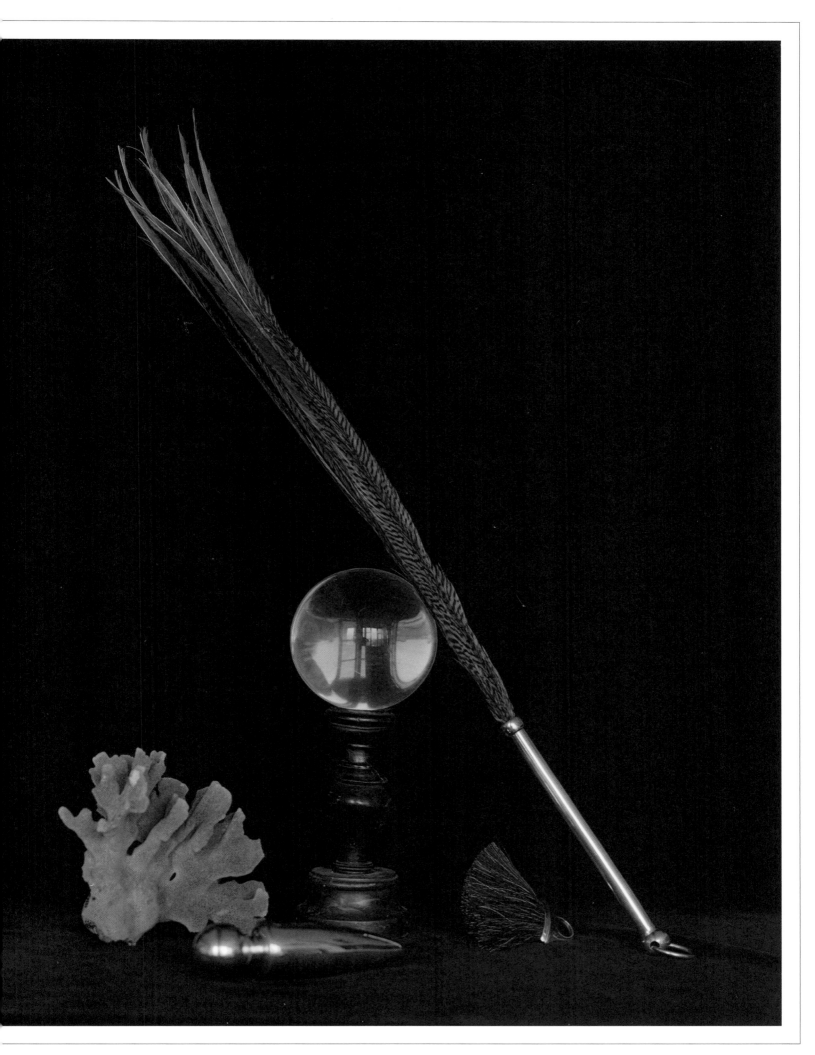

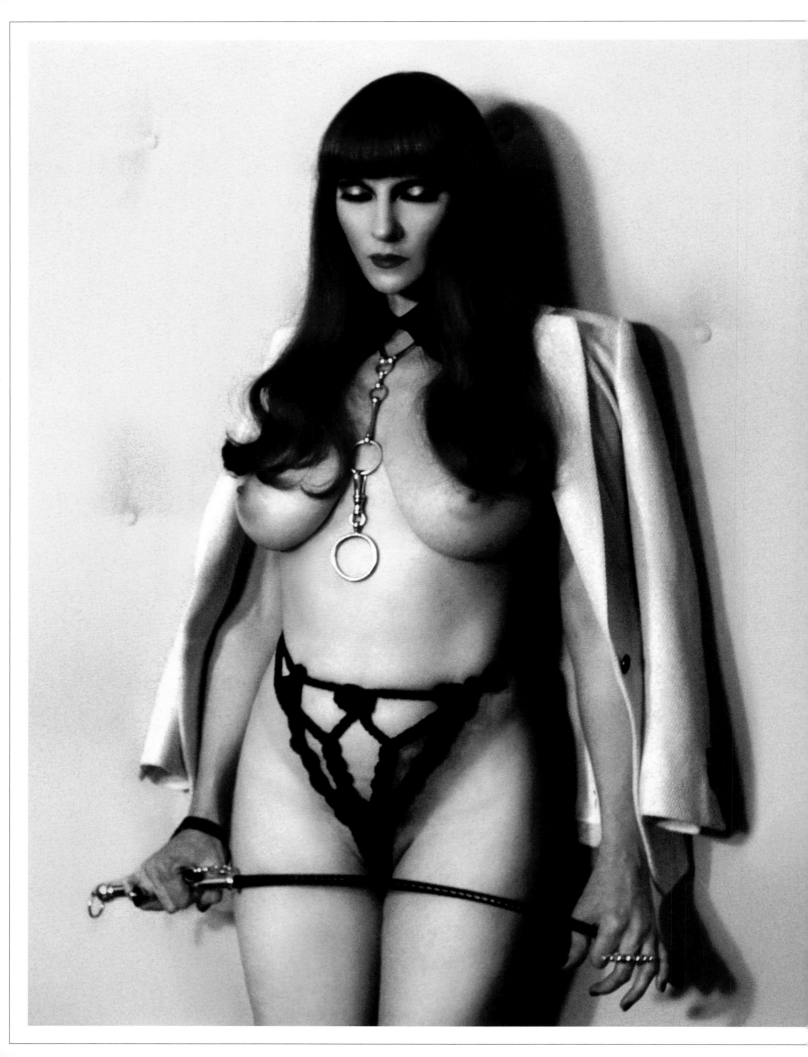

VII.
SCEPTERS
OF DESIRE

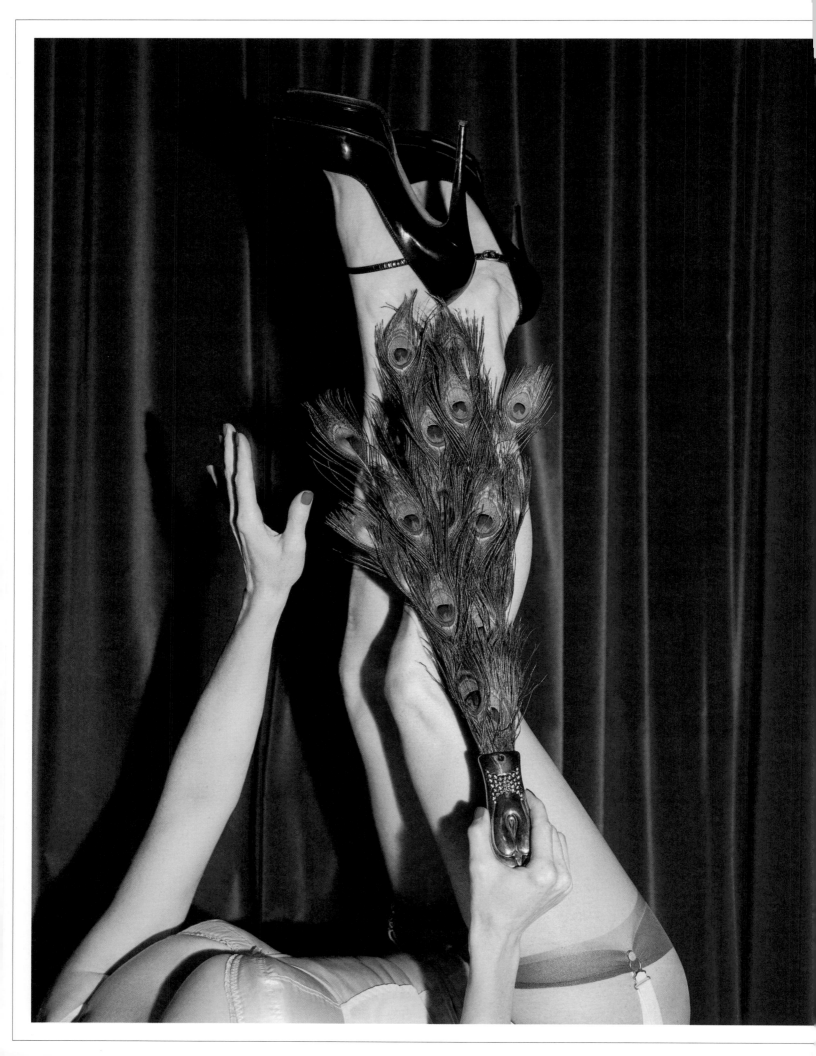

Some of the Paradise Found jewel-tools are to be used specifically within a ceremonial context. My elegant spanking paddles, handwoven whips, and silver dilettos hold inherent great power, which is why I call them "scepters" rather than merely "sex toys." Ceremonies the world over make use of luxurious materials to honor the sacred. I decided to elevate my instruments to reflect the inestimable value of sexual satisfaction in our lives and to celebrate the art of loving without socially imposed limits. After all, why shouldn't an object of erotic value be finely crafted? My scepters of desire are both a feast for the eyes and a portal to heightened sensorial realms. Fine craftsmanship, natural materials and durability infuse realms of pleasure once deemed "dark" with paradisiacal light. At the time I started creating these instruments, people—especially women—were obliged to shop on the "wrong side of town" for anything that had to do with sexual enhancement. I wanted to reinvent the way we venerate and stimulate the body, as well as how we traditionally categorize erotic tools and anyone who enjoys the pleasures they provide. Dedicated to sybarites, my jewel-tools with their slick, polished surfaces and weighty, noble presence are timeless erotic companions. From magnificent rituals to informal rites, ceremonial objects inspire awe, wonder, and possibilities that lie beyond the profane physical world. I believe my scepters do not need to be hidden. They are functional sculptures—objets de curiosité for the novice, provocative temptations for the initiated. Thanks to the sumptuous boundary-defying leather Whip Collier (pp. 177, 180), discreetly wear a flagellation tool in public. Exhibit the Veneration Kit (pp. 172, 174, 175), glinting in its beautiful custom-made box, for all to contemplate. A sexual ceremony can be entirely built around one or more scepters of desire. My designs are extensions of the hands and body, precious prosthetics that bestow the gift of sharing impactful stimulation. The anatomic handle on the Elegant Spanker (pp. 179, 181) is an irresistible invitation for an erotic spanking. The handle of the Sado-Chic crop (p. 183) is engraved all the way up to its spherical pommel, mirroring its hand-woven leather shaft. These handsome grips endow the instruments with perfect balance—for impeccable aim. Warm up sensitive skin then take the heat off by using gentler tools, like ostrich feather fans, ticklers, and pleasure puffs, whose slightest touch will delightfully multiply the pleasures. While the flick of the Horsehair Whip (p. 192) may safely stroke the entire body, the use of other instruments of erotic flagellation should be confined to the muscular areas of the back and fleshy buttocks. Orchestrate sensations in a gradual ascent and watch attentively for the skin's rosy glow that signals heightened sensitivity. A tool's impact is also psychological. Indeed, the primary purpose of the Teacher's Pet (p. 182) is to direct a submissive from a playful distance during erotic discipline scenes. A common misconception about the scepters of desire is that they are only used to inflict pain. The perception of pain is subjective. A sensation that one person may consider pleasurable may cause another discomfort. And the same instrument may be used to incite either intense or subtle, sensuous sensations; it all depends on the bottom's desire and the top's respectful intent.

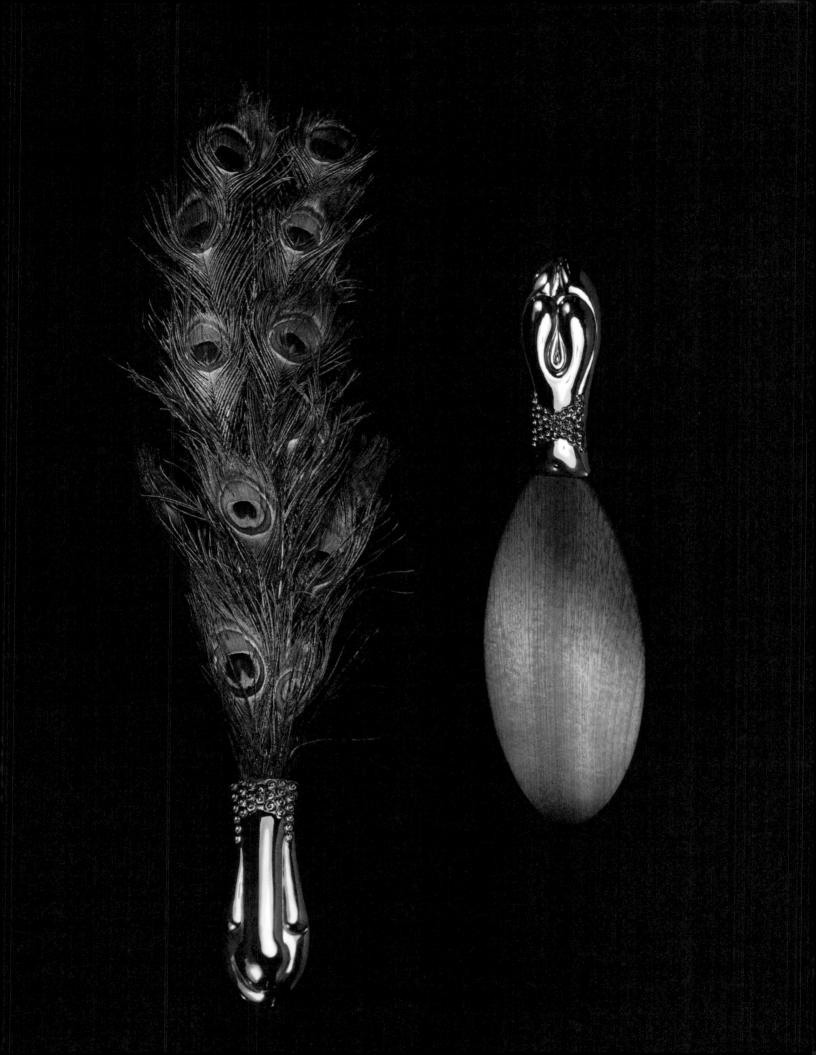

Veneration comes in the form of a peacock feather tickler and cherry wood spanker.
Their repoussé sterling silver handles portray totemic sexual attributes, talismans
that have been used for millennia to charm and protect. Now they permit the skillful
orchestration of tickling, stroking, and spanking rituals.

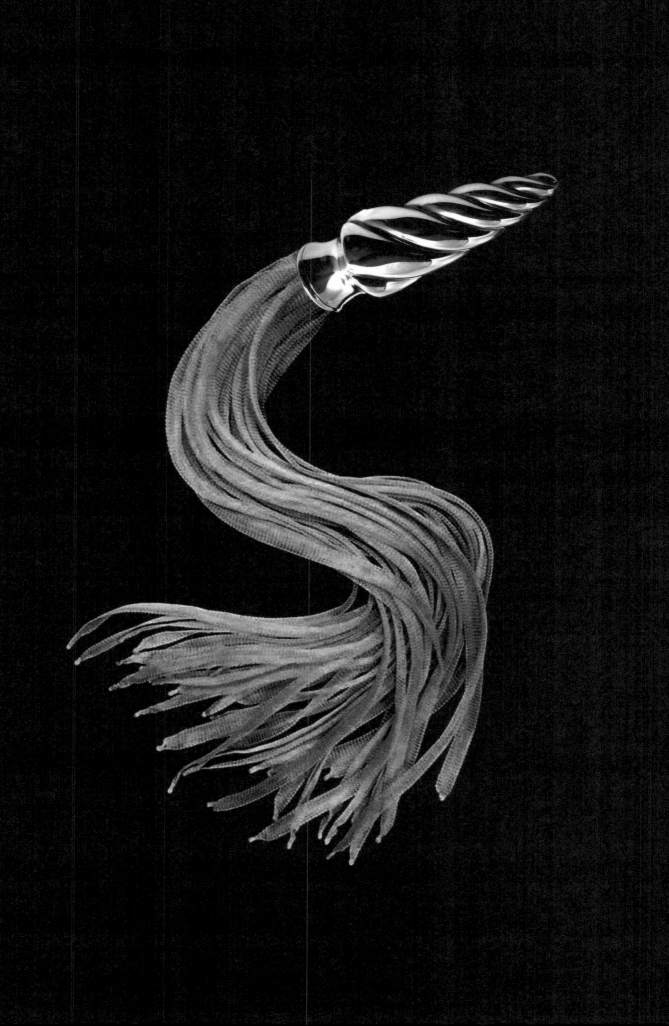

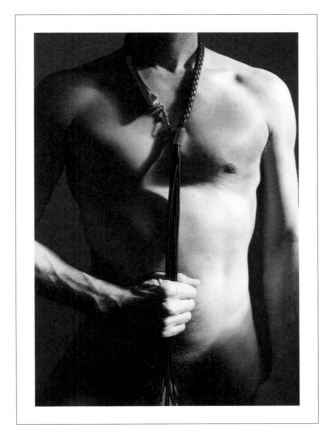

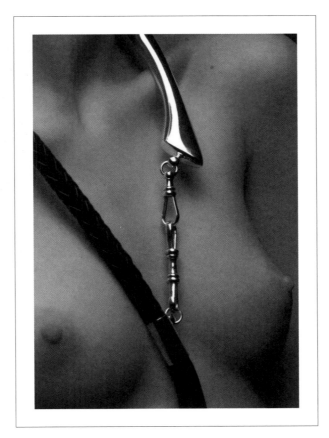

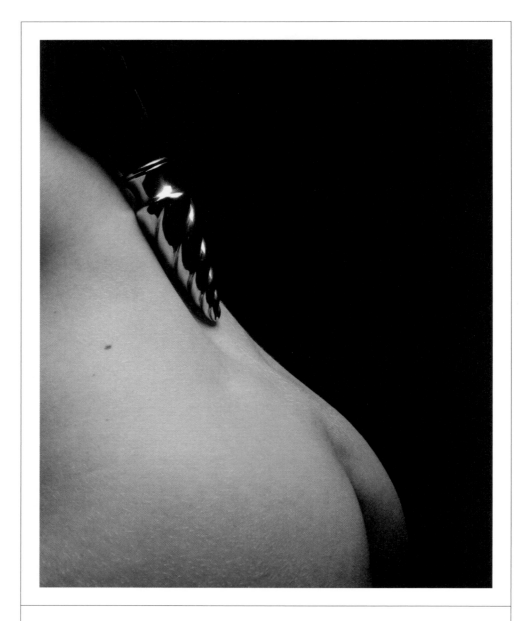

The insertable Unicorn Whip evokes the orgiastic ceremonies of the cult of Venus.
Gentle, controlled whipping suffices to raise a warm, tingling glow. The Unicorn
with silver lashes bestows magnificently novel sensations while the Elegant Spanker
is favored by those who practice more traditional forms of erotic discipline.

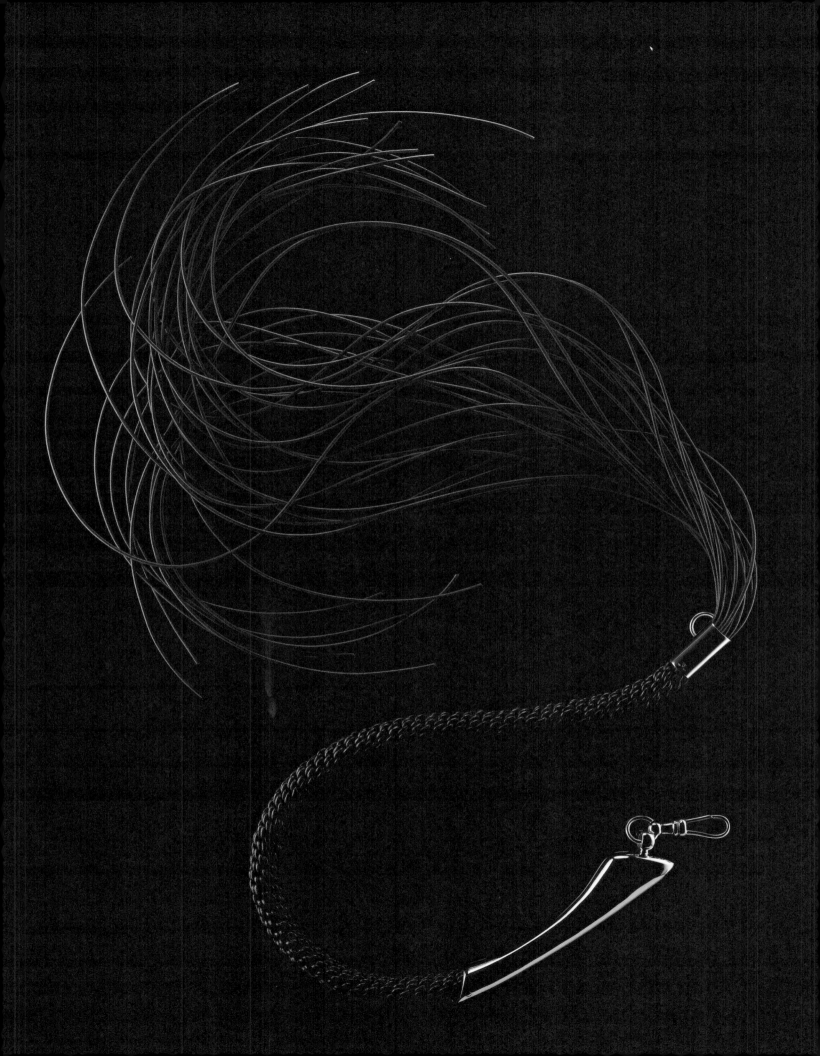

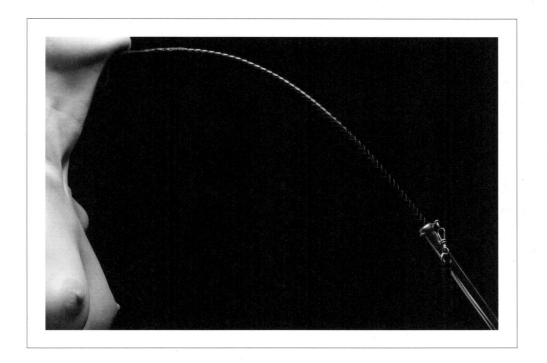

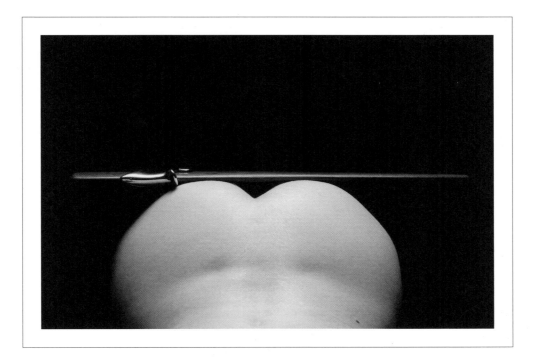

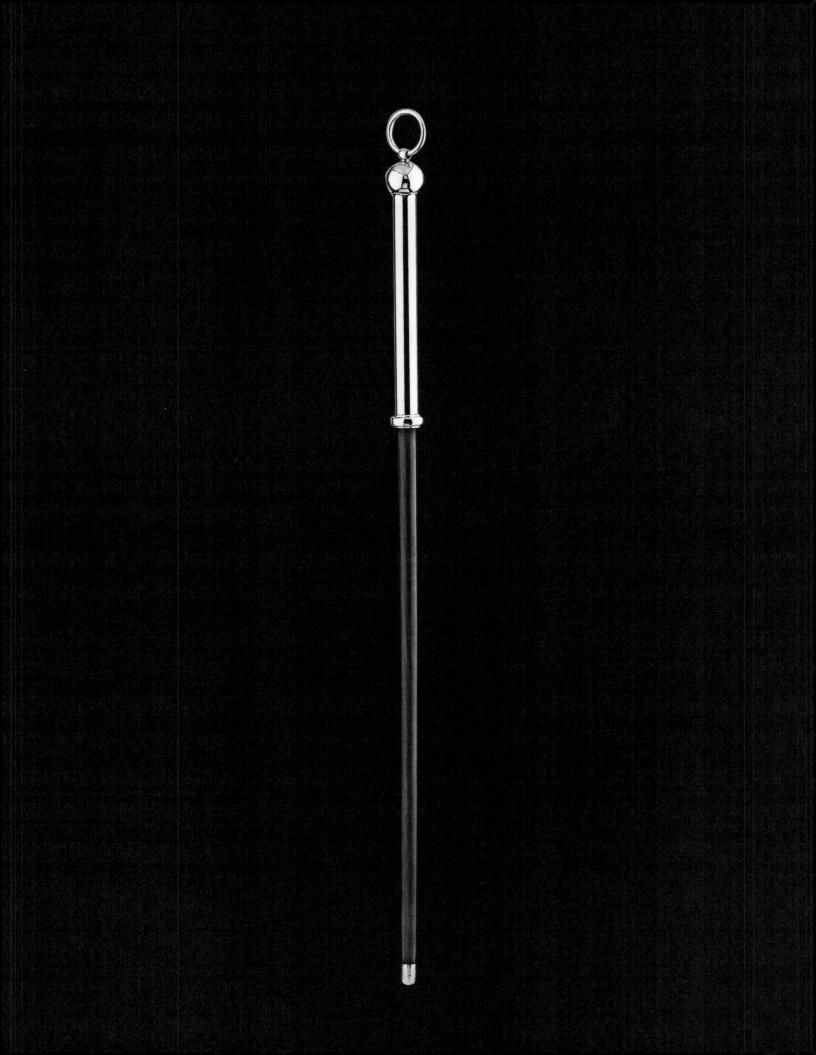

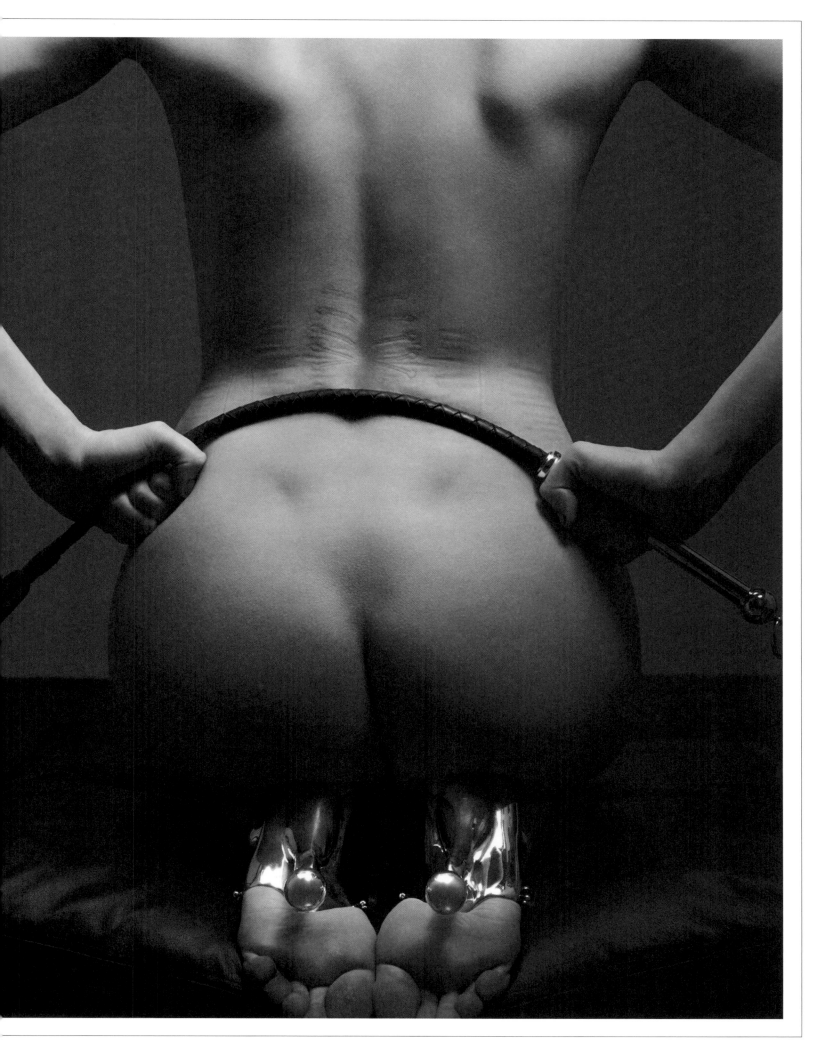

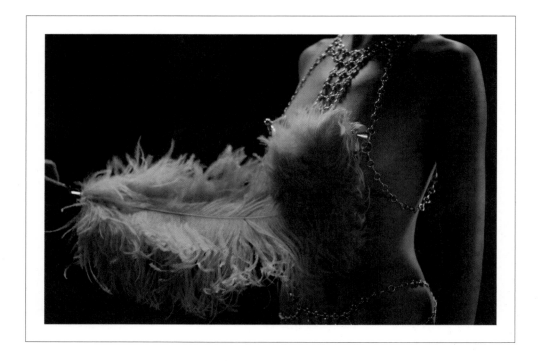

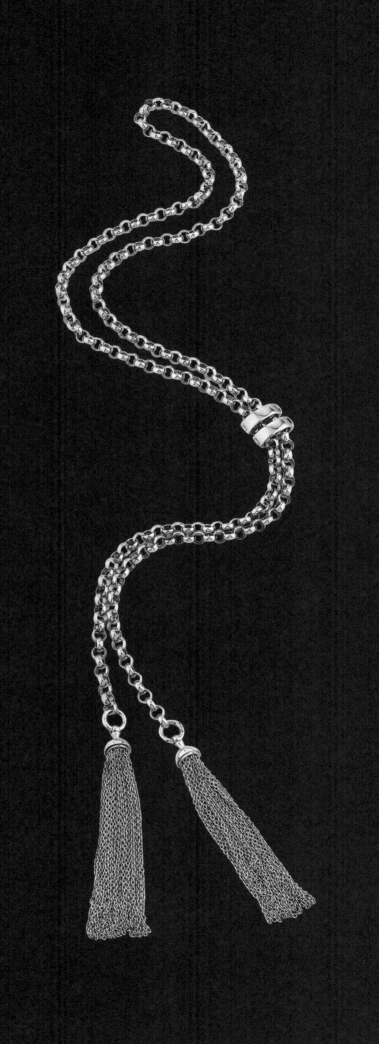

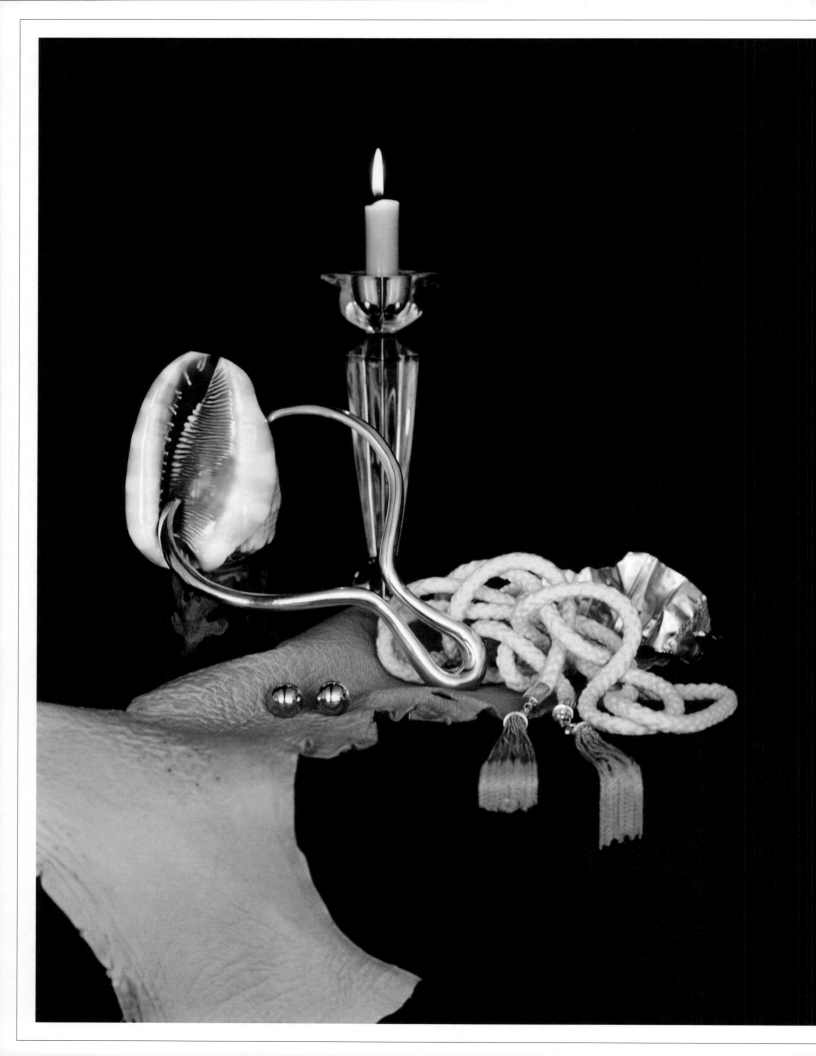

When genital and full-body sensations are combined and alternated, the entire body, as well as the mind and spirit, becomes charged with sexual vibrations. Representing the embrace of a miniature stylized couple, my clamps are designed to grip not only the nipples, but other highly sensitive erectile tissues like the outer lips of the vulva, the scrotum, or the shaft of the penis (p. 191). My Clamps Collier (p. 190) can be worn as a necklace without anyone knowing the enticing secret it holds—almost like extra fingers, clamps attached to chains make tantalizing these zones possible while you focus your amorous attention on other areas. Not everyone appreciates their impactful sensations, but for some, such edge play pushes the boundaries of pleasure, mounts sexual tension, and, with sweet release, incites a blissful rush of endorphins. I also dedicated a significant part of my work to objects that are designed to bejewel and stimulate the interior of the body. Dilettos (more commonly called dildos) enhance the progression of the sexual ceremony. The word "diletto" is derived from the Italian verb dilettare, meaning to delight and give pleasure. Dilettos ease the demands placed upon the male member and ultimately permit lovers to engage in lengthy intervals of stimulation, essential to the "sexual high." In one form or another, dilettos have been around since the dawn of humankind. My sterling silver dilettos (pp. 195, 196, 197) were inspired by Greco-Roman fertility ceremonies. The slim necks of the "vessels" are capped with polished spheres that can be removed in order to fill the dilettos with elixirs d'amour, body oil, or any other liquids appropriate for erotic play. When the diletto is inserted, the sphere remains on the outside of the body. The dilettos come in a set of three progressive sizes, but even smaller jewel-tools have enormous powers to please. The Shag Bague is a tiny teaser of a diletto that can be used to stroke the G-spot or as an anal dilator. The Unicorn also has a dual function. This horsehair whip, inserted into the nether region, turns a consenting bottom into a perfectly groomed pony. It can be used as a whip, with gentle gestures, to raise an exciting glow. The Love Gun strokes the G spot, the highly sensitive almond-shaped organ that lies inside the vagina, just a few centimeters from the opening, on the upper inner wall. This erotic sculpture is a wonderful accompaniment to female masturbation, and its anatomic handle provides a firm grip. The male equivalent of this tool is the Trophy. Based on a medical tool, it serves to stimulate the "P-spot," more commonly known as the prostate gland, which lies approximately seven centimeters inside the lower rectum. Many men are unfamiliar with the erotic powers of the rectum; relaxation, lubrification, and arousal are key to pleasureable anal insertion. Once the object is in place, the curled handle presses pleasantly against the perineum. Inspired by the ancient Chinese instruments of desire that give them their name, my silver, gold, or marble Ben Wa Balls provide exquisite rolling sensations of vaginal fullness (p. 186). The Ben Wa Chain (pp. 188, 189) turns these intimate spheres into a necklace, bracelet, or belt, to empower beyond the boudoir. The use of these tools strengthens the pelvic floor and enhances the pleasures of female orgasm, as well as the mutual joys of penetration.

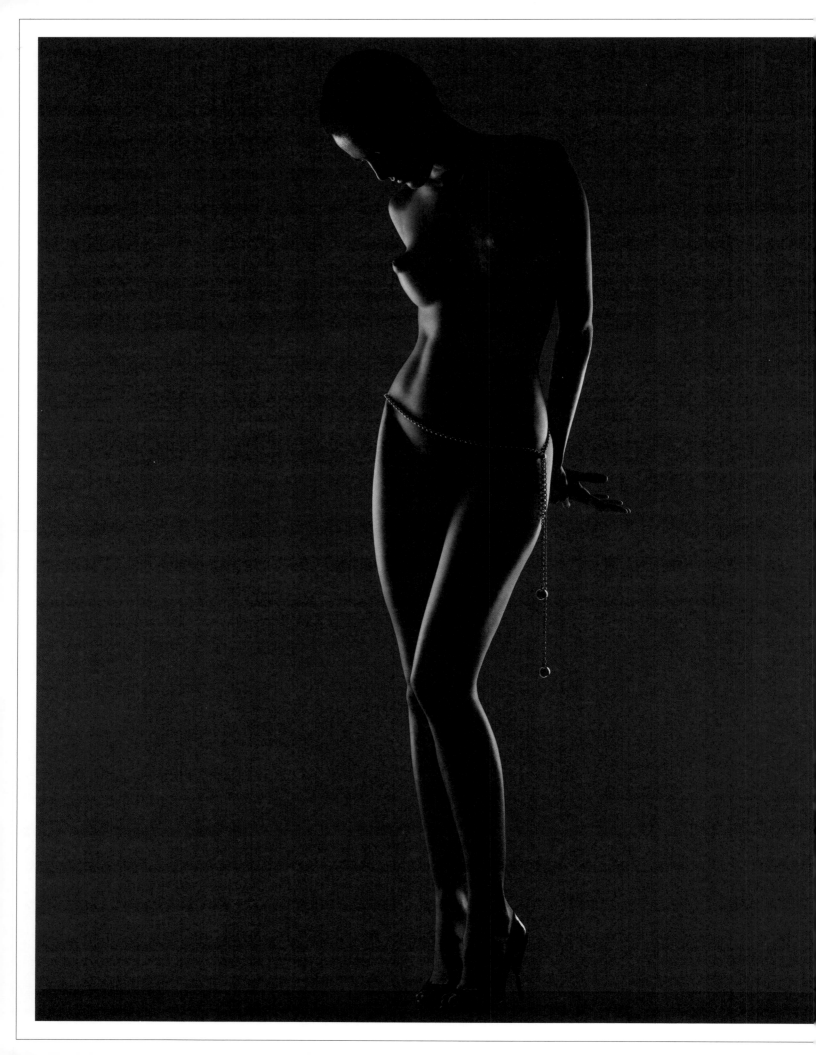

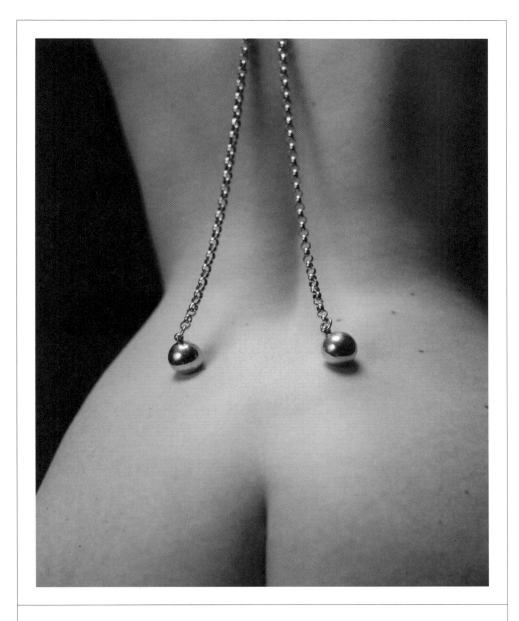

Ben wa balls and silver tassels are slyly attached to chains soft
and flexible enough to be worn as a bracelet, necklace, or as a sexy belt.
The silver spheres can be delightfully tucked inside the body while
the tassels can be used as whips—its secrets are yours to keep or reveal.

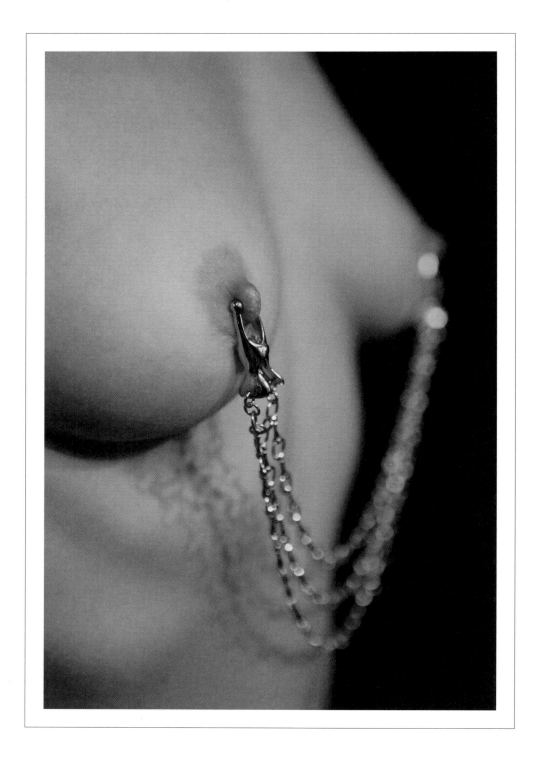

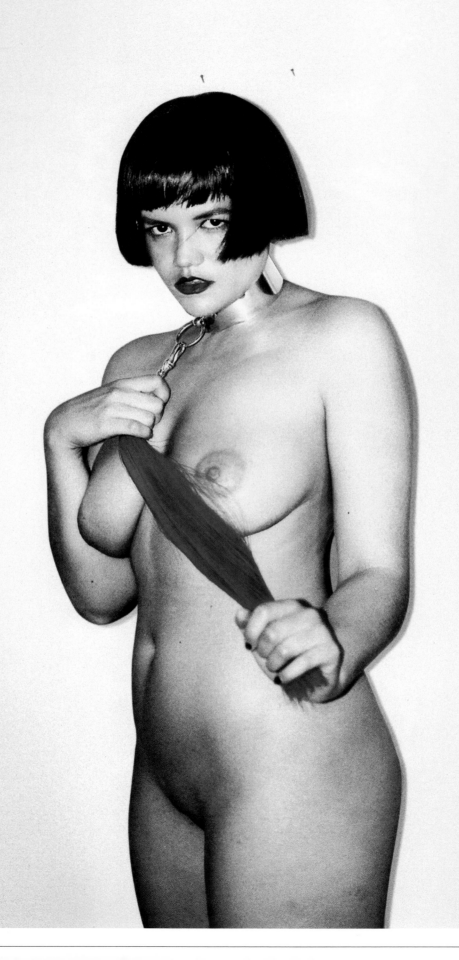

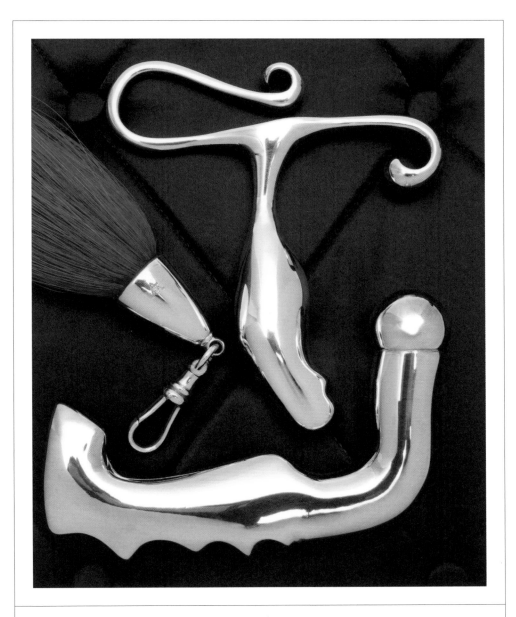

Sterling silver is body-safe and naturally antibacterial. Based on a
medical tool, the Trophy gently massages the male prostate. Its partner,
the Love Gun, strokes the female G-spot. Silver dilettos can be
placed in hot or cold water for those who enjoy temperature play.

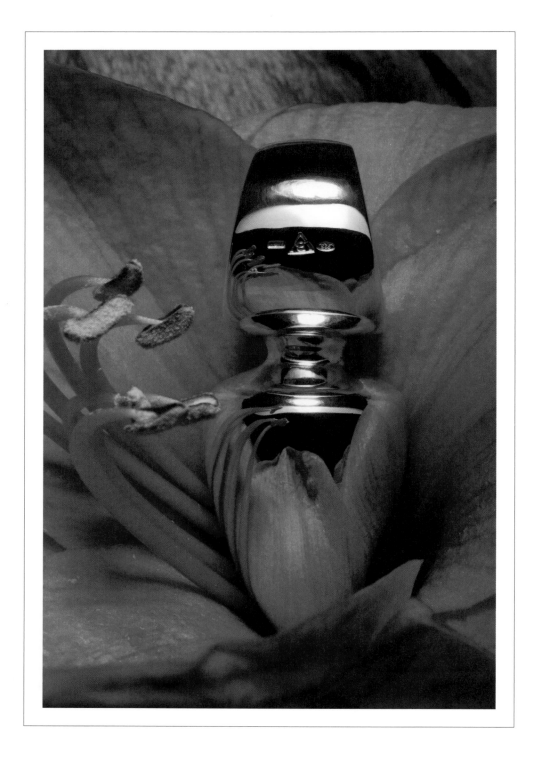

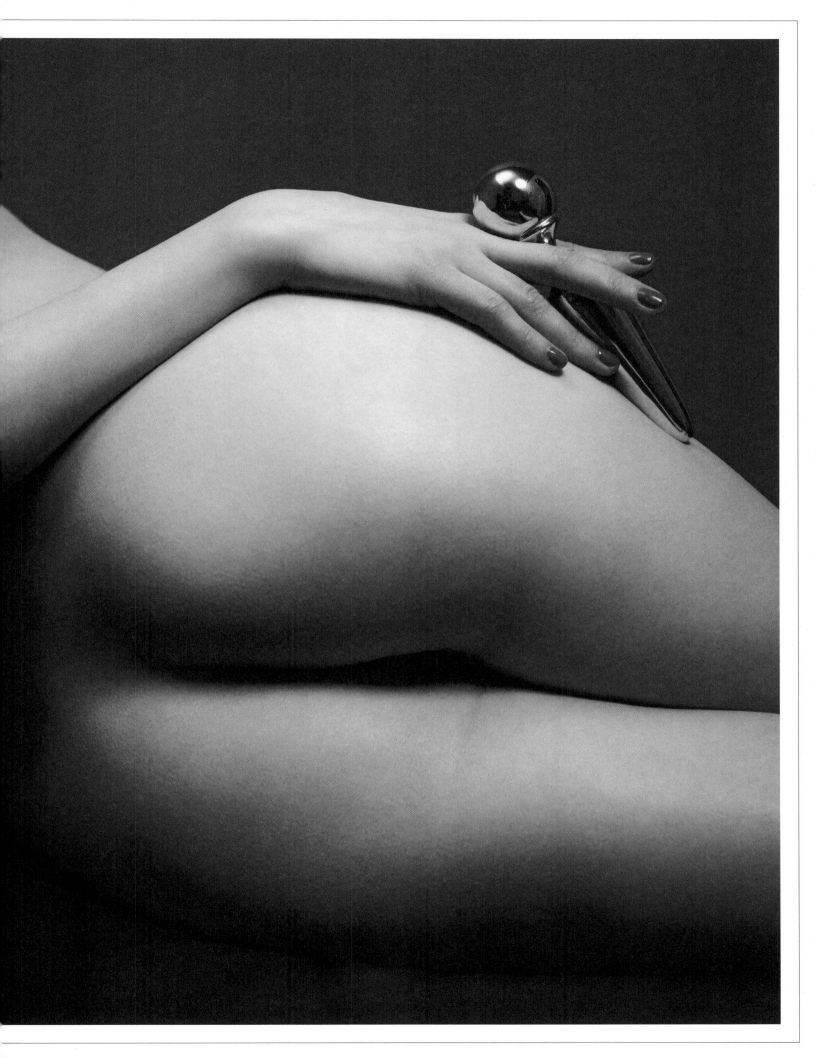

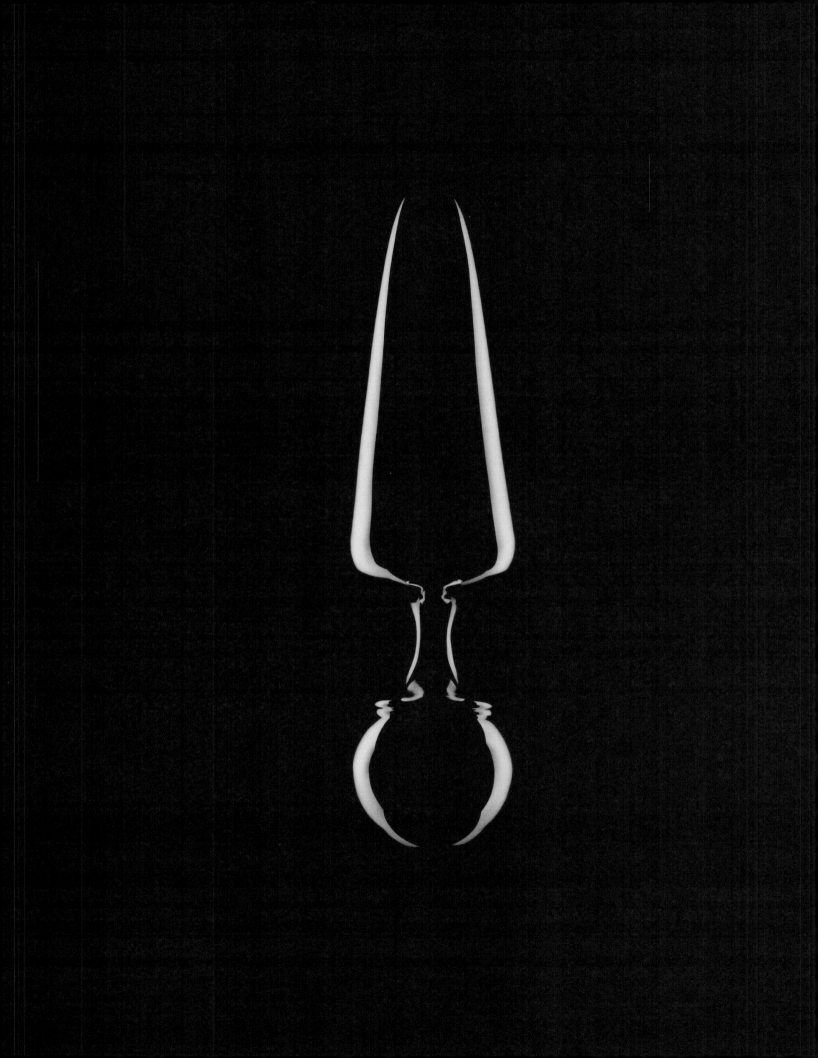

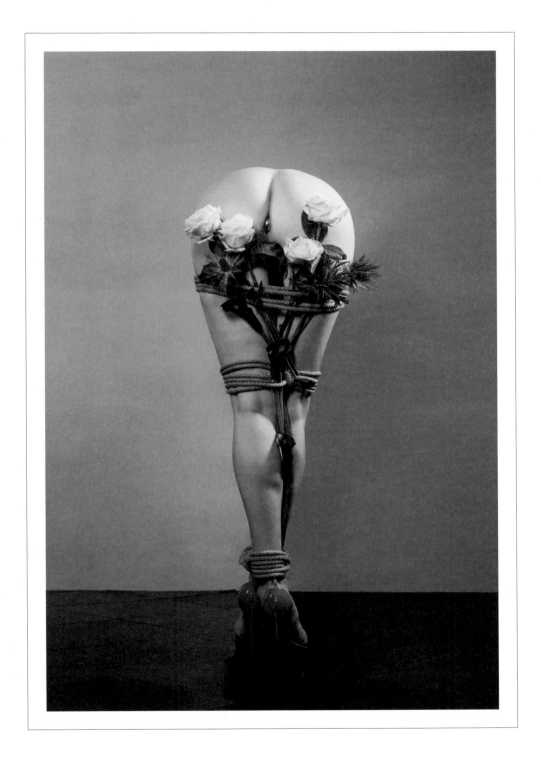

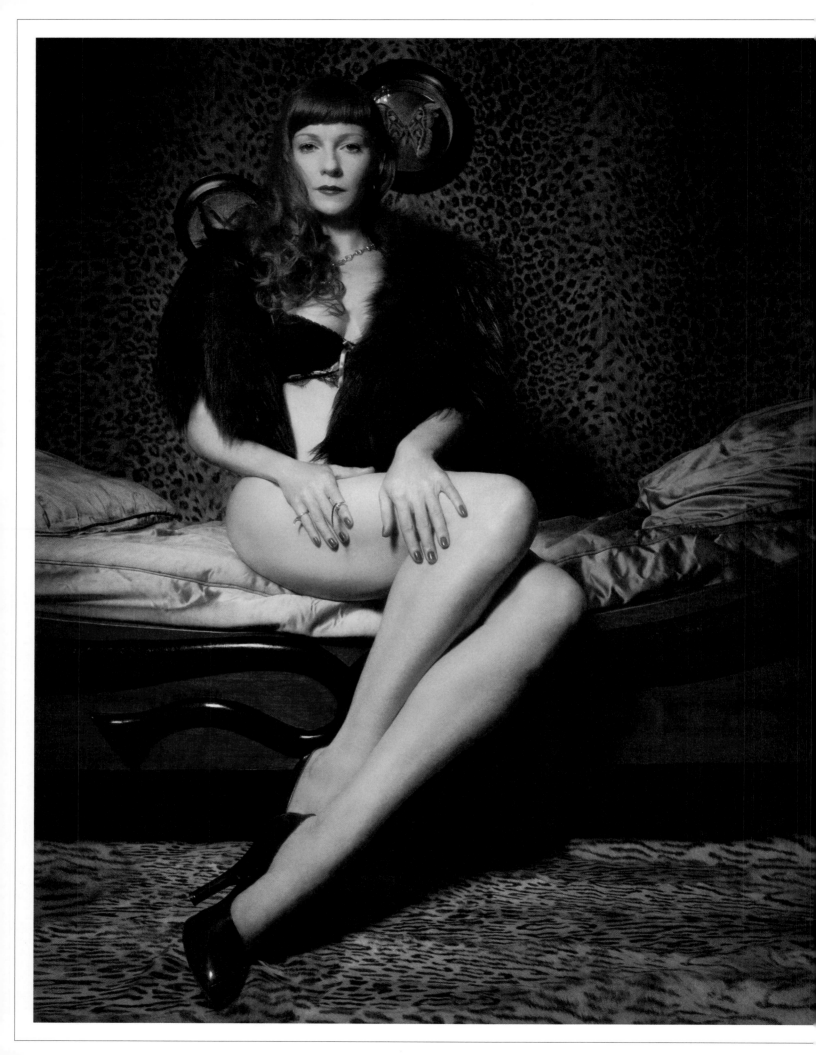

VIII.
THE CEREMONY

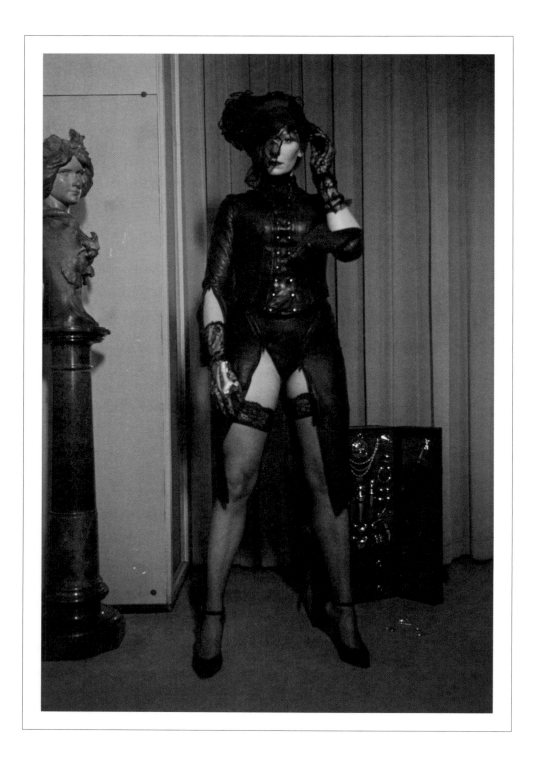

I had long dreamt of working in the house museum of architect, designer, and photographer Carlo Mollino. I am greatly inspired by the theatrical dimension of his interiors, far removed from the everyday world. His use of mirrors, voluptuous velvet, sliding walls, exotic floor and wall coverings, transformational furnishings, and trompe-l'oeil were all carefully chosen to transport one swiftly into the pleasure realm. After all, where beauty reigns, fantasy follows. One day I traveled to Turin to visit this secret refuge and ask the current owner's permission to stage and document a fetish fantasy of my own in the apartment, and he agreed. It would be the first time in fifty years that liberated women would once again be photographed in this supreme temple of desire and design. Honored by his enthusiasm, I carefully chose my trusted partners, the photographer Jeff Burton and Corina Millado (aka Syren). As with any important ceremony, composing the many elements took time—four years!—but anticipation would make our experience all the more rewarding. At last, in 2007, in Carlo Mollino's enigmatic space, I finally unlocked the Boudoir Box. It was the first time its secrets were revealed for the camera. I learned that my fellow sybarite Mollino had never actually lived in the apartment's erotically charged rooms; instead, he had built his temple specifically as a sort of playroom, a set where his fetishistic photographic ceremonies could come to life. The existence and purpose of this space had been a well-kept secret, revealed only after Mollino's death in 1973. He was a noted Egyptologist, and, as if in a pharaoh's tomb, every aspect of the décor appeared to be chosen to create a happy transition to the afterlife. Here, amongst leopard-skin walls, a rare butterfly collection, zebra-skin rugs, and abundant curtains, Mollino dressed—and undressed—his subjects to his liking for his immortalizing lens. In the corner of the bedroom, the sleigh bed, enveloped in a white veil like a funerary boat, seemed ready to transport Mollino into the afterlife. Did the ladies he photographed, like a host of ushabtis, escort him to his eternal, royal rest? Ceremonies are orchestrated experiences that build to a crescendo. From the moment the time and place is set, the ceremony commences. A well-planned sexual ceremony sets the creative body and mind free to play and enjoy. Fantasy is the ceremonial guide; the environment, props, jewel-tools and other related gear are all chosen accordingly. As the stages of the ceremony unfold, partners gradually transcend together. In this alternate pleasure dimension, anything and everything sensual and consensual can take place safely, privately, and ecstatically. The ritual may last for hours... or even for days. Our own ceremony drew to a close after four days of erotic bliss in Mollino's sublime environment. As I locked the Boudoir Box and Jeff Burton put away his camera, we all felt Mollino's temple fall asleep again, like a Sleeping Beauty waiting to be awakened once more. But for my trusted partners and me, the memory of this magical moment remains as potent as ever. The participants in such a ritual remain eternally connected. Pleasure transforms us as individuals; it opens doors to the most intimate part of ourselves and one another. When we place pleasure and beauty at the center of our lives, we discover a fountainhead of satisfaction—truly it is Paradise Found.

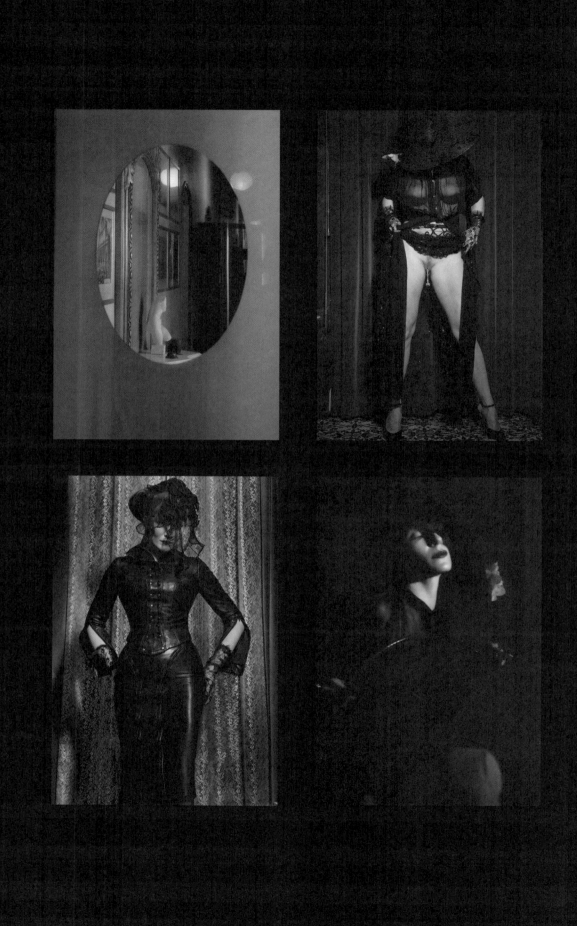

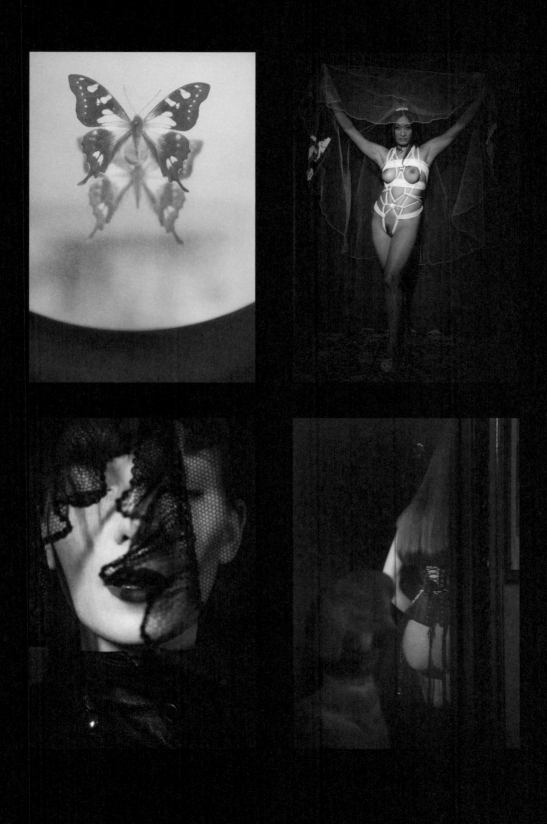

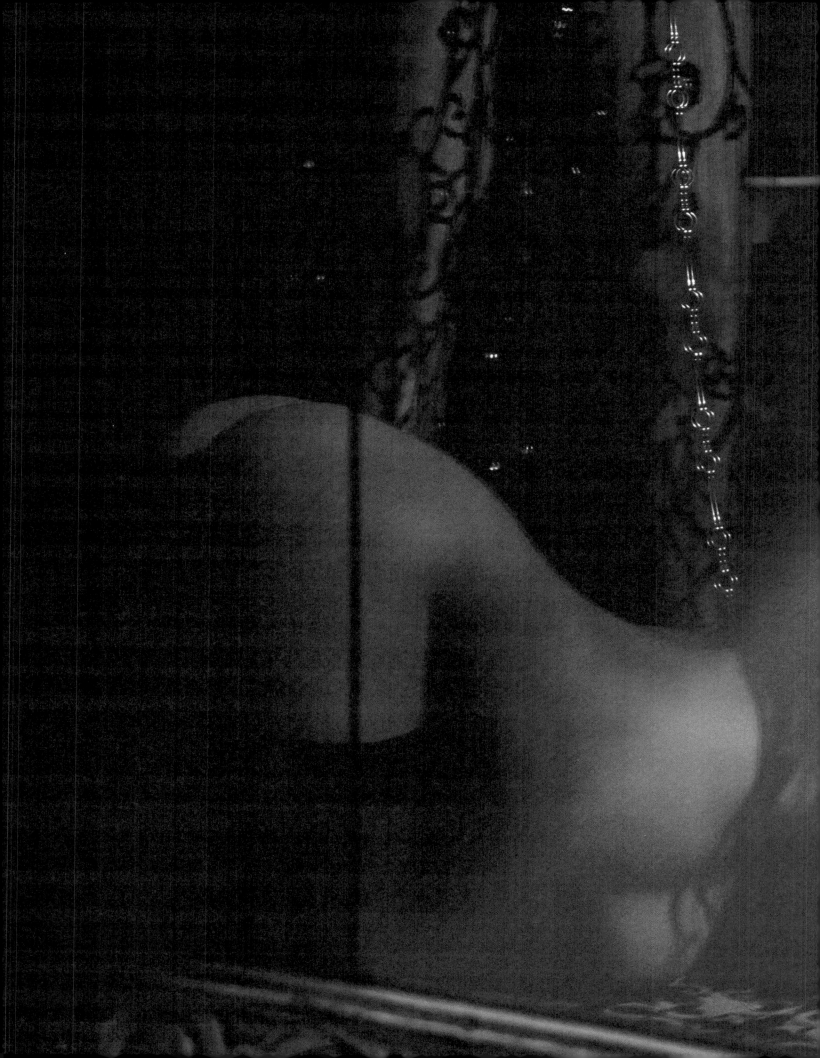

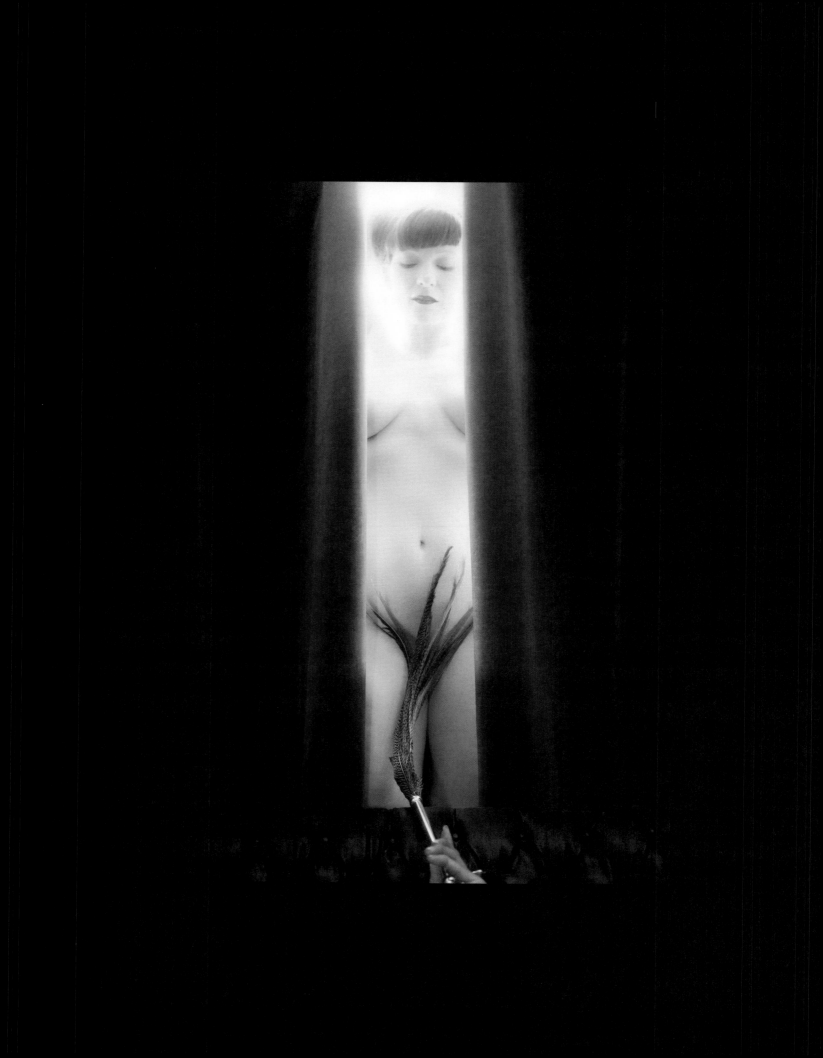

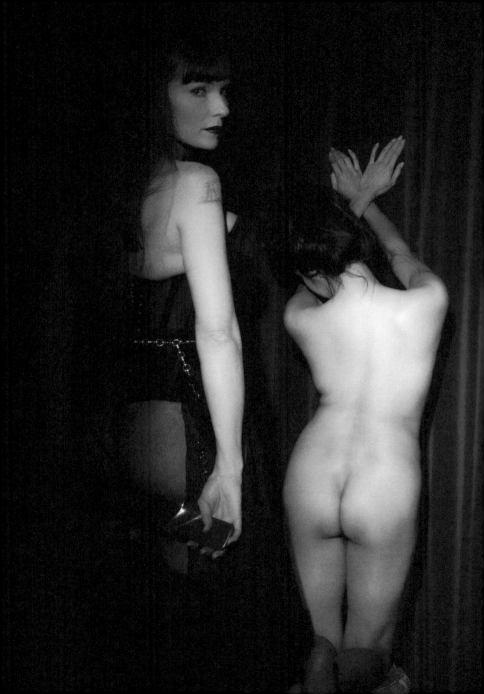

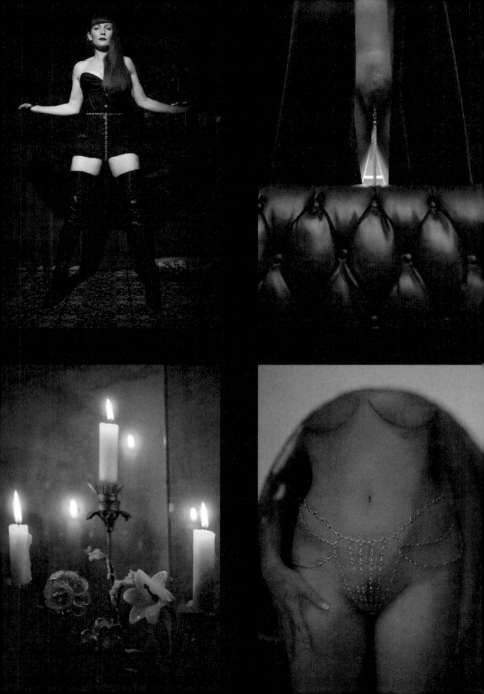

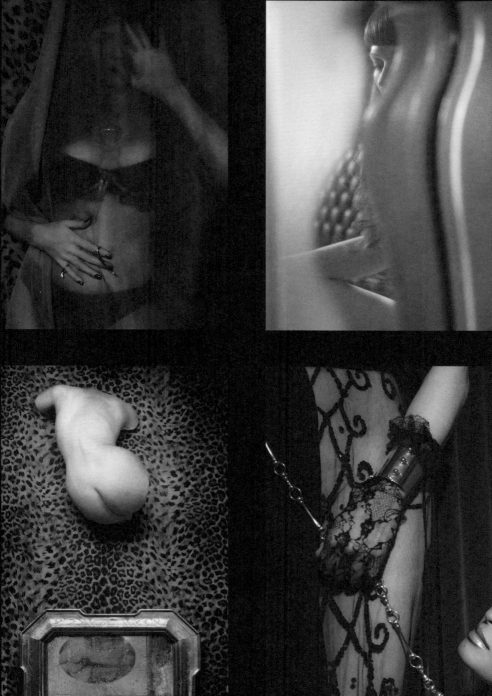

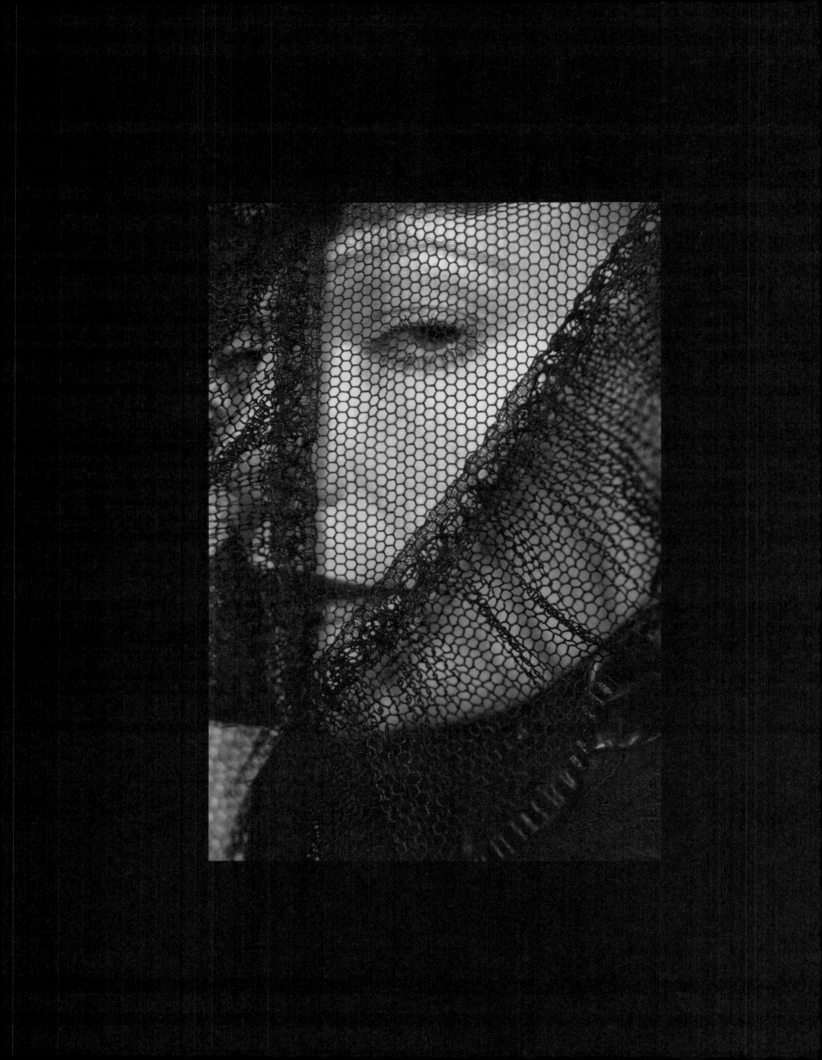

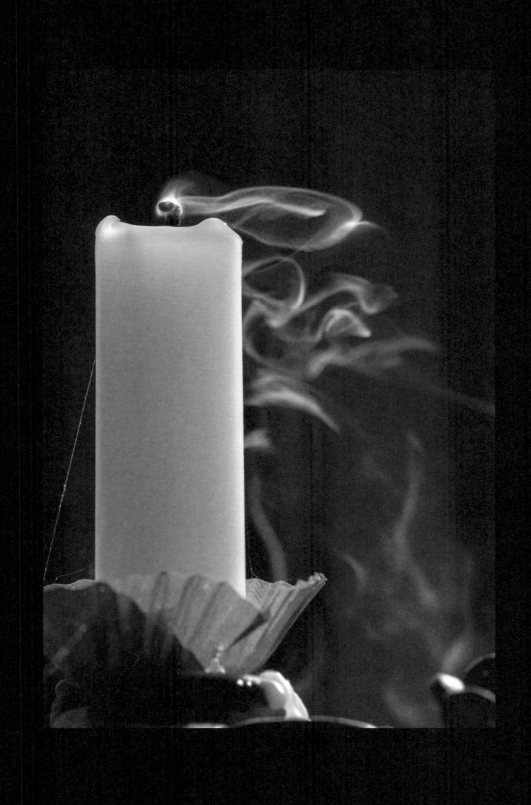

INDEX
Jewels & Images

ACKNOWLEDGMENTS

If I were to include every person that made Paradise Found possible, from hair and makeup artists, set designers, and stylists, to journalists, editors, producers, artisans, and collectors who supported my mission over the past thirty years, it would require writing another book. You know who you are, and I thank you. Charles Miers of Rizzoli, thank you for seeing the value of composing this volume. My deepest appreciation also goes to my editor Elizabeth Smith for her ongoing contribution alongside production manager Colin Hough Trapp at Rizzoli; you both worked so seamlessly with my team. Clara Hamandjian, I couldn't have wished for a better project manager; your devotion to Paradise Found set the bar for excellence in combination with the creative direction of Thomas Lenthal and art director Damas Froissart. Your combined sense of timeless elegance is infused in every page. A big merci to Zoé Tullen for helping everyone to navigate the BV archive, especially Luba Vadimovna Nel, whose magic post-production wand harmonized every image. Thank you, Paolo Canevari, for your personal support over the course of the project. Alongside Marc Orsatelli and Tania Gandré, my ultimate beauty squad, I also thank all of the models who granted us permission to use their stunning images, in order of appearance: Kate Moss, Lotta Volkova, Anna Cleveland, Tessa Kuragi, Lily McMenamy, Quiun Linden, Aja Jacques, Romain Brau, Mariacarla Boscono, Alana Zinner, Tony Bruce, David O'Donnell, Miss Fame, Violet Chachki, Agathe Roussel, Tamy Glauser, Layard Thompson, and Corina Millado. And last but not least, I thank all the photographers and illustrators for helping to celebrate the thirty-year anniversary of Paradise Found Fine Erotic Jewelry with your beautiful work: Thibault Montamat, Thomas Krappitz, Giovanni De Francesco, Nicola Carignani, Olivier Zahm, Yasmin Gross, Nicola Majocchi, Maria Ziegelböck, Ellen von Unwerth, David Downton, David Bellemere, Terry Richardson, Lara Giliberto, Delfina Dellert, Douglas Kirkland, François Berthoud, Rafael Dubus, Katrin Backes, Jean-Baptiste Mondino, Thomas Rusch, Michael James O'Brien, Bettina Rheims, Erin O'Neil, Ali Madhavi, Katerina Jebb, Danica Lepen, Vee Speers, Guillaume Thomas, Franck Murra, Robert Maxwell, Raul Higuera, Liz Collins, Nick Knight, Irina Ionesco, Sabine Pigalle, Gilles Berquet, Armin Morbach, Susanne Junker, Eva Ionesco, Sarah Maingot, Craig McDean, Frédéric Sofiana, Jeff Burton, and lastly Eric Maillet, who left the earthly dimension during the project (RIP, your work will live eternally on). Just love to all... Betony

First published in the United States of America in 2022
by Rizzoli International Publications, Inc.
300 Park Avenue South
New York, NY 10010
www.rizzoliusa.com

Copyright © Betony Vernon

Publisher: Charles Miers
Editor: Elizabeth Smith
Production Manager: Colin Hough Trapp
Managing Editor: Lynn Scrabis

For Betony Vernon:
Project Manager: Clara Hamandjian

Graphic Design: Lenthal Studio

2022 2023 2024 2025 / 10 9 8 7 6 5 4 3 2 1

Printed in Italy

ISBN-13: 978-0-8478-7216-9

Library of Congress Catalog Control Number: 2022932860

Facebook.com/RizzoliNewYork
Twitter @Rizzoli_Books
Instagram.com/RizzoliBooks
Pinterest.com/RizzoliBooks
Youtube.com/user/RizzoliNY
Issuu.com/Rizzoli